Nigel Henderson
Parallel of Life and Art

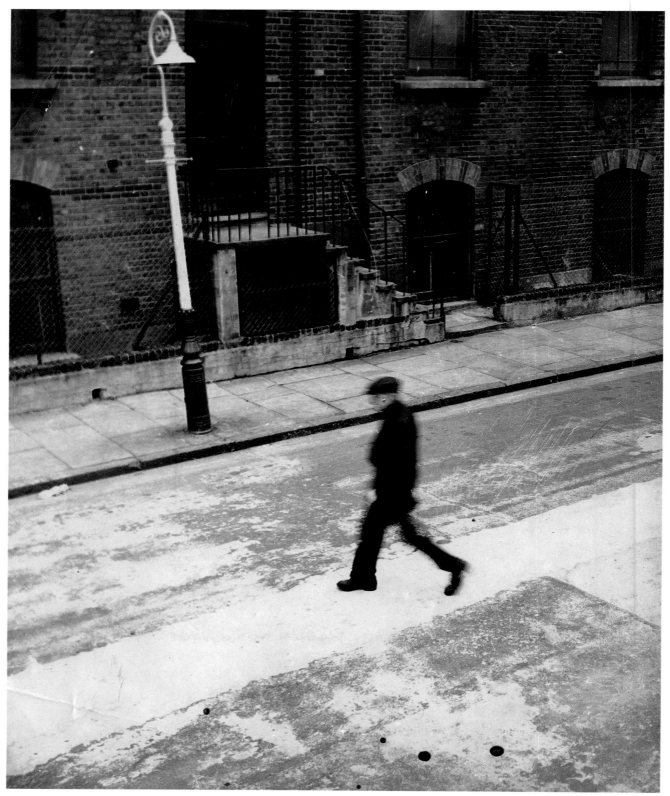

Man in Bunsen Street, Bethnal Green, 1950.

Victoria Walsh

Nigel Henderson
Parallel of Life and Art

Foreword and Afterword by Peter Smithson

With 159 photographs in duotone and colour

 Thames & Hudson

Published to accompany the exhibition
Nigel Henderson: Parallel of Life and Art
organized by Victoria Walsh for Gainsborough's House
and funded by the Arts Council of England

Exhibition Tour

Gainsborough's House
46 Gainsborough Street, Sudbury, Suffolk CO10 2EU
27 September to 25 November 2001

Graves Art Gallery
Surrey Street, Sheffield S1 1XZ
8 December 2001 to 2 February 2002

Scottish National Gallery of Modern Art
The Dean Gallery, Belford Road, Edinburgh EH4 3DR
16 February to 7 April 2002

Architectural Association
34–36 Bedford Square, London WC1B 3EF
24 April to 15 June 2002

First published in the United Kingdom in 2001 by Thames & Hudson Ltd,
181A High Holborn, London WC1V 7QX

British Library Cataloguing-in-Publication Data
A catalogue record for this book is available from the British Library

ISBN 0-500-28325-7

Printed and bound in Italy by Conti Tipocolor

Contents

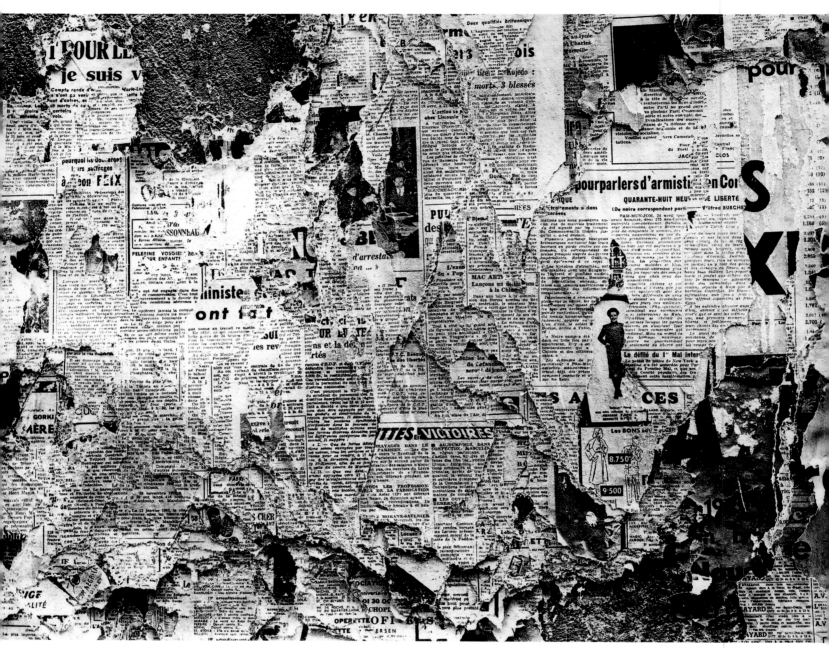

Paris wall, 1949.
This photograph was subsequently used as a design for wallpaper and fabric produced by Hammer Prints Ltd, the company set up by Nigel Henderson and Eduardo Paolozzi in 1954.

Foreword

The two events which are central to this story are both a long time ago ... 1953 for 'Parallel of Life and Art', 1956 for 'Patio & Pavilion' ... nearly fifty years.

Long enough to forget the detail.

But not to forget — or ever to forget — the hilarious confluence of Nigel Henderson and Eduardo Paolozzi.

What Alison and I did together with them was almost without discussion: much laughter, and, really from Nigel and Eduardo both, the rare use of few words.

Victoria Walsh has much to say about Nigel Henderson's use of 'image'.

It is the key to the period.

But, why something is 'a good image' cannot be understood outside the persons and the period of its use.

Such condensation of meaning into a single word is a characteristic of people campaigning together.

Such then were we.

Peter Smithson

Preface

In 1997, after a decade or more of relative anonymity, the name of Nigel Henderson (1917–1985) began to re-emerge following the inclusion of a major work by Alison and Peter Smithson, the *CIAM Grille*, in 'Documenta X' at Kassel in Germany. First presented in 1953 at the ninth meeting of the Congrès Internationaux d'Architecture Moderne (International Congress of Modern Architecture) at Aix-en-Provence in the South of France, the 'grille' was conceived as a proposition to abandon the concept of infrastructural zones (housing, transport, industry and leisure) which underpinned contemporary urban planning. In its stead, the 'grille' called for a reconsideration of the relations that existed between the house, the street and the district which collectively defined, to a very large extent, the individual's experience of living in a city. As a visual manifesto of the Smithsons' ideas for the future of urban development, the work radically transformed the thinking behind housing programmes and urban planning for a generation of architects, planners and social theorists. The visual articulation of the Smithsons' ideas rested on Henderson's photographs of the East End of London, which formed part of the 'grille'. As the Smithsons openly acknowledged, however, these photographs were not merely selected as illustrations of their ideas, but had actually been instrumental to their rethinking of urban life.

During this period of the 1950s, when he was most actively involved in the Institute of Contemporary Arts (ICA) in London, Henderson was a well-established and well-respected artist amongst his contemporaries. Subsequent generations have, however, only enjoyed infrequent encounters with his work from this period. In 1977 there were two exhibitions of his early work, at Kettle's Yard in Cambridge and at the Anthony d'Offay Gallery in London; and in 1978 another at the Midland Group in Nottingham. In 1990, 'The Independent Group: Postwar Britain and the Aesthetics of Plenty' at the ICA introduced his work to a new audience, but, for anyone wishing to pursue an interest in Henderson's work beyond this show, there was no readily accessible account of his life or reproductions of his early work (although mention should be made of the extensive material about the 1950s gathered in Graham Whitham's chronology in the ICA catalogue). The most comprehensive and reliable sources of information on Henderson to date can be found in the catalogues which

accompanied the show at the Anthony d'Offay Gallery and a major exhibition of collage work which took place at Norwich School of Art in 1982. While the d'Offay catalogue chronologically plots the key episodes of Henderson's life and career, as recounted by him to Ann Seymour, the Norwich catalogue originates from an extraordinarily insightful exchange of letters between

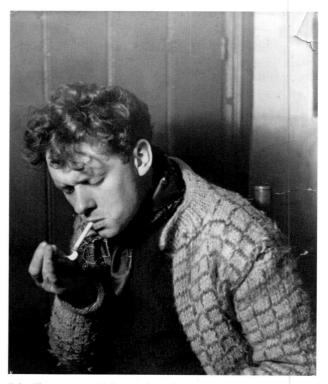

Dylan Thomas, *c.* 1936 (photographer unknown). Collection Wyn Henderson.

Chris Mullen (the catalogue's author) and Henderson, and I am indebted to Chris Mullen for allowing me to use these letters freely in the course of this publication. A more recent and incisive account of Henderson's contribution to post-war British art and photography can be found in Martin Harrison's *Young Meteors: British Photojournalism 1957–1965*, published in 1998.

While Henderson's association with the Independent Group and his incorporation into its various myths and histories has secured him a valuable place in such a show as that at the ICA in 1990, it has nonetheless modified an understanding of the singularity of his working practice and aesthetic and of the removed

relationship he held with this group – a relationship which was determined partly by his seniority in age and partly by the extraordinarily cosmopolitan and culturally privileged circles in which he had moved as a young man before the Second World War. By 1939, Henderson could name among his friends and acquaintances Virginia Woolf, Vanessa Bell, Adrian Stephen, T. S. Eliot, Dylan Thomas, Antonia White, W. H. Auden, Bertolt Brecht, J. D. Bernal, Peggy Guggenheim, E. L. T. Mesens, Roland Penrose, Margaret Gardiner, Freddie Mayor, Humphrey Jennings, Julian Trevelyan, Marcel Duchamp and Max Ernst. By 1950, he had further met Constantin Brancusi, Fernand Léger, Alberto Giacometti, Hans Arp, Georges Braque and Jean Dubuffet. From this list alone it is possible to anticipate what will become clear in the following essay: that Henderson's artistic roots lay primarily within European Surrealism, rather than in the emerging concerns with popular culture and imagery that he is often aligned with. Moreover, his early studies in biology and botany would induce a lifelong fascination with a visual order quite separate from that known to his contemporaries at the ICA.

In the ICA catalogue to the Independent Group show in 1990, James Lingwood stated in his entry on Henderson that only a 'partial and inadequate perspective' of his work could be grasped by locating him within any particular tradition, such as British social documentary photography, or any specific grouping. Indeed, make any reference to Nigel Henderson as a 'photographer' and David Sylvester is quick to correct: 'He was an artist – who took photographs.' Contemporaries of Henderson have also been ready and enthusiastic to acknowledge in conversation the larger contribution he made to post-war British art than is generally recorded. William Turnbull recalls what an 'animator of other people' Henderson was, while Richard Hamilton describes the friend who lent him his copy of Duchamp's *The Green Box* for twenty years, as a 'great conduit of ideas and information'. On reflection, Peter Smithson has concluded, 'I have come to regard Nigel as one of the great artists of his time.'

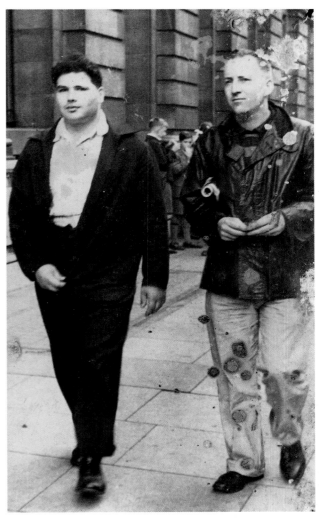

Eduardo Paolozzi and Nigel Henderson, *c.* 1947 (photographer unknown). Tate Archive.

Acknowledgments

In 1998, when I was first approached about organizing an exhibition and a publication on the work of Nigel Henderson (a name unfamiliar to me at the time), I visited the Tate Archive which I was told held a quantity of material donated by the artist's widow, Janet Henderson. Uncatalogued, box after box of negatives, photographs, letters, notebooks, scrapbooks and numerous packets of collage material gathered over three decades – cigarette cards, bus tickets, matchbox covers, newspaper cuttings – were patiently brought to me by Adrian Glew, whose looks of sympathy and smiles of encouragement sustained me over the many hours I subsequently spent in the Archive during the next three years. In the course of scavenging through the material (like the efficient Courtauld graduate I am) trying to decide whether to take the project on or not, I came across a letter of 1971 written by Henderson to one of the most enduring figures of his life, his mother Wyn. As I read the following lines, full of the sardonic wit and mirth that I have come to cherish in the artist, I was filled with as much trepidation as curiosity:

I don't think I have written you since I went up to Hornsey to do a couple of seminars on the early 50s – the Independent Group, 'Growth and Form', 'Parallel of Life and Art', 'This is Tomorrow' – these manifestations, so relatively random in motive and conception at their time, given such 'immaculate' status twenty years on. Possibly the 'While u Wait' cleaning and pressing service of past events widely extended to young 'art historians' by fresh graduates of the Warburg or Courtauld Institutes….

The gauntlet was thrown down. There was nothing to do but take up the challenge. On whether this challenge has been met, the jury is out. But I am indebted to Isabel Vasseur, a close friend of Henderson's, for putting this project my way and entrusting me to carry it off sufficiently for a new audience and a new generation to have the opportunity to enjoy and judge for themselves the contribution that Henderson made to post-war British art. 'Facts alone are wanted in life', claimed Gradgrind in *Hard Times*; but while few of us might wish to hold to this – and Henderson for one would certainly not have – the need to put some facts down about his life and work has become increasingly necessary as curators, artists, architects and students alike have begun to revisit and reassess the 1950s, and in particular the singular part that Nigel Henderson played in the fields of art, architecture, design and photography.

To this end, I cannot extend enough thanks to Janet Henderson, Nigel's widow, and Steve Henderson, Nigel's youngest son. Without their tireless goodwill and support of this project, it would have been impossible to move beyond the usual list of facts and dates cited in accounts of Henderson's career and to reach a more incisive understanding of the early work and the momentum behind it. And by goodwill I mean allowing me to regularly invade their homes and open cupboards and drawers and loft hatches and shed gates in a bid to unearth much of the material that has led to this publication and the exhibition behind it. During the many long, and occasionally indecently cold, days at The King's Head, Landermere Quay (the house which Nigel and his first wife Judith inherited and moved to in 1954 and now the home of Steve Henderson), and at The Hall in Kettlebaston, where Janet Henderson lives, I was also joined by Andrew Hunter from Gainsborough's House in Sudbury. A good friend of the family, thanks are due to Andrew for initiating the project, having been first approached by Janet Henderson, and for overseeing it with an open, but careful, eye. I am also grateful to Justin, Drusilla (Jo) and Ned Henderson, Nigel's other children, for supporting the project.

In trying to piece together the context from and within which Henderson's artistic practice emerged, I was both fortunate and privileged to enjoy a number of lengthy conversations with Susan Watson, Nigel's sister, who sadly died as this book was going to press. Her vivacity and eloquence in conjuring up the characters that inhabited her and her brother's childhood and adolescent years helped to flesh out many previously abbreviated stories. Another exceptional resource was also generously made available to me in the form of a series of letters exchanged between Chris Mullen and Henderson. Following a question-and-answer format, these letters became the basis for Chris Mullen's essay for the catalogue that was produced to accompany Linda Morris's exhibition 'Nigel Henderson' at the Norwich School of Art in 1982. Revealing him as an agile sparring partner to Henderson's wit and acuity, the letters are a testament to the friendship and trust that were forged between the two.

My considerable thanks for his support throughout also go to Keith Hartley from the project's associated institution, the Scottish National Gallery of Modern Art, who in the early stages of research

helped me to map out the territory to be covered. I subsequently met with a number of Henderson's contemporaries and was taken by the level of esteem and degree of affection in which he was held as an artist and friend. Without exception, all of Henderson's contemporaries that I spoke to enthusiastically endorsed the idea of an overview of his early work, and I am grateful to the following for their time and interest: David Sylvester, William Turnbull, Richard Hamilton, Freda Paolozzi, Frank Whitford, Roger Mayne and, in particular, Colin St. John Wilson. I am indebted to Peter Smithson for the insights he offered up on the exhibition 'Parallel of Life and Art' and the installation 'Patio & Pavilion', and for the careful observations he made on the text which he so generously agreed to frame with a Foreword and Afterword. I would also like to thank Robin Spencer, Mark Haworth-Booth, Jeremy Akerman, Andrew Brighton, Karole Vail and Fiona Pearson for pointing me in the right direction for various documentary and secondary material; Rosalind Horne for her invaluable help in identifying many of the original negatives for the exhibition 'Parallel of Life and Art'; Victoria Lane for helping me steer my way through complicated photographic orders from the Tate Archive; and Gerrie van Noord for being a sympathetic listener.

As no definitive list of works or collections exists, a considerable amount of time was spent trying to track down works and owners and, although I would anticipate that the exhibition and this publication will bring to light many more owners of Henderson's work, I would like to thank the following institutions and individuals for their help in securing this information: James Lingwood, Linda Morris, James Birch (Birch & Conran), Andrew Murray, Caroline Cuthbert, Peter Blake, Barry Flanagan, James Meller, Nicholas Serota, Anne Goodchild at City of Sheffield Art Galleries, Arts Council of England Collection, Eastern Arts Collection, Government Art Collection, The Laing Art Gallery, Colchester Castle Museum, Norfolk Museum, Museum of London, Tate, Victoria & Albert Museum, Centre Georges Pompidou, Brooklyn Museum of Art and the Museum of Modern Art in New York.

Our special thanks go to Jeremy Theophilus and Marjorie Allthorpe-Guyton at the Arts Council of England. Not only did they both know Henderson during periods of their careers in East Anglia, but they were also among the first to acknowledge the need for a serious reconsideration of his contribution to post-war British art. We are grateful for the financial assistance that has been forthcoming from the Arts Council, without which the project as a whole could not have been realized. When we were struggling, apparently against the odds, to negotiate large numbers of unprinted negatives still held by Janet Henderson, we received a financial gift from the photographer Dorothy Bohm to allow contact prints to be made, and we are most grateful for her timely assistance and to Martin Harrison for bringing our dilemma to her attention.

To conclude, the Henderson family, Gainsborough's House and I would like to extend our great thanks to Martin Harrison, who in 1998 had independently begun to plan a publication on Henderson's photographs of the East End and London jazz scene of the 1950s. As it became clear to what extent our paths were crossing, he very generously stepped aside and secured this publication, for which he is the designer, in place of his own. After many cigarette-filled conversations on the phone, I personally would like to thank him for being such a reliable sounding board on which I have tried to iron out some of the starch in the creases of my writing.

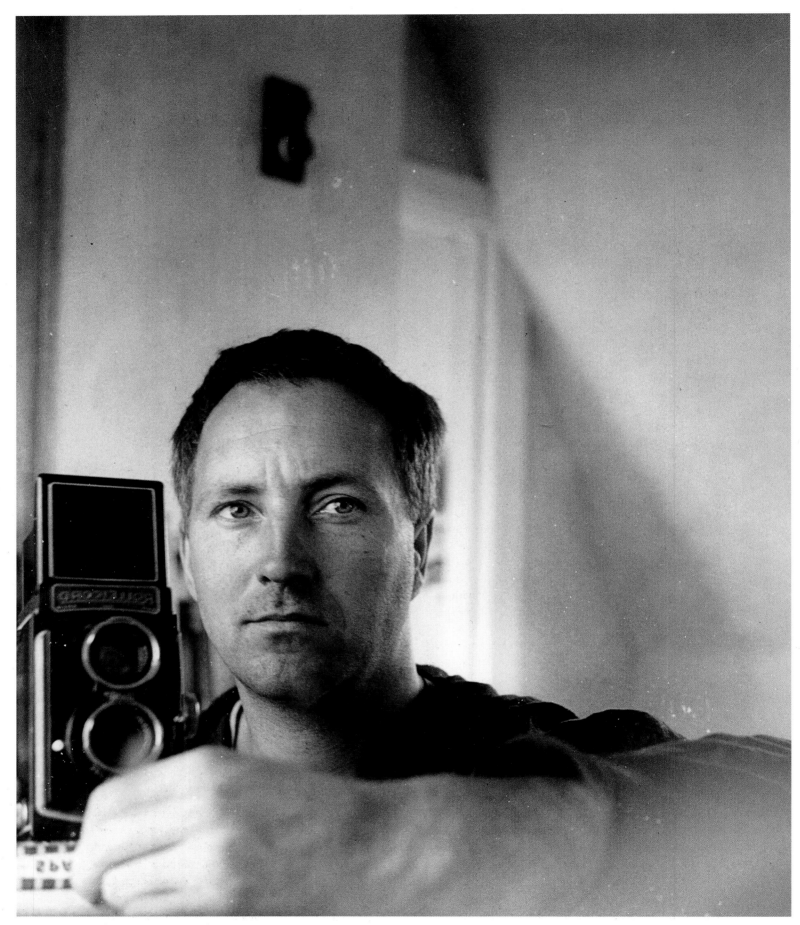

Nigel Henderson, self-portrait, *c.* 1951. Tate Archive.

The Early Years 1917–1949

'1917 – Born on April Fool's Day'

Self-effacing, self-mocking, and of a quintessentially English wit, Nigel Henderson was often known to begin an account of his life with the above remark. Henderson's parents, who were from strikingly different backgrounds, married during the First World War. His father, Kenneth Henderson, whom he rarely spoke about during his lifetime, came from a prosperous middle-class family and was a Guards officer on leave when he first met his future wife, Winifred Ellen Lester, known as Wyn. After the war ended, he was involved in the family's interests in South America, which had been established by his uncle, Lord Faringdon. Faringdon, a contracting engineer, had become successful in South America through the construction of various railway networks and the related acquisition of real estate. Wyn Henderson, born to unmarried parents, had enjoyed a far less conventional life. By the age of seventeen, she had performed in music halls and worked on various concert circuits, occasionally writing as a music critic. These activities were ultimately replaced by a more substantial career in the small private-press world in which she worked for John Rodker's Aquila Press and later Nancy Cunard's Hours Press in Paris. By 1924 the couple were divorced and Henderson's father was granted custody of their two sons: Nigel, eight, and Ian, nine. Committed to business in Buenos Aires, Henderson's father left the boys with his parents to be brought up at their house on Wimbledon Common in southwest London. Half of their school holidays, however, were to be spent with their mother, who retained custody of their sister, Susan, aged seven.

Reluctant to dwell on his early childhood, Henderson occasionally alluded to this part of his life through odd images and phrases which hinted at some of the more painful and abiding memories: 'London. Putney Vale cemetery via Minerva To Harrods. Via Putney, Fulham, Cancer and Consumption Hospitals, Michelin. Car numbers.... Car sickness.'[1] According to his sister, the memory of frequent journeys to Harrods with his grandparents in their leather-upholstered, chauffeur-driven car (which passed Putney Vale cemetery en route) haunted Henderson throughout his life, leaving him with a prescient fear of disease and enclosed spaces. For Henderson, the holiday periods spent with his mother came as a joyous reprieve from the stifling middle-class environment of his grandparents' house and lifestyle.

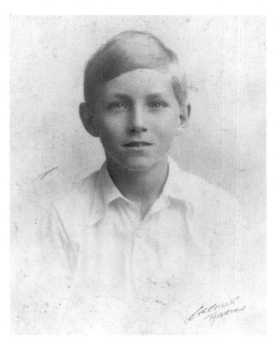

Nigel Henderson as a young boy. Tate Archive.

'A scarlet woman and the Mecca of our desires', Wyn Henderson was the focal point of both her sons' lives. Witty, gregarious, flirtatious and charming, she was the complete antithesis of her former husband's family, as Henderson later recalled: 'She was a real shocker to the social pretensions of my father's family who stumped up to send my brother and I to expensive schools and provided a luxurious gaol house for half the school holidays.'[2] Henderson successfully released himself from the second gaol house of his childhood by being asked to leave early from his public school, Stowe, in 1933, having ceremonially burnt a Union Jack flag. Soon afterwards he moved in with his mother at her flat in Gordon Square, Bloomsbury, in London.

The move to Gordon Square marked the beginning of a new life for Henderson as he began to enjoy the eccentric lifestyle and circle of friends and acquaintances which surrounded his mother, although the constancy of love and attention which he so acutely desired from her continued to elude him:

… she was a realist, quite totally amoral, knew what people were made of, quickly got their affection and respect … and was devoid of malice. If she had had more intellect perhaps she would have made a great courtesan. She had a shattering procession of lovers from the viewpoint of a possessive little boy who seemed to see sod all of an effective parent and was desperately keen to get off that perpetually moving damned

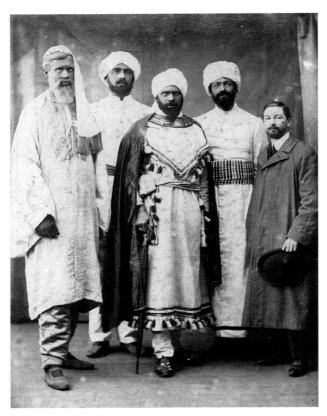

Theatrical events were often staged at The King's Head, Landermere Quay. The photograph, *c.* 1910, presents various Bloomsbury Group members dressed for performance, including Adrian Stephen (far left) and his sister Virginia, later Virginia Woolf (far right), both of whom also took part in the notorious '*Dreadnought* Affair'.

escalator and get down to some reassuring snug place with a sense of belonging. No luck! She was ... a genuinely unselfseeking servitor of genius wherever she found it....[3]

The circle of friends in which Henderson first found himself centred around the Bloomsbury Group. Through his mother's friendship with Julian Bell, he was invited to watch a performance of Virginia Woolf's *Freshwater* at Vanessa Bell's studio and later enjoyed a stay at Charleston, the Bell family home in Sussex, where Julian Bell tried to encourage a match with his sister, Angelica. During this time, Wyn also began a course of Freudian psychoanalysis with her neighbour Adrian Stephen (brother of Vanessa Bell and Virginia Woolf), having found herself without a job in the profession that had not only secured her a reliable income, but had also brought her many good friendships with writers such as T. S. Eliot, James Joyce, Antonia White and Dylan Thomas. Having worked for John Rodker's independent press in the late 1920s and subsequently Nancy Cunard's in Paris (from which she had brought home for her

son uncut editions of the works of the Comte de Lautréamont, Paul Éluard and Louis Aragon), she had settled down working for Desmond Harmsworth in London. In 1934, however, she introduced Harmsworth to Francis Meynell of the Nonesuch Press, which subsequently led to the merging of the two businesses the following year and to the loss of her own job. Temporarily withdrawing from London, Wyn Henderson moved to Cornwall, where she ran a hotel and enjoyed visits from her close friend Dylan Thomas.

Potentially homeless in London, Nigel Henderson readily accepted Adrian and Karin Stephen's offer of a place to stay, even if it did happen to be the waiting room of their practice in Gordon Square. Weekends, however, were spent at the Stephens' country house, The King's Head at Landermere Quay in Essex, a sixteenth-century smugglers' inn on the edge of marshland, later to become Henderson's own home. Here the two psychoanalysts spent time with their young daughters, Judith and Ann, drawing Nigel into the family circle like a surrogate son. Saturated with Bloomsbury history, Henderson would learn during these weekends of the colourful theatricals and dramatic exploits of the Stephens, which included Adrian's involvement with what is now known as the '*Dreadnought* Affair', the occasion when various members of the Bloomsbury Group posed as the Emperor of Abyssinia and his entourage and visited Portsmouth to inspect the crowning glory of the Admiralty Fleet, HMS *Dreadnought*. Gordon Square also brought Henderson into contact with Rupert Doone, who was running the Group Theatre, and through Doone he met and socialized with W. H. Auden and Bertolt Brecht.

The most dramatic impact and enduring influence on the youthful Henderson was, however, created by Vera Meynell, the publisher's wife: 'From Vera Meynell I learned to fall painfully in love ... it was alright to love the magnetic Vera if you had the nerve, and odd though it seems to me now, I did. But it was an ordeal. She was quick, dark, light in structure, taut and sophisticated – and terrifically in pursuit of. I was 17 ... and she was 38.'[4] Enchanted and enthralled by Meynell, Henderson enrolled at Chelsea Polytechnic to study biology, a subject which partially interested him but keenly occupied his muse, whose 'court' at weekends included, among others, the eminent scientist J. D. Bernal, acclaimed for his pioneering work on modern molecular biology. At these gatherings Henderson would listen spellbound 'as Bernal used to tell me about spaceships and voyages to come. He had a nasty image of a nearly

Adrian Stephen.

Peggy Guggenheim and Wyn Henderson, 1973. It was Wyn Henderson who decided in 1938 to name the gallery in Cork Street, London, Guggenheim Jeune, a play on the name of the famous gallery Bernheim Jeune in Paris.

literal think-tank as we would now call it. Good brainy men decapitated … with surgical skill and their heads cushioned in a nutrient solution and linked with others in the same bath – and holding wise colloquy withal!'[5]

Shocking as such images were to the young Henderson, a more profound change in his perception of the world was taking place in his studies at Chelsea. For, here, days were spent dissecting frogs and examining specimens under the microscope. The seductive force of the various stages of dissection, examination and revelation inherent in the cross-section transformed Henderson's imaginative relation with Nature and set in motion his lifelong interest in the hidden visual order of animal and plant life, as he wrote, 'a small visual fever can come over me when I find drawings and sections and micro stuff. And a plant only becomes a plant when undressed, the crinolines frustrate me, the party frocks. I want the sexual conspiracies, the devices for seed dispersal, the trap baited right inside the great free-for-all of natural survival.'[6]

Despite abandoning his studies in 1939 for a full-time job as assistant to Dr Helmut Ruhemann, picture restorer to the National Gallery, Henderson found a certain visual sympathy existed between the layering of cellular tissues revealed by the microscope and the layering aspect of paint on the canvases of Old Masters. This sensibility for fragile layering tacitly worked itself into Henderson's evolving interest in the aesthetic of collage, although he had spent some time since leaving school trying to paint and develop a style of his own. His knowledge and understanding of collage, though, were significantly enhanced by his growing

familiarity with the work of key Surrealist artists which he encountered at the Guggenheim Jeune gallery in London, which his mother had helped the American collector Peggy Guggenheim to open in 1938, having struck up a friendship with her in the early 1930s.

A 'kind of fairy godmother', Guggenheim had enthusiastically taken to the young Henderson (noted for his quiet but beguiling charm) when she first met him in Paris during trips to see his mother in the 1930s.[7] Happy for him to accompany her on visits to artists' studios and exhibitions, Henderson was introduced first-hand to the Surrealist art being created at the time and absorbed all that was on offer to his fresh and open mind. During these visits Guggenheim introduced him to Max Ernst and Yves Tanguy. As Henderson later noted, the great benefit of personally meeting and mixing with such established artists at this time was the 'first-person-singular feeling' that he gained of them. Through informal conversations about art with Guggenheim and her friends, Henderson gained the confidence to believe that he could directly participate in the kind of contemporary art that he felt an empathy with, by contrast to that which predominated in England at this time. Fortuitously, given his youthful shyness, his first meeting with Marcel Duchamp came about after Guggenheim, 'accustomed to bailing him out of drinking sessions' in Paris, rescued him from a bar one night and took him round to the flat of Mary Reynolds, who was then living with Duchamp.[8] Unfamiliar with Duchamp or his work, Henderson was 'knocked out by his personal magnetism' and the two fell into easy conversation. This meeting was later consolidated when Duchamp came to

London to hang the opening exhibition of Guggenheim Jeune in 1938 and asked if Henderson was free to help him. Striking up a genuine rapport which would last over a decade, Henderson later recalled:

In that long day I spent with Duchamp a couple of years before the war hanging an exhibition of Cocteau's drawings of hands and fingers and boring narcissus-featured androgynes – a day that both hung in the air forever and passed in a puff of smoke like a hashish dream – Duchamp quietly drew me out and extracted my interest in science and an expression of a wish to fly. He told me he thought I ought to fly and conserve my interest in science. 'Throw nothing away.' All said so gently, ironically, serenely – it was almost like hearing the voice from within.[9]

Later that year, Wyn Henderson sneaked two of her son's collages into an exhibition at Guggenheim Jeune of collage work by Picasso, Braque, Gris, Ernst and Tanguy, confident that Guggenheim was unlikely to object to such promotion of her young protégé, even if he did choose to decline her repeated offers of financial assistance.

Henderson's exposure to Surrealist art at this time also came about through his mother's friendship with other gallery owners such as Freddie Mayor of the Mayor Gallery and Roland Penrose of the London Gallery (which was located next door at 30 Cork Street), although he independently met the Belgian E. L. T. Mesens (Penrose's co-director) through his involvement with the Group Theatre run by Basil Wright, a friend of Mesens. Wyn, particularly adept at making friends, also spent much time in the company of Peter Watson, Peter Gregory and Margaret Gardiner, who was a keen collector of Surrealist art, a neighbour of Penrose's and a financial supporter of his gallery. While the Mayor Gallery and Guggenheim Jeune held a number of important shows of Surrealist art, the arrival of the Belgian Mesens brought a new approach to the staging of exhibitions, as Henderson had the opportunity to view when Mesens organized the eclectic 'Machines in Art'. As the *News Review* reported:

To show how mechanism has affected art, enterprising Director Mesens … has staged … an exposition of prints, models, and modern paintings…. This resulted in an unprecedented marriage between such surrealist artists as Francis Picabia, Max Ernst, and Marcel Duchamp with engineers' blue-print drawings, Victorian prints, railway mugs, and working cross-section of an internal combustion engine…. Most important exhibition of the modern artists inspired by the machine is contributed by Marcel Duchamp. Covering the whole of a glass topped table are the complete notes, sketches and random scribblings made by Duchamp in the course of preparing a mechanistic masterpiece which took fifteen years to complete. Title is 'The Bride Stripped Naked by her Bachelors'.[10]

The following year England went to war and Henderson became a pilot in Coastal Command. Twenty-two years old and from a somewhat unusual background of gentrified England, Bohemian Bloomsbury and Surrealist Paris, Henderson took to the skies with a fragile and precariously volatile sense of self. Like the protagonists of Antoine de Saint-Exupéry's novels which kept Henderson company throughout his life, flying could bring peace through estrangement, terror through uncertainty:

Oh God! that I could more readily accept the humdrum, the ordinary in life. To do a job and to do it well – to feel … socially integrated. But I haven't reached a stage where I can entirely accept that happily – no, not at all. It's this blasted 'romantic' streak in me that makes me hanker for the marvellous, the thing that you can never quite achieve except in dreams – the super-real. So, in effect, I seem to go in for self-deception to achieve that aim, blindly blundering up against a wall refusing to see it as a wall at all. I am apt to surcharge an experience like flying with too much emotion so that I can easily fall into the opposite mistake of undervaluing it. Take night-flying. At one time I am capable of being enchanted by the illusion of dream, of 'unreality', of flying under an ominous black arch of cloud and looking ahead to the long snow-covered spit of land, bathed in moonlight and spotted with flashing lights, beacons and aerial lighthouses. Another time I'll undergo the experience grimly, horrified by the essential uncertainty of mechanical things, instruments, lights, with an awful premonition that something ghastly is going to happen. I can't seem to weld the two reactions to a single more realistic whole.[11]

As if to bait tragedy, or perhaps just defiantly confront the fear of disaster, Henderson came very close to killing himself and his crew during a flight back from an operation in Norway. Heading straight for a cliff face ('as if I was going to imbed us') and pretending to be deaf to the alarmed voices of his crew, he miscalculated the time and distance between the aircraft and the clifftop, only just skimming over its edge at the last moment. For as mentally shattering as the experience of flying during the war became (he was put on modified duties in 1943), it did prompt Henderson to identify a visual correlative between the cellular world he had discovered under the microscope and his perception of the landscape from an aerial perspective. This synthesis

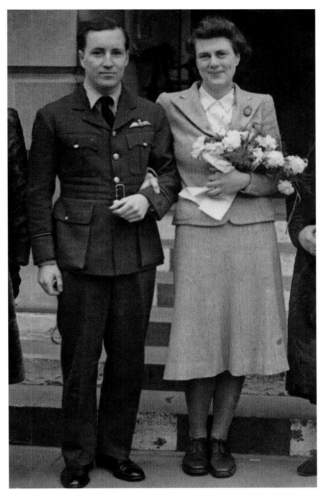

Nigel and Judith Henderson on their wedding day, 1943. Tate Archive.

of the micro and the macro would subsequently become a prevailing interest of Henderson's work as he transcribed and played with the qualities of one to the other. As he would later recount:

The physically amazing thing about flying, after the speed impression of taking off and low flying, is that as you gain height the sense of motion drops away. It's nothing like looking out of a railway carriage and seeing the blurry silver worms zipping past or the ritual nodding of the telegraph lines. It is impressively stable and still up there and this is the important point, the world is laid out for you in unfamiliar terms … the visual field is flattened more after the plan view of the microscope section than the elevation that everyday seeing is accustomed to.[12]

By the end of the war, Henderson suffered a nervous breakdown and began to attend a clinic at Guy's Hospital on a regular basis, although, as he later reflected, 'to survive it is to experience Rebirth' and he was grateful 'to have the opportunity to re-knit to a truer pattern'.[13] Although the war had dismantled certain aspects of the world he had previously known, Henderson had been encouraged and supported throughout this period by the sure figure not only of his mother, but also of Judith Stephen (daughter of Adrian and Karin Stephen), whom he married in 1943. As their correspondence during the war reveals, Judith not only provided the loving security which Henderson had always craved from his mother, but was also an intellectual soulmate, having been exposed to the same cultural milieu as her husband.

A student of Bertrand Russell's at Cambridge, where she had studied economics and anthropology from 1937 to 1940, Judith Stephen pursued her interest in anthropology in the United States under the tutorship of the radical Ruth Benedict and Margaret Mead at Bryn Mawr College in Pennsylvania. Returning to England in 1941, she was employed in the Ministry of Works until the end of the war, when she became a tutor in neighbourhood study courses run for students in vacation time. Concurrent with this teaching position, she was also enlisted on a neighbourhood study project called 'Discover Your Neighbour' organized by the sociologist J. L. Peterson, the then warden of the Bethnal Green House Settlement in the East End of London. Based on the principles of social anthropology, the aim of the project was to gather information about the specific habits and behaviour of the local community, from which could be extracted insights of various use to welfare practitioners. A precondition of this study was residence within the area, so in 1945 the Hendersons moved into 46, Chisenhale Road, in the heart of the East End, which had suffered severe bombing raids during the war and large-scale poverty.

That year, although still fragile from his wartime duties, Henderson succeeded in gaining a four-year serviceman's grant to study art at the Slade School in London, though he soon found the tutors parochially English and far removed in their thinking from the artists he had met and moved among before the war. Fortunately, or fatefully as Henderson viewed it, he soon made friends with a fellow student, Eduardo Paolozzi:

He was only twenty and apart from minor concessions to art school artiness (big meerschaum pipe, abattoir boots, obligatory duffel coat) there was no arty presumption in the mind, but a great appetite for knowledge and experience from whatever quarter it wrung. He seemed to understand with formidable

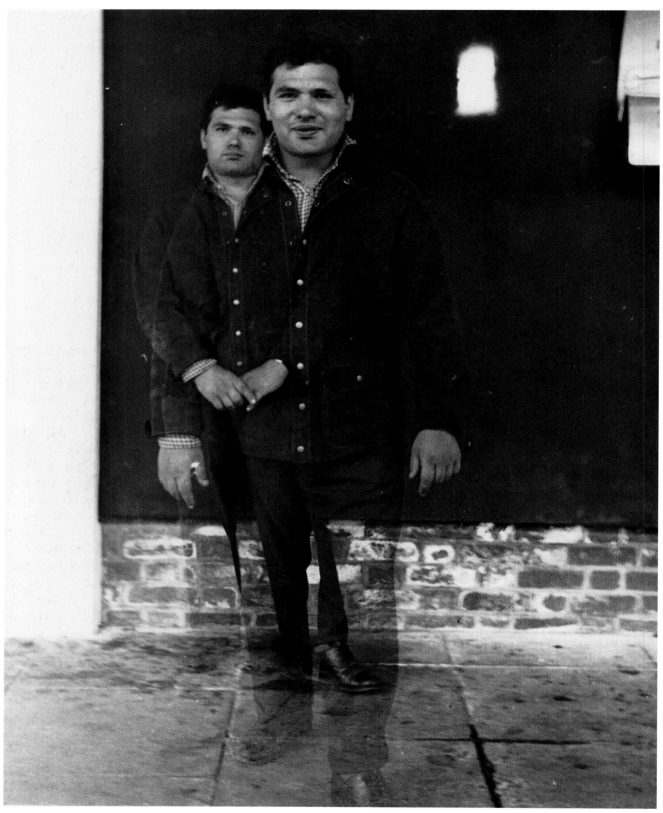

Eduardo Paolozzi, 1951.

clarity that art was not to be derived constantly from art in polite circles for polite circles, but re-sensed and fused from the enormous mass of material … from the specific cornucopias of our time. And he had a formidable digestive apparatus.[14]

The impact which each had on the other was immense. For Henderson, Paolozzi was a powerful antidote to the type of middle-class English which he had grown to despise in his youth. Strong and bullish with dark Mediterranean features, Paolozzi's physique alone alluded to an entirely different world compared to the one Henderson inhabited. For Paolozzi, who came from a poor working-class Italian family in Edinburgh which had suffered real tragedy during the war, Henderson was an apotheosis, belonging to the cultural and intellectual elite of English society that was well segregated from his own life. Foils to one another, they quickly established a strong, almost exclusive, friendship (although they also became friends with the sculptor William Turnbull, another Slade student) as they spent the majority of their days visiting museums and exhibitions and attending lectures in the Anatomy Department of London University. As Paolozzi noted, they shared a binding loyalty to 'all things French' and his own interest in Surrealism was greatly stimulated by the Surrealist art collections of Margaret Gardiner and Roland Penrose, to which he was introduced by Wyn Henderson. Indeed, according to Paolozzi, it was through Wyn Henderson that he initially met Freddie Mayor, who gave him his first exhibition in 1947.[15] Following the financial success of this exhibition (it raised £75) Paolozzi decided to leave the Slade and moved to Paris in June to study art.

For an artist, Paris in 1947 was a compelling place to be, even though the city had experienced one of its coldest winters ever, severe rationing still dominated daily life, and strikes were taking place throughout the spring: Tristan Tzara was lecturing at the Sorbonne on Surrealism; the Galerie Maeght was hosting shows of international Surrealism; the first show of 'l'art brut' was staged at the Galerie René Drouin; Henri Matisse published *Jazz*; and André Malraux published *Le Musée Imaginaire*. In the midst of this culturally vibrant atmosphere, Paolozzi took rooms first in the Boulevard Saint-Jacques and then in the Rue Visconti. On 12 August he wrote to Henderson, imploring him not to delay his visit: 'Do *not* be held up when you've got your ticket. *Just come*. That is important', adding that Bill Turnbull had just left after a brief stay and concluding, 'I will be delighted to meet Peggy Guggenheim.'[16]

Arriving in Paris in August 1947, Henderson took Paolozzi to meet Guggenheim at the Hôtel de Crillon, where she was staying, and found her already entertaining Hans Arp, who introduced himself as 'Jean', briefly confusing the two young men as to his identity when he invited them to visit his studio. Once there, 'he opened a drawer which had all bits of shaped paper … that he used either to have shapes cut in wood, or … three-dimensionally'.[17] This kind of professional openness and generosity from an established artist was of great appeal to artists like Paolozzi and Turnbull, who could experience nothing comparable in England, and even Henderson retained a certain degree of awe for these encounters.[18] As he wrote to Judith, he and Paolozzi visited Fernand Léger at his studio, who warmly welcomed them and talked about his work, inviting them to a private screening of his film *Ballet Mécanique*.[19] Through Paolozzi's initiative, they also visited the studios of Braque, Giacometti and finally Brancusi, prompting Henderson to exclaim to his wife in a letter, 'Good! – another myth in perspective at last!' In addition to these highly memorable occasions, Henderson also accumulated a whole body of new imagery from two particular museums which Paolozzi took him to see: the Palais de Découverte and the Musée de l'Homme, which housed 'a fine ethnographic collection that eats up anything I've ever seen'.[20]

Back in London, Henderson continued at the Slade, trying hard to master the skills of drawing and painting, for which he had little aptitude, and finding greater reward in visiting exhibitions and avidly reading books. Although he missed the company of the ebullient Paolozzi, he soon found another friend in the artist Richard Hamilton, whom he met after the two of them stepped back into each other at an exhibition. In the conversation that ensued, Hamilton mentioned that 'he had come to the end of his rope' at the Royal Academy Schools where he was studying and Henderson suggested by way of reply that he try the Slade.[21] They parted company on Hamilton's words 'I'll get my grant switched and see you at the Slade next term', and Henderson was pleased to see him in the Life Room of his college a few months later. Following in the path of Paolozzi, Hamilton also enjoyed various introductions brought about by Henderson. Despite the distance, the friendship with Paolozzi remained constant and at the end of 1949 he brought Henderson the gift of an enlarger back from Paris – a gift that would mark the start of Henderson's experimental rapport with photography and its processes.[22]

Milk bottle, 1949–51. Photogram (glass negative). Tate Archive.

'Prints Inventive'[23] 1949–1951

Hendograms

Reconciled to the fact that he had little facility for drawing, Henderson came to regard the small enlarger that Paolozzi had given him as a 'crude drawing instrument'. Filling the frame conventionally used to hold the photographic negative with domestic objects and bomb debris, Henderson began to produce photograms by passing the light of the enlarger through the frame to create a print of the material within:

I was really excited by the phenomenon of photo-sensitivity…. All sorts of things had got to go down on paper, many lugged back from those gold-mines of semi-transmuted things like bomb-sites … and I could see how a change of scale and of context, and sometimes the limited presentation that a photogram gives, further abstracted the achieved image from the points of origin. I had here a method of drawing and a technique for close scrutiny of all kinds of marks and energies of line and shape and texture.[24]

Apart from the mangled metal, rusted ironwork and contorted wire mesh which Henderson collected on his daily walks around Bethnal Green, he also drew upon the domestic material that surrounded him, such as tissue paper, string and wool. Curious to see the visual qualities that glass would present in a photogram, Henderson on one occasion filled a milk bottle with boiling water so as to break it down into its constituent parts and then passed light through the fragments as they lay on the printing paper. The resulting photogram is an extraordinarily compelling image due to its powerfully synaesthetic character: it is both physically present and absent.

As Henderson began to explore the physical properties of various materials which he subjected to this process, he soon found that the random arrangement of material in the frame often created unpredictable images, in which the material seemed to transcend its empirical reality and inhabit a realm of more ambiguous and tentative relations. As Tristan Tzara wrote of Man Ray's photograms, 'He presents in space an image that goes beyond it.'[25] This visual dislocation of matter from reality, form from content, was invariably dependent on two particular aspects of the photograms: the manipulation of scale between the selected objects and material, and the spatial relation between these and the surface of the picture plane. This can be seen most

effectively in a photogram of 1949 titled *Photogram to suggest microscopic life*. In this image, Henderson combined nondescript metal elements from junk heaps and bomb sites with enlarged exposures of 'torn and teased heels of socks and elbows of jerseys' which visually mimicked 'the fractured cells of botanical micro sections', as Henderson later described.[26] By juxtaposing these elements apparently viewed from diagrammatically opposed perspectives and conflating them within one space, as defined by the picture surface, Henderson was effectively playing with the different modes of perceptual response which he had experienced during both his studies in microbiology and his daytime flying in the war.

While Henderson's visual conceptualization of space as an artist derived from his first-hand knowledge of microbiology and flying, the new perspectives revealed by these practices was a key issue in much theoretical writing on art at the time. One significant publication to address this issue was Gyorgy Kepes's *Language of Vision*, published in 1944, in which the author wrote:

New technological discoveries have brought about a fundamental revaluation of vertical position as a sign of depth. Bird's-eye-view and frog's-eye-view in photographs and a new vision in aerial observation were the most important factors. For the airman, as well as for the photographer, the horizon line changes constantly, and consequently loses its absolute validity…. Thus freed the signs of space representation can function as plastic forces. The order of actual space and the space of the picture-plane are in close congruency…. Manual representation has traditionally been based also upon a scale related to the spectator. The photographic image, however, is cut out from the familiar spatial frame of reference and there is frequently no cue for deciphering the spatial scale. A micro-photo and an aerial photo can be easily confused.[27]

Although Paolozzi's gift of an enlarger had clearly provided the opportunity for Henderson to experiment with photograms, his knowledge of these as an artistic form was undoubtedly gained from another key publication, *The New Vision* by the Hungarian Bauhaus figure László Moholy-Nagy. First published in 1939, and reprinted in 1947 as *Vision in Motion*, an extended section of the book was dedicated to the photogram, which Moholy-Nagy saw as the starting point for any serious photographer. Extolling the virtues of the photogram's

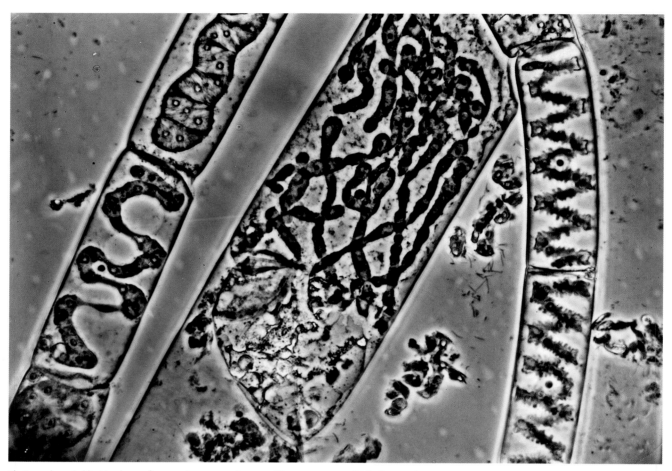

Photograph copied by Henderson from a science magazine, possibly as source material for later work.

capacity to reveal an extended range of tonal values, he exclaimed, 'The enemy of photography is the convention, the fixed rules of the "how-to-do". The salvation of photography comes from the experiment.'[28] In choosing to specifically emphasize the term 'experiment' rather then the activity of experimenting, Moholy-Nagy was implicitly drawing attention to the scientific frame of mind and practical approach that he was anxious for artists to adopt in their work. As he wrote in the opening pages of the book:

The actual aim [of the artist] is sociobiological synthesis. This cannot be achieved without 'laboratory experimentation' …. But without experimentation there can be no discoveries and without discoveries no regeneration. Although the 'research work' of the artist is rarely as 'systematic' as that of the scientist they both may deal with the whole of life, in terms of relationships, not of details.[29]

Evidently, in the creation of his photograms, Henderson's aptitude for experimentation instinctively transferred itself, or rather extended itself, from the discipline of science to the discipline of art. From the unorthodox selection of material he chose out of curiosity (which even included large blocks of ice that rapidly melted) to the teasing out of ambiguous imagery through the manipulation of scale and texture, Henderson was a disciple of Moholy-Nagy's vision of the new artist. Holding no formal training in photography (and only privy to a darkroom in the form of the family bathroom at night), Henderson later described the photograms as 'the product of the natural exuberance of developing one's first contact with a very versatile medium'.[30] Although the photograms which Moholy-Nagy reproduced in *Vision in Motion* all celebrated the 'ghost' tones that could be produced by this process, Henderson's photograms are distinct from these in their emphasis on the graphic quality of objects and material. But that Henderson considered himself to belong to this tradition is nonetheless signalled by the fact that he chose to refer to his images as 'Hendograms' in the

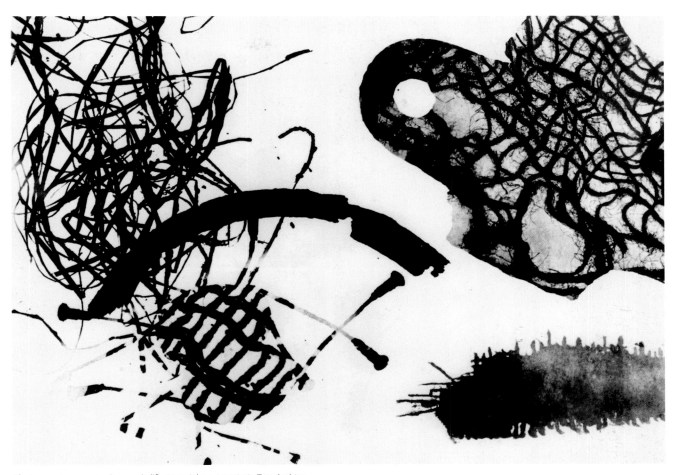

Photogram to suggest microscopic life, 1949 (glass negative). Tate Archive.

tradition of eponymously titled photograms by such predecessors as Man Ray (rayograms) and Christian Schad (schadograms).

Significantly, in another publication of 1946, which Paolozzi owned and which may have been known to Henderson, the Hungarian further observed that 'the photogram for the first time produces space without existing space' and, more generally, that 'the passion for transparency is one of the most spectacular features of our time. We might say, with pardonable enthusiasm, that structure becomes transparency and transparency manifests structure.'[31] Arguably, much of the impetus behind Henderson's experimental photograms was this shared enthusiasm for exploring, revealing and playing with the structural aspect of material from the man-made and the natural environment, but whereas Moholy-Nagy's views were rooted in a strategic and coherent programme to redefine the parameters of art, Henderson was predominantly satisfying his own whimsical curiosity about the world around him.

And part of this curiosity would time and again return him to the cross-section:

I suppose if I read more about art (er … Art?) I would have found somebody saying what I haven't seen or heard 'said' i.e. They would have really opened up about that form of enquiry and presentation known as the Cross Section. *Presumably (?) developed as a thin slicing mode for examination with staining techniques to differentiate tissues etc. and also to allow light to penetrate for microscopic examination … these scientific innovations, backed up perhaps by the massive sectioning of the navvies for rail and canal and dock gave the eye a new authoritative statement about the organization of nature – a relatively internal view (further underlined by the x-ray spectacular not to mention the sectioning or freezing of the dimension of Time by the high-speed photographic shutter). I assume that this is the overall conditioning that forces those serious about the practice of art to be so concerned about the integrity of the actual picture surface.*[32]

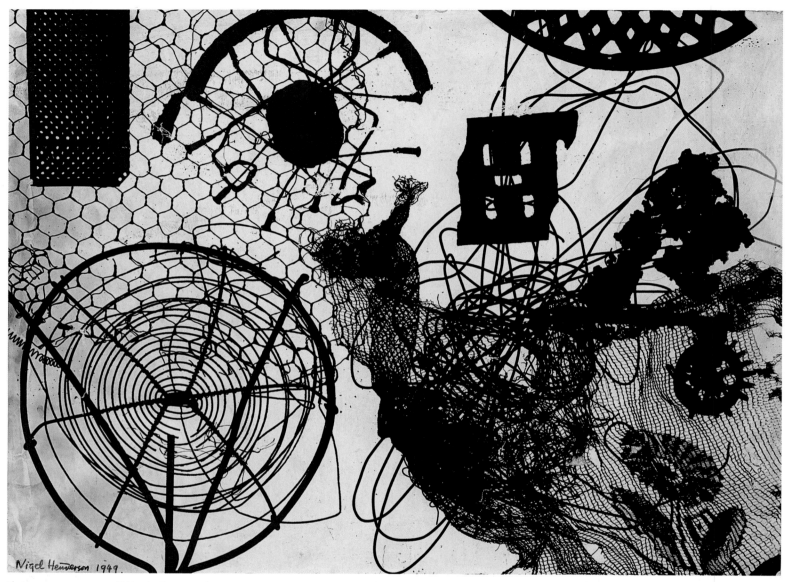

Photogram, 1949–51. 14 x 18½ in. (35.6 x 47.0 cm).
Henderson looked upon his 'Hendograms' as 'a method of drawing and a technique for close scrutiny of all kinds of marks and energies of line and shape and texture'.

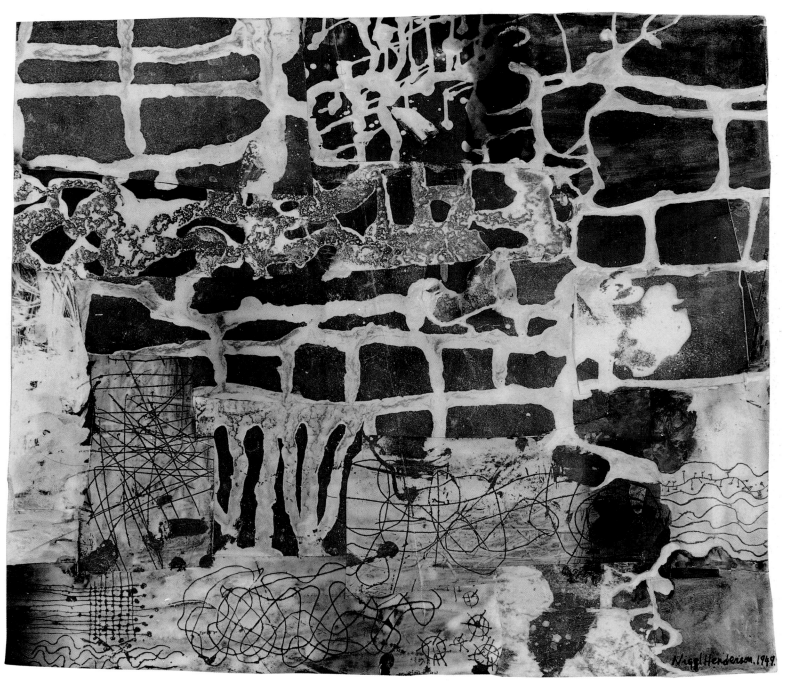

Collage, 1949. Oil and photograph on board. 13¼ x 15 in. (33.7 x 38.1 cm). Tate Collection.

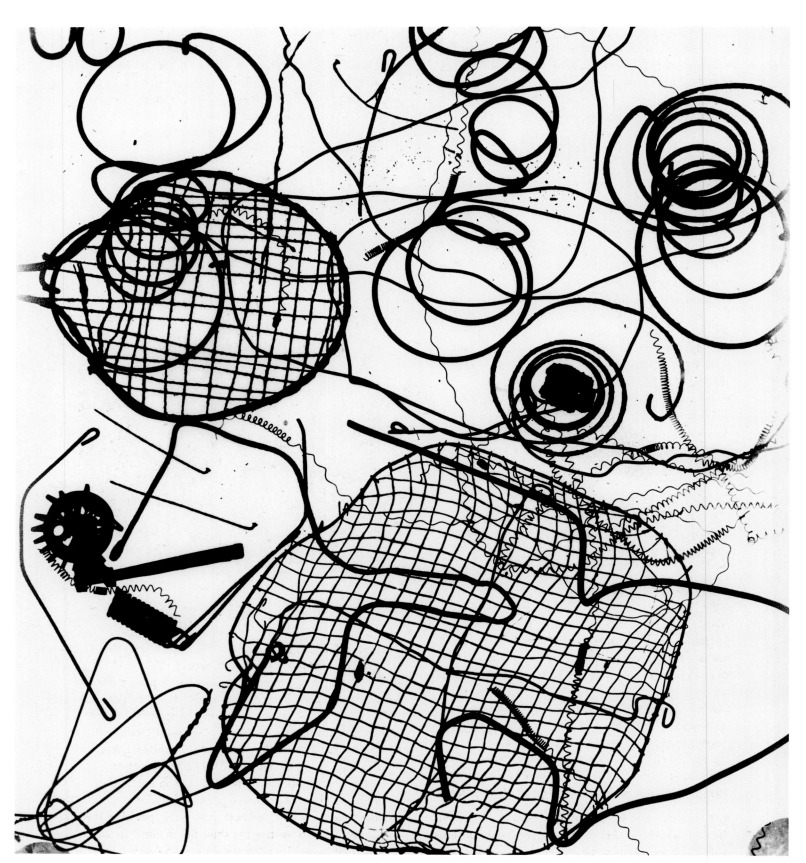

Photogram, 1949–51 (glass negative). Tate Archive. Henderson's interest in photograms developed as a by-product of working in a photocopying agency.

Given the extent to which Henderson's aesthetic sensibility was underpinned at this time by his fascination with the structural order of organic and biological life, it is perhaps not surprising that he communicated this interest to his friend Richard Hamilton. In 1949 Hamilton proposed that they organize an exhibition together and was intrigued by Henderson's rather tentative suggestion of a show based on the idea of seed dispersal. Soon after this, however, Henderson received a letter from Paolozzi in Paris drawing his attention to a book called *On Growth and Form* by D'Arcy Wentworth Thompson, the Scottish embryologist. Originally published in 1917, Thompson's basic thesis was that mathematics could explain the formation and growth of the natural world, such as skeletons, eggs and crystals. Quickly locating a copy and eagerly working his way through it one long afternoon, Henderson was struck by its content: 'It was very timely as a piece of intellectual scaffolding.'[33] With great eagerness he passed news of his recent discovery on to Hamilton, who voraciously read the book and enthusiastically declared, 'That's it!' The subject and content of the exhibition now generally established, Henderson took Hamilton round to meet Roland Penrose at his house in Downshire Hill, Hampstead, and during the course of the meeting he realized with some astonishment that his friend 'had by this time done an extraordinarily quick and able gutting of the book and condensed it into ten pages or so with small inset drawings as illustrations – a working script'.[34]

First drafted in December 1949 and revised in February 1950, Hamilton's proposal began by identifying Thompson's book as the impetus behind the show, continuing:

… the visual interest of this field, where biology, chemistry, physics and mathematics overlap, was considered an excellent subject for presentation in purely visual terms. The laws of growth and form pertaining to the processes of nature are quite contrary to the processes of artistic creation. However complex the form (accepting Thompson's hypothesis) it is the result of very precise physical laws; the complexities of art, on the other hand, are the products of involved psychological processes. Nevertheless, the painter and the sculptor have much to gain from the enlargement of their world of experience by an appreciation of the forms in nature beyond their immediate visual environment. It is the enlarged environment opened by scientific studies that we would reveal for its visual qualities.[35]

Although the section headings increased in number for the final exhibition, their titles indicate the seriousness with which the exhibition material was assembled and arranged: Crystal Structure, Organization in Colloidal Systems, Chromosomes and Cell Division, Skeletal Structure, Vertebrates, Plankton and so on. As obscure as some of these titles may have seemed, they were strictly confined to the exhibition handbook, in which Herbert Read explained that 'the purpose of this exhibition is not informative in the scientific sense. It aims rather at concentrating attention on the formal qualities of scientific material, and these are self-explanatory.'[36] And the formal diversity of imagery on display was quite considerable because of the variety and juxtaposition of media and photographic genres: drawings, models, cine film and stills, photographs, photomicrographs, electron-micrographs, radiographs and photograms – of which two, one of a spider and one of a radish leaf, were by Henderson.

Eduardo Paolozzi, c. 1950.

The exhibition took place at the Institute of Contemporary Arts' new gallery at Dover Street in London on 3 July 1951 and was officially opened by Le Corbusier, who elegantly praised the show and noted, 'The authors of this exhibition are people who have observed, who are sensitive and who are poets…. The exhibition has moved me very deeply, for I found in it unity of thought which gave me great pleasure.'[37] Despite the fact that Henderson had withdrawn from the project by the middle of 1950 (it became clear that 'it was Hamilton's drop'), Henderson's role in establishing the premises for the exhibition is nonetheless evident, and perhaps it was appropriate that the task of documenting the show fell to him.[38] In these photographs, published in the *Architectural Review* in

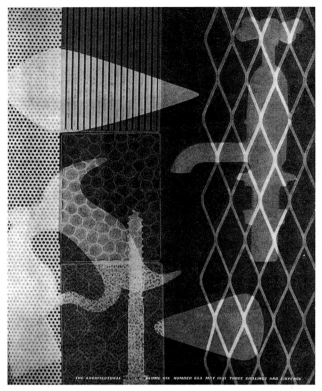

Photogram reproduced on the front cover of *Architectural Review*, May 1951.

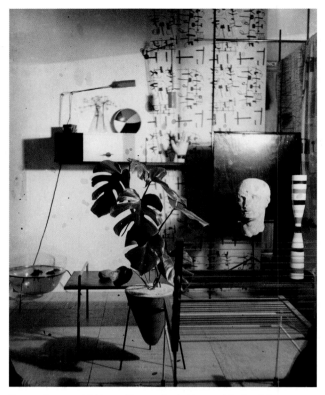

Terence Conran exhibition at Simpson's, *Architectural Review*, July 1952.

October 1951, the radical choice of imagery selected from non-art disciplines and arranged within a dramatic and darkened stage-set of enlarged models of cell structures was captured for a larger audience to appreciate.

The *Architectural Review*'s explicit acknowledgment of Henderson as the photographer of the exhibition shots was perhaps indirectly due to the artist's new-found friendship with Ian McAllen, the editor of the publication. Henderson used to drop by his office on a regular basis and show him the work he was doing and McAllen would occasionally buy a selection of photographs at 'five bob a wack', or £2 if they were published. Early in 1951, McAllen invited Henderson to create a photogram for £10 for the front cover of the May edition, which was going to be devoted to building. Henderson produced twenty photograms overnight, from which McAllen subsequently chose one for the front cover. It was a timely and fortuitous commission, as William Johnstone, the Principal of the Central School of Arts and Crafts, saw the cover and found it sufficiently convincing to invite Henderson to join his staff as a tutor in Creative Photography, an invitation which he happily accepted, particularly as both Turnbull and Paolozzi were already teaching there.

Stressed Images

In February 1952, the *Architectural Review* reproduced another type of experimental image by Henderson: the 'stressed' photograph. This was created by 'stretching and distorting the printing paper while enlarging in order to stress a point or evoke an atmosphere'.[39] Taken during a visit in 1951 to Viticuso, Paolozzi's home town in Italy, the photograph presents elongated images of Paolozzi in the company of a couple of villagers casually gathered together in a street. While the villagers happily pose and gaze directly at Henderson, Paolozzi appears at the side, preoccupied and removed from their communion with the camera – an impression which is realized through the distortion of space within the image. As a straight photograph, this image could almost pass unnoticed, but once manipulated (and made 'unfamiliar' in Bauhaus terms), it assumes a psychological and symbolic value beyond its representational one.[40]

Perhaps the most impressive collection of 'stressed' photographs that Henderson produced is the playful, but equally poignant, series of images of boys 'doodling' on their bikes in the street, as Henderson described it. Capturing in the original negatives the

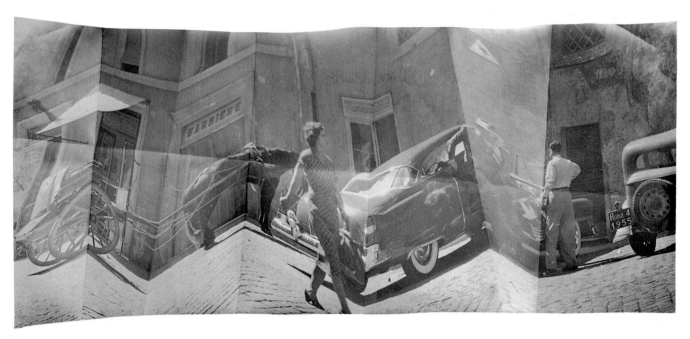

Stressed photograph of a street scene in Italy, *c.* 1951. 9¾ x 20 in. (24.8 x 50.8 cm).

sense of fleeting innocence in the carefree antics of the boys, Henderson simultaneously freeze-frames these moments and prolongs them indefinitely by distorting the images not only through the photographic manipulation of the enlarger, but also by pleating the photographic paper during printing. As Henderson wrote of these images produced in 1949:

For me [this process] would form sometimes an 'expressionistic' image giving a slightly 'intoxicated' version which suggested to me a certain delirium in which a boy may fantasize and divert himself with a bike for hours on end. If I pleated the paper horizontally I could create a pattern of stress which further animated the situation by putting the wheels and frame 'through it' as it were and creating an identification with the boys' efforts and the tension of the wheels and frame....[41]

In 1956, in response to a letter about these images, Henderson freely cited Moholy-Nagy's *Vision in Motion* as a key reference point.[42] Among the definitions which Moholy-Nagy offered of 'vision in motion', two in particular resonate when one considers these images:

vision in motion
is seeing moving objects either in reality or in forms of visual representation as in cubism and futurism. In the latter case the spectator, stimulated by specific means of rendering, recreates mentally and emotionally the original motion.

vision in motion
is simultaneous grasp. Simultaneous grasp is creative performance – seeing, feeling, and thinking in relationship and not as a series of isolated phenomena. It instantaneously integrates and transmutes single elements into a coherent whole. This is valid for physical vision as well as for the abstract.[43]

As with the synaesthetic photogram of the milk bottle, the distorted images of boys on bikes offer themselves as elegant examples of Moholy-Nagy's conceptualization of 'vision in motion'. It would be a mistake, however, simply to view these images as experiments in the formal representation of movement, or the kinetic articulation of space, as it is clear from another account by Henderson that the viewer's relation to such images was a significant factor in their formulization: 'The effect ... is in some degree to destroy the boundaries of the image, by appearing to lap them round the seeing eye, thus drawing it within the frame.'[44] Moreover, it is evident from Henderson's writings that he regarded the capacity for 'simultaneous grasp' as fundamental to the artist's creative process and the viewer's ability to forge an imaginative and empathetic relation with the work; in short, the basis for a dialogue. In another note which clearly echoes a passage of Moholy-Nagy's that elaborates upon his theory of vision and distortion (created by the disruption of the fixed horizon in painting), Henderson also wrote

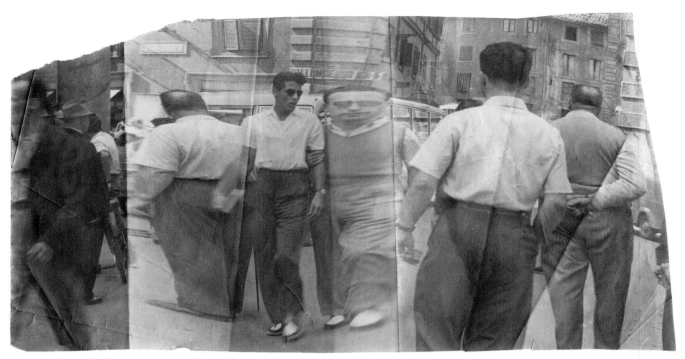

Stressed photograph of a street scene in Italy, *c.* 1951. 8 x 10 in. (20.3 x 25.4 cm).

in his notebook of 1951 that 'the problem of our generation is to bring the intellectual and emotional, the social and technological components into balanced play, to learn to see and feel them in relationship'.[45] In an abridged form, what Moholy-Nagy wrote was:

Intellectual grasp has to be coordinated with the emotional. The spectator must be prepared to sense the underlying meaning of the artist's approach not as a 'verbalizable' …. Later, after he [the spectator] liberates himself from traditional vision, he will be able to apprehend this emotionally and intellectually…. Through the use of this psychological insight and the psychoanalysis of Sigmund Freud, space-time fundamentals may be understood also as the syntax and grammar of an emotional language which may re-create the path of the inner motion.[46]

For one denied the verbalization of emotion in his youth, the mental refuge which Henderson found in these dreamscapes of a childhood that he never experienced is profound.[47]

Another series of stressed images which Henderson developed, however, is far more elusive. Derived from a single Victorian lantern slide (one of many which he collected), various transformations of an image of bathers by the sea were incorporated into a photo-mural for which Henderson subsequently won an award when it was exhibited at the Milan Triennale in 1954. Included the same year in an exhibition of his photographic work at the ICA, these images also attracted the attention of Jean Dubuffet, who bought six for his private collection and wrote to thank and praise Henderson, encouraging him to create more in this genre.[48] Reminiscent in part of images created by the Victorian hall of mirrors, one straight image of a woman bather is duly transformed until the proportions of her torso and legs take on a monumental, almost elephantine, aspect which evokes a tangible sense of physical mass and flesh. Intent on maintaining the image's ambiguity, however, Henderson is careful not to reduce the image to caricature and quite deliberately leaves the figure's head and upper torso untouched, thereby creating a familiar counterpoint from which the disturbing image can emerge. In another series, the elongated, almost emaciated, bodies of young male bathers are presented in various stages of undress and activity by the water's edge until the space they inhabit becomes as timeless and abstracted as their own bodies.

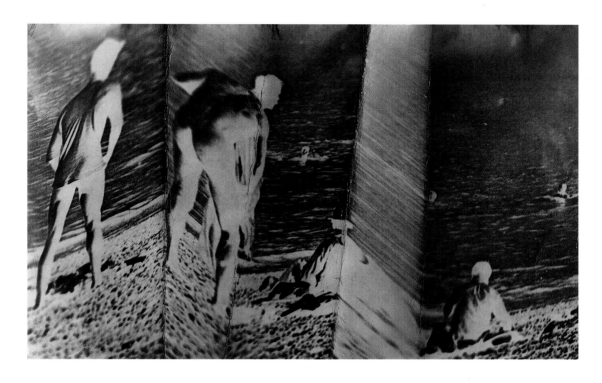

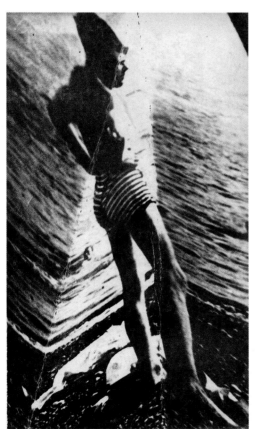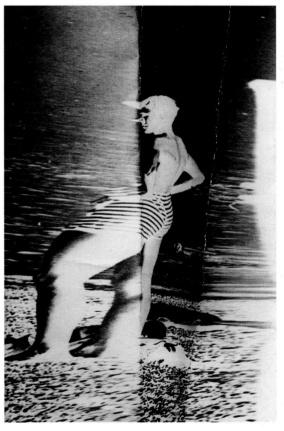

Above, and following three pages: Stressed images of bathers, *c*. 1950, for which Henderson's raw material was 19th-century lantern slides. Unusually for Henderson, these were printed in a very small format, with maximum dimensions of 5½ x 3½ in. (14 x 9 cm).

Henderson created stressed images by 'stretching and distorting the printing paper while enlarging in order to stress a point or evoke an atmosphere'.

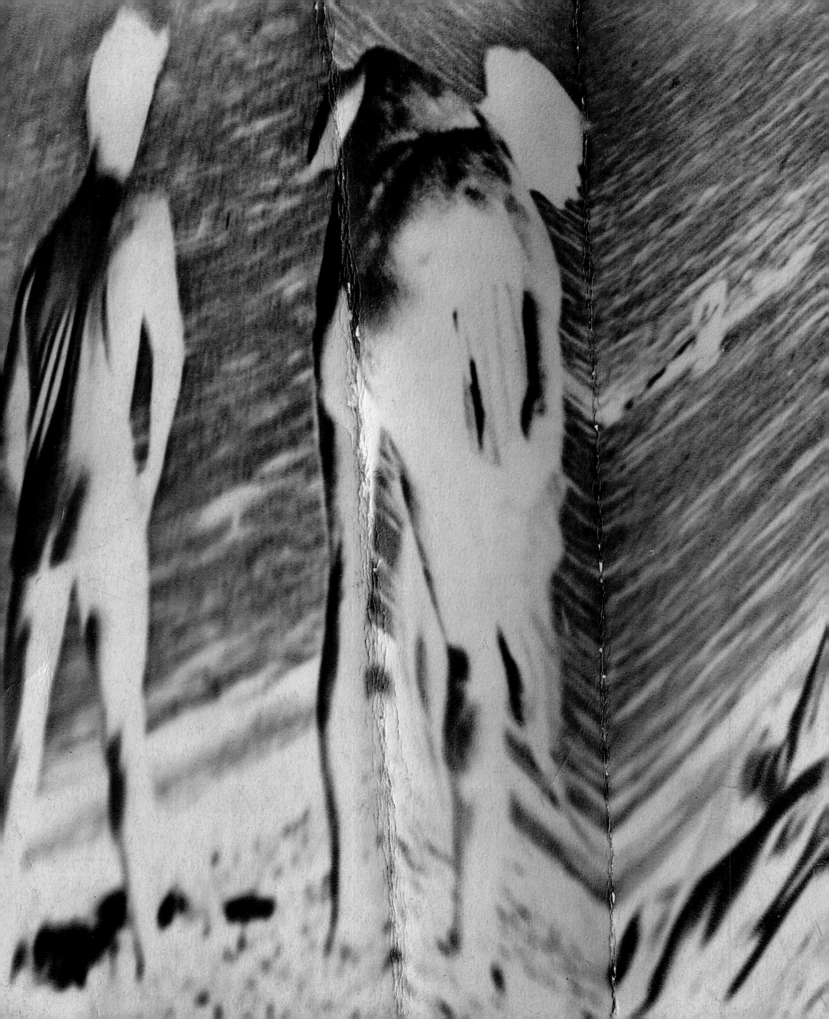

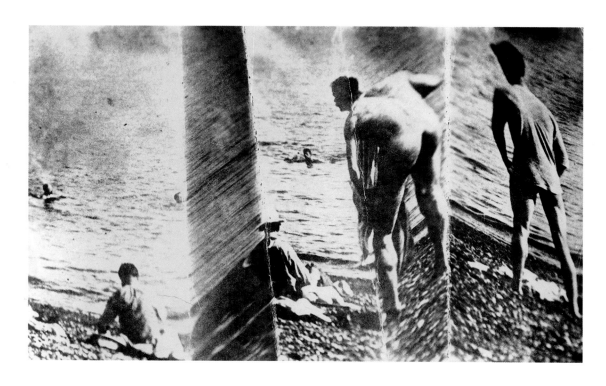

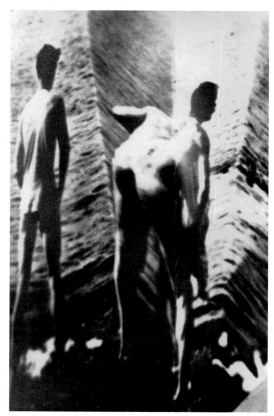
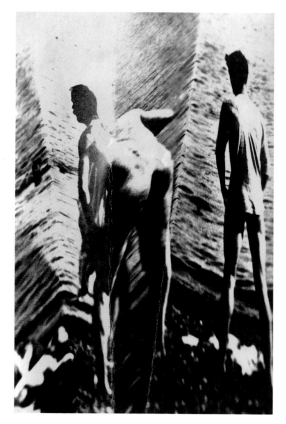

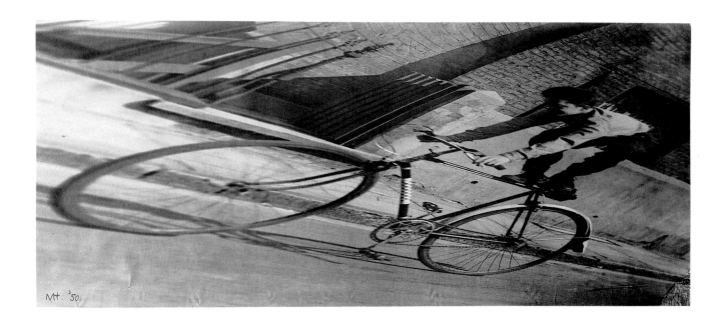

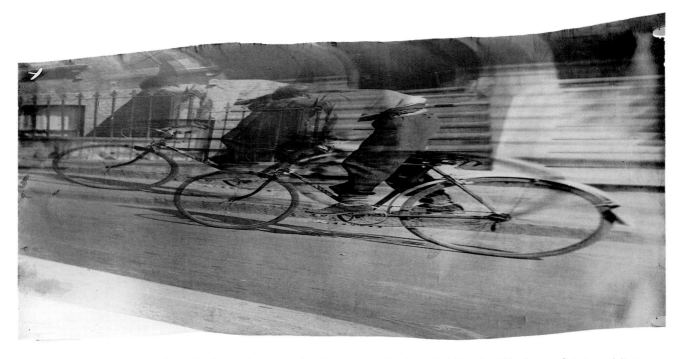

Henderson's stressed photographs of boys 'doodling' in the street on their bikes summoned up 'a certain delirium in which a boy may fantasize and divert himself ... for hours on end', *c.* 1950. Above: 8¼ x 17¾ in. (21.0 x 45.1 cm); below: 10 x 19¾ in. (25.4 x 50.2 cm).

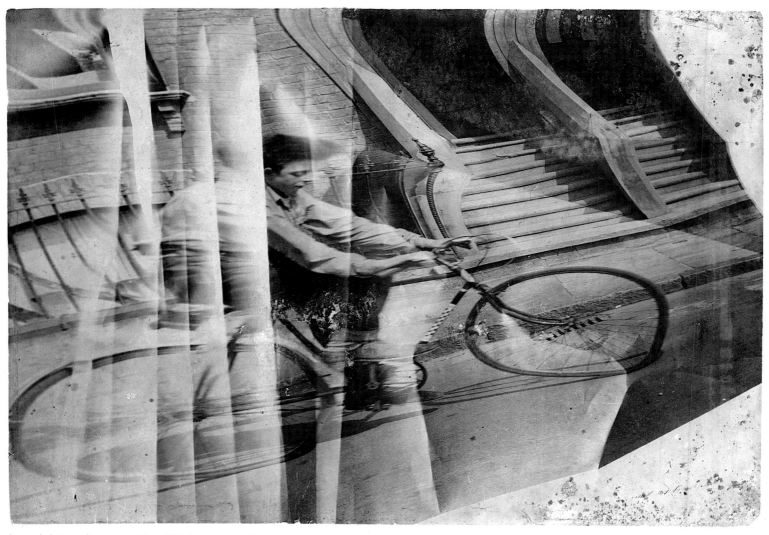

Stressed photograph, c. 1950. 13¼ x 19½ in. (34.9 x 49.5 cm).

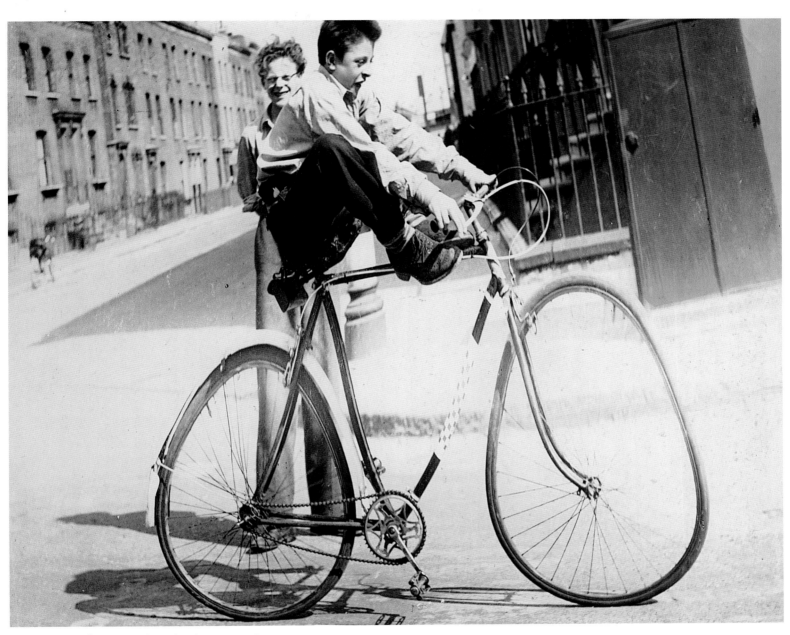

Stressed photograph, c. 1950. 15¾ x 19¾ in. (40.0 x 50.2 cm).

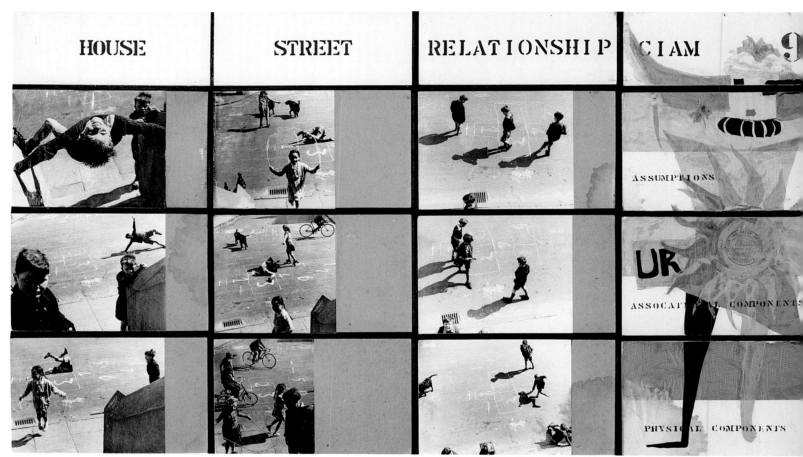

Alison and Peter Smithson, *CIAM Grille*, 1953
Collage, photographs (by Nigel Henderson), ink on paper and *papiers collés*
Eight panels, each 102 ⅜ x 21 ⅝ in. (260 x 55 cm) framed
Musée national d'art moderne, Paris.

From Henderson, the architects discovered the value of the street which formed a 'microcosmic world in which the street games change with the seasons and the hours are reflected in the cycle of street activity'. Redefining the role of the street in urban planning, the Smithsons presented their ideas through this work to an international congress of architects in 1953. The impact of their ideas subsequently led to the demise of heroic Modern architecture.

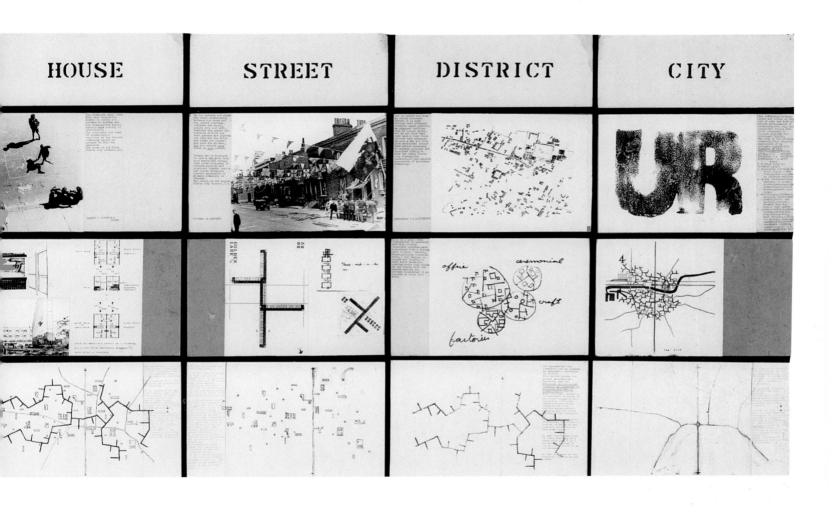

HOUSE STREET DISTRICT CITY

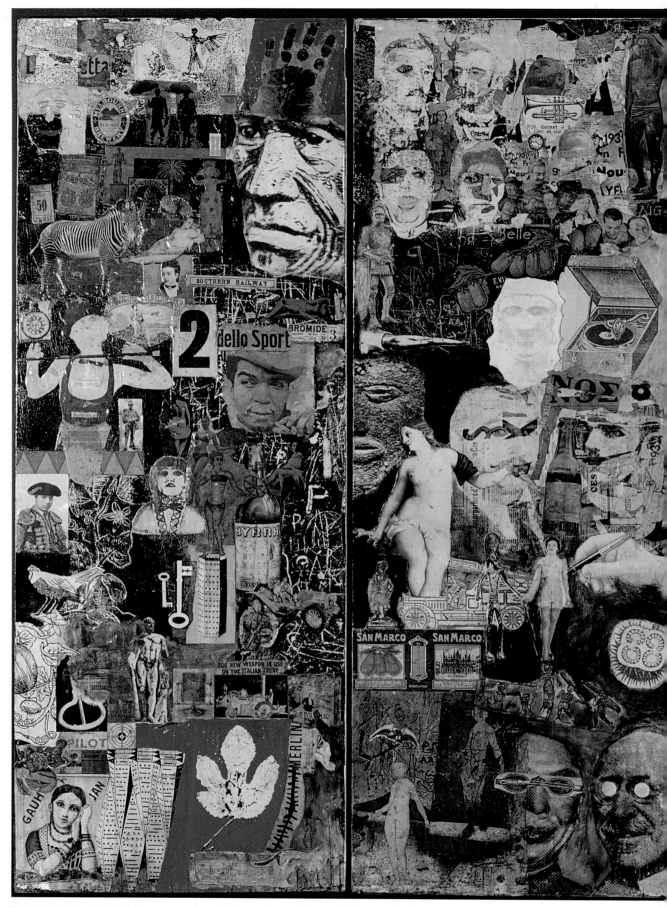

Screen, 1949–52 and 1960. Photocollage on plywood. Four panels, each 60 x 20 in. (152.4 x 50.8 cm).
Collection Colin St. John Wilson.

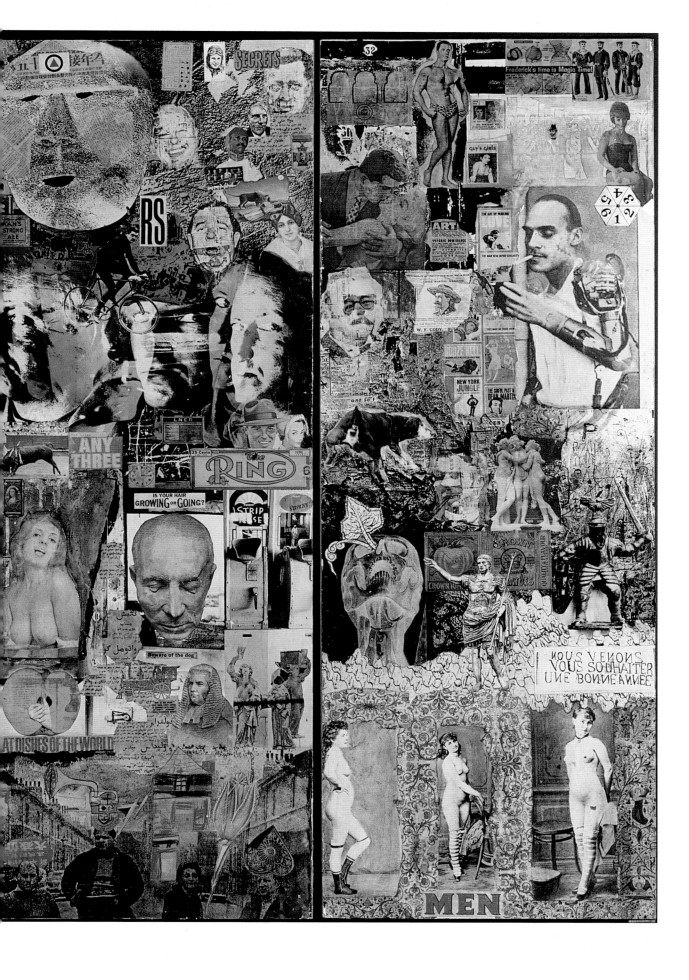

41

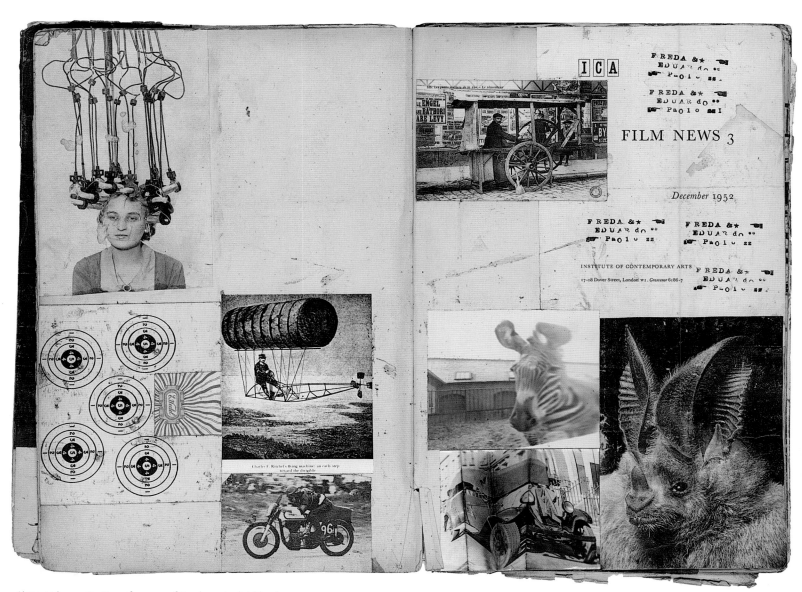

Above and opposite: Pages from one of Henderson's sketchbooks, *c.* 1952.

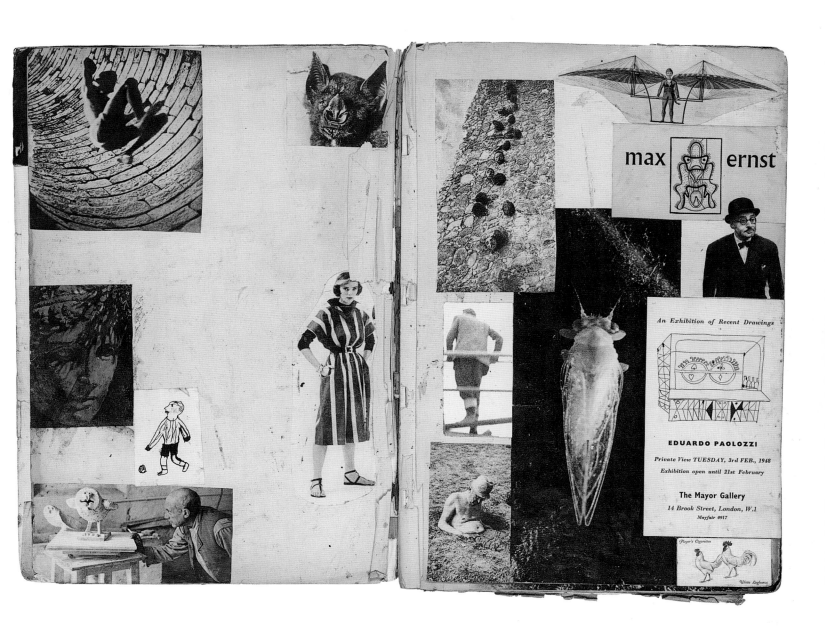

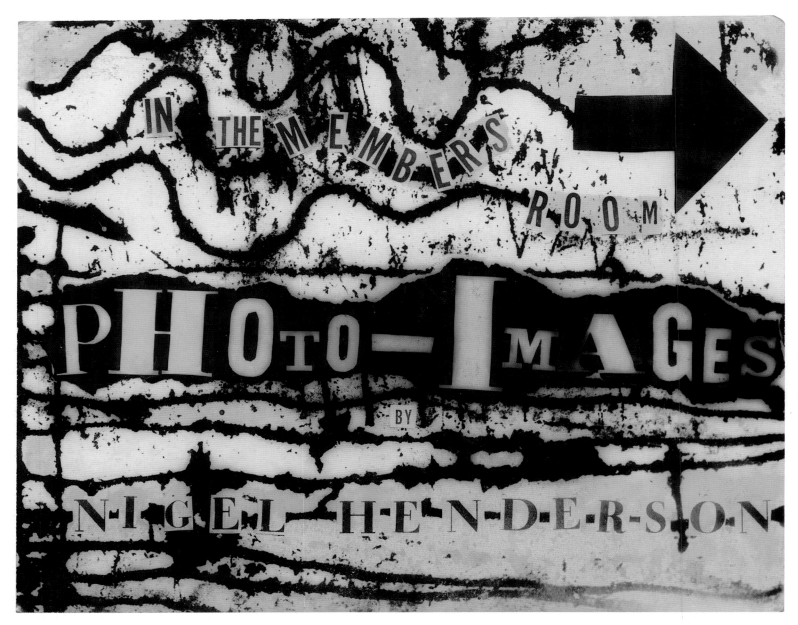

Title panel for Henderson's exhibition at the Institute of Contemporary Arts, 1954.

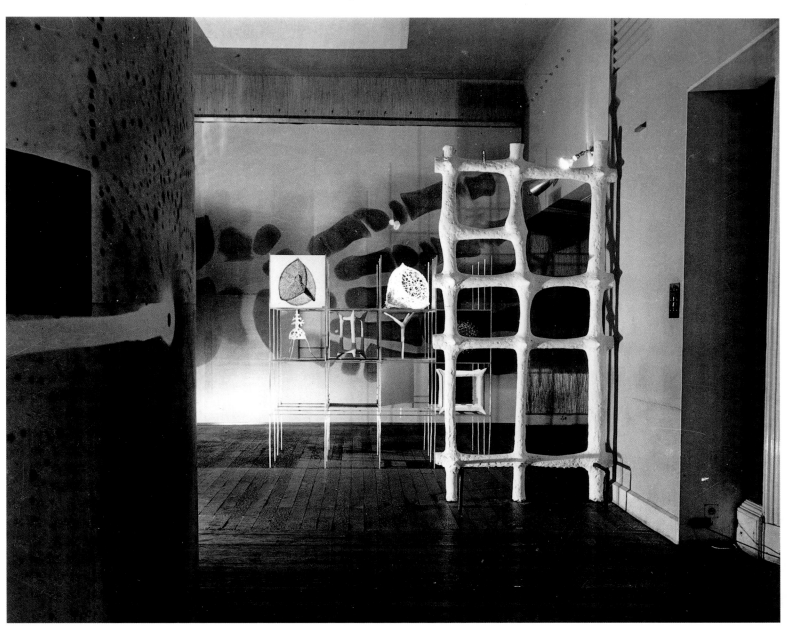

Installation shot of the exhibition 'Growth and Form' at the Institute of Contemporary Arts, 1951.

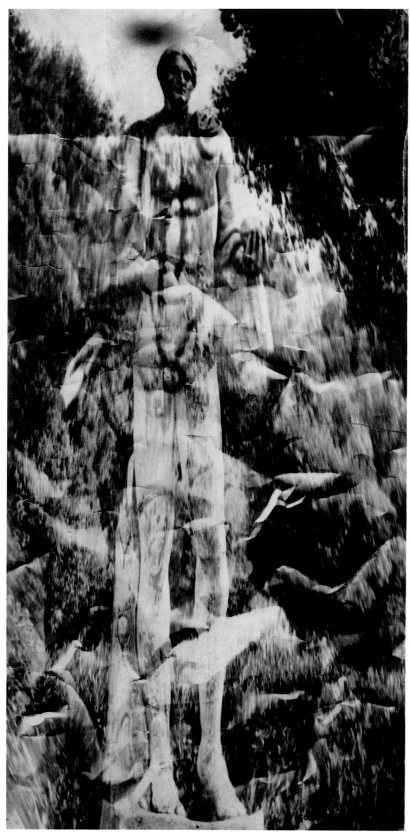

Vertical Statue, 1952. Stressed photograph mounted on board, 20 x 9¼ in. (50.9 x 23.5 cm).
Arts Council Collection.

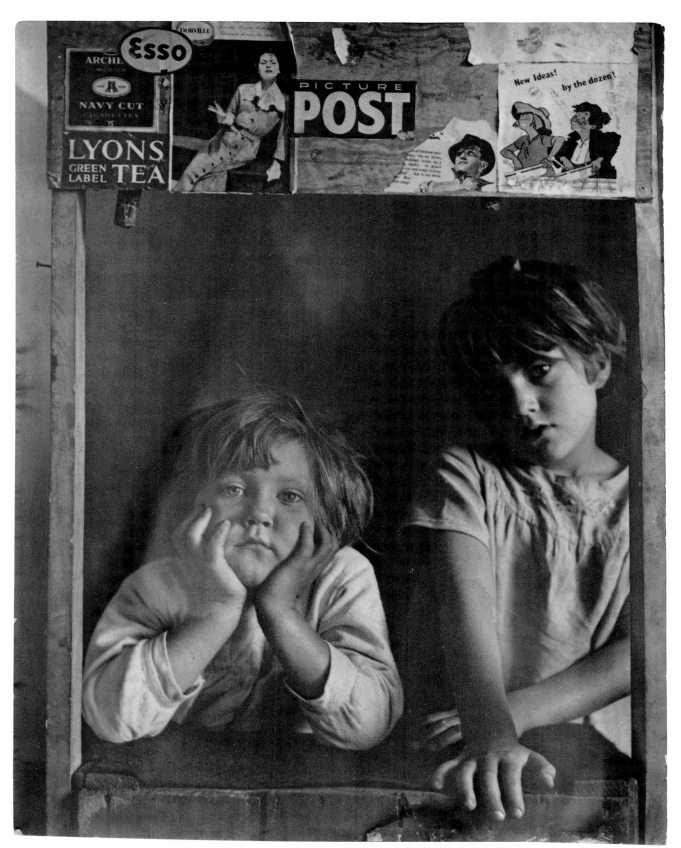

Justin and Drusilla (Jo) Henderson at 46, Chisenhale Road, Bethnal Green, *c*. 1950.

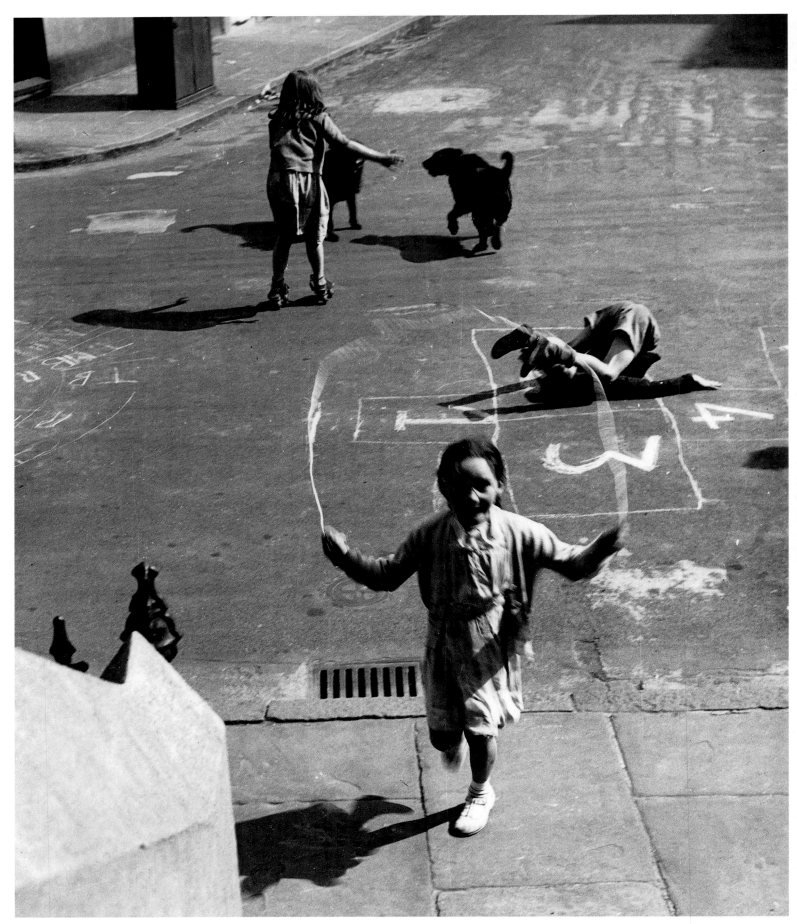

Gillian Alexander skipping, Chisenhale Road, 1951.

Photographs of the East End 1949–1953

In 1945, when the Hendersons moved into the Bethnal Green area of London, they discovered a world far removed from the one to which they were accustomed. Marked by extreme poverty, overcrowded housing, poor sewerage, dank air and large-scale bomb damage, Henderson, with his nerves like 'stripped wires', nonetheless found relief in the long, ambling walks he took around the neighbourhood and unfamiliar streets of the adjacent boroughs of Stepney, Hackney, Poplar and Bow. While, like their neighbours, the Hendersons suffered from an acute lack of money and the misery of rationing, their privileged middle-class backgrounds and public-school education inevitably set them apart from the community in which they subsequently lived for nine years. As Henderson later recalled:

My wife and I knew we would experience alienation in the working class environment. Perhaps this feeling intensified the feeling I had that I was watching live theatre … like an audience of one in a public theatre of All. My neighbours appeared to be living out their lives in response to some pre-determined script. These rituals were formal, very strong and coercive to me [and] because of their unfamiliarity exotic…. 'Limitation of means creates style' said the painter Georges Braque of painting. I found this true of life around me recognising a poetic homogeneity in the patient tired faces of people and houses and pavements; a savage humility begotten of limited means, I thought.[49]

Assuming the role of the naturalist–explorer he had always harboured a fondness for, Henderson first took to the streets with a Leica camera that had been given to him on extended loan.[50] Finding this too small, he purchased a Rolleicord and soon after a plate camera – or 'scrutiny box' – in which he could view, or rather examine, the subject before him reflected in miniature. Having received no formal training in the use of the camera (as the Slade looked upon photography as the 'Devil's Domain'), Henderson had not anticipated the fact that with the Rolleicord he would be producing square negatives and printing on oblong paper. This discrepancy did not particularly disturb him, as he felt more motivated by the desire to catch the essence of a moment than to present a formally coherent and refined image, although such considerations played some role in the necessary cropping of his images of the East End.[51] Henderson's preference for a camera which displaced him from a direct encounter with his subject is not perhaps surprising, given his innate shyness, but it also helped him to maintain an impartial and objective eye – an eye fostered by the personal and social displacement he felt in this new urban environment.

Personally referring to them as 'reportage', Henderson's photographs of the East End collectively form a unique record of daily life in some of the most deprived areas of post-war London. But, unlike the photographs published to accompany George Orwell's *The Road to Wigan Pier*, these photographs do not document poverty or the hardships of labour, nor the more obvious rituals and ceremonial events of marriages and funerals.[52] What these photographs do record is the daily life of the street, with its palpable air of permanence in the routines of the milk float's delivery and the rag-and-bone man's step, punctuated by the comings and goings of locals carrying out their daily chores, while, forming a backdrop, shop windows display men busy with their tools mending and making, and tobacconists announce their growing range of merchandise in a chaotic arrangement of billboards, signs, posters and magazine covers. In quieter residential streets, boys 'doodle' on their bikes, girls play hopscotch and impress each other with their skipping talents, and mothers stand on doorsteps chatting to neighbours. Like the car and bus, interior shots are nowhere to be found: only the public space of the street in which all life comes together and renews itself for the day in hand and the day to come.

Clearly for Henderson, whose early years were defined by the oppressive bourgeois lifestyle of his grandparents and the fragmentation of childhood brought about by boarding school and his parents' divorce, the lambent energy of street life, the good-humoured tenacity of the locals, and the potential to move among both freely, unjudged, if not unnoticed, were both enticing and strangely liberating. In the first draft of a prose poem on London written in 1949 for his friend Paolozzi (who was still in Paris), Henderson contrasted the rhythm and nature of the working day's ending for 'professional and administrative people in lands of maisonette, of mezzanine and mansard' who journeyed home to their 'piped hot water systems' and 'thick carpets in a world of hushed doors' with that of the East Ender:

Our cloth-capped man on his bicycle lives in the more compact geography, working near the living house, trading in the street

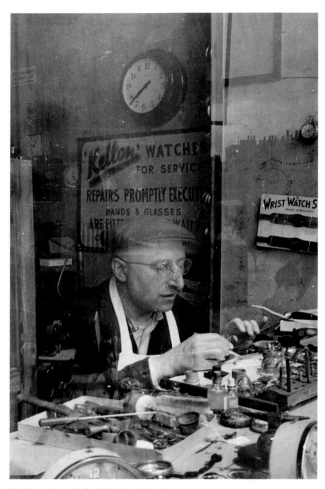

Watch-repairer, Bethnal Green, 1949–53.

or living over his small shop in a day to day economy without larder stores and credit accounts.

A watch-repairer works in his window abutting the street in the medieval craftsman's way. The empirical articles of his trade are scattered around him in an organic order, obedient to the logic of his seeing fingers.

One shop front crowds another in that bizarre interplay of trade and sign that contributes to the complex texture of the city. Funeral parlour and Ice Cream Parlour share the universal symbiosis and, from the window niche, the prurient headstone of an angel reassures us that in the midst of death we are in life.[53]

Paolozzi would have appreciated the pathos of Henderson's rendering of the differences between the middle- and working-class lifestyle and the underlying sense of being a witness to a passing world of trade, craft and skill, historically handed down from one generation to another. For as Paolozzi, himself uprooted from an artisan culture in Italy and brought up in a small family business in the poorer outskirts of Edinburgh, knew, the days of such cohesive community life were limited, whether for good or for bad.[54] While Paolozzi would ultimately desire to transcend this simple and physically hard way of life for one more sophisticated, Henderson clearly found the simplicity of working-class life and the high visibility of trade and manual labour a welcome alternative to his childhood experiences and memories of trips to Harrods, a shop which itself epitomized the progress of capitalism and made much of goods which declared their modernity through the materials and processes of the new methods of commercial, industrialized production.

In the same way that Surrealism had resonated with Henderson before the war, offering a world in which common sense, rationality and thinking disciplined by the institutions of class were suspended, if not destroyed, he now found that a residual sensibility for surrealist imagery drew him to sites and sights which seemed to invite the uncanny and the marvellous. Although, as he sadly lamented, Surrealism in its political, revolutionary form had undoubtedly lost its hold after the war, once the urban landscape had become saturated with such imagery: 'Houses chopped by bombs while ladies were still sitting on the lavatory, the rest of the house gone but the wallpaper and the fires still burning in the grate. Who can hold a candle to that kind of real life Surrealism?'[55] But Henderson's eye was always alert to moments of surrealist import, as in the unsettling photograph of a market wig stall on which stand four highly made-up dummy heads, disembodied and seemingly freestanding, with plastic expressions varying from sweet smiles to blank recognition. Virtually assimilated into the row of heads, however, a second glance reveals the head of a passing middle-aged woman wearing a similarly fixed expression, but of a more ambivalent nature – sad, resigned, indifferent to the world around her. Another photograph shows a market stall selling stockings which, again disembodied, are divorced from their functional aspect and metamorphosed into strange ethereal presences, alternately concealing and revealing the semitranslucent faces and profiles of women gathered on the other side. Although, in capturing these moments, Henderson was acting on his instinct for the uncanny, he may also have been responding to an image of the very same stalls and market in Petticoat Lane that Moholy-Nagy was commissioned to photograph in 1936 for a publication on London's street markets.[56]

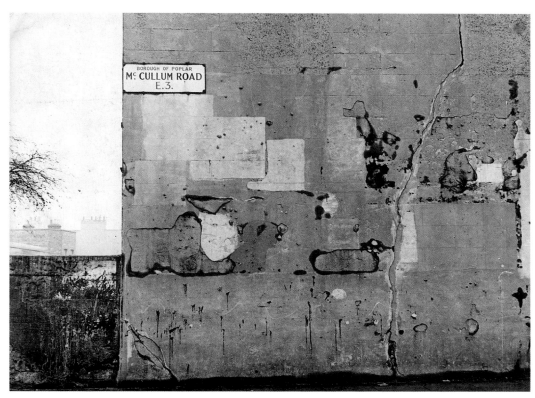

Wall, McCullum Road, 1949–53. As Peter Smithson noted, 'A walk with Nigel is to see the inanimate as animate....'

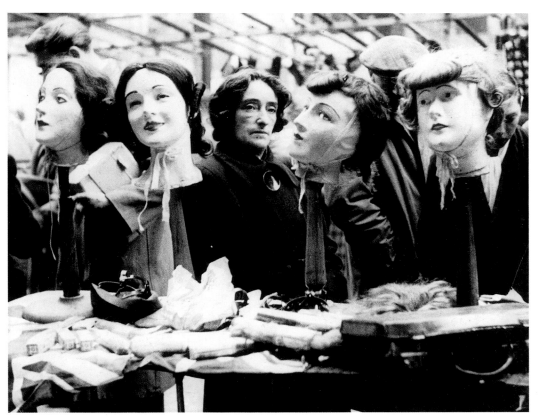

Wig stall, Petticoat Lane, 1952.

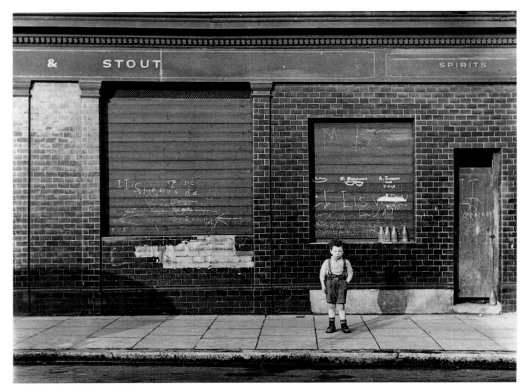

Boy before boarded-up pub, Stepney, 1949–53.

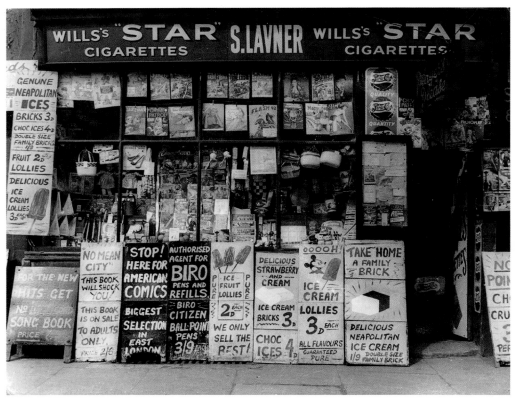

Shop front, Bethnal Green, 1949–53.

The chance of being in the right place at the right time to trap on film these moments in time and out of time, Henderson specifically articulated through the philosophy and vocabulary of Surrealism:

'Accident' – Let's have it in inverted commas, please. Accident the subtle prompter in the wings of the unconscious – no friend to the BRASH – the coarsely confident or possibly ? the VISUAL ENGINEER. Accident the great humbler….What we call SELECTIVE ACCIDENT to be good must function like the objet trouvé – a chance set of 'found' phenomena bringing about an order which you might ideally have wished/invented to create from scratch. It is a question of RECOGNITION.[57]

Although Henderson would later go on to visually engineer the ironic juxtaposition of material to form personal landscapes in collage, his compulsive walks around the East End clearly fed his imaginative grasp of the potential of the ready-made, be it an object or a scene, to carry or take on a significance beyond general appearance. One of the most potent examples of this is the photograph taken from outside a pub of two men's heads transmogrified by the dimpled patterning of the window glass. Equally, at this time Henderson would also begin to appreciate the redemptive quality of humour inherent within certain kinds of visual and verbal punning typical of Surrealism, as is testified by an early photograph of a puggish little boy stroppily standing in front of the closed shutters of a pub below the sign-painted word 'STOUT'. While the majority of Henderson's images that generate from an element of chance are of men, women and children, he was not insensitive to the incidental means by which the ephemera and physical material of the urban environment could also undergo a subtle transmutation, as seen in his photographs of billboards, advertising hoardings, patched-up brick walls and Klee-like graffiti on glazed doors. But, as Henderson noted, his focusing in on such sites was not only inspired by the work of Brassaï, which he encountered in Paris in 1947 (and in Surrealist publications such as *Minotaure*), but also by the work of other artists interested in the weathered and worn textures of the material environment:

Some particular marks like the slicks and patches of tar on the roads, the cracks and slicks and erosive marks on pavement slabs. The ageing of wood and paintwork, the rich layering of billboards etc…. I linked with the work I did more directly with the enlarger and which I later felt made some common ground with some aspects of the work of artists like Tapiés [Tàpies], Burri, Jean Dubuffet.[58]

But for as much as Henderson was surrounded by a wealth of such imagery in the dilapidated buildings and bombed-out ruins of the East End, he had clearly acquired a feeling for the abstracted and desolate forms of the urban decay from his reading before the war, and in particular the writings and poetry of T. S. Eliot and W. H. Auden.[59] Moreover, during the late 1930s he had also known the photographs of Humphrey Spender, Julian Trevelyan and, most importantly, Humphrey Jennings, which captured the surrealist aspect of the semi-derelict towns of the industrial wastelands of the North of England.

All three photographers were well versed in the ideas and doctrines of Surrealism, but the impetus behind their work was not primarily aesthetic, but documentary. Taken under the auspices of Mass Observation, their photographs were intended to exist as visual evidence of the lives and habits of the working class in poverty-stricken areas of Britain. Formed in 1937 by Charles Madge (poet and *Daily Mirror* reporter) and Tom Harrisson (journalist and anthropologist), Mass Observation also included London cultural figures such as the poet David Gascoyne, Kathleen Raine and Stuart Legg. The first bulletin they published began by stating 'how little we know of our next door neighbour and his habits' and lamented that 'the anthropology of ourselves is still only a dream'.[60] To redress this situation, Mass Observation had been set up with the aim of becoming 'a scientific study of human social behaviour' based on extremely detailed information about the daily lives of 'ordinary people'. This information would be recorded in diary form, with the emphasis on objectivity and factuality, by 'ordinary individuals' recruited to observe, closely but secretly, the lives of their neighbours. More often than not, the observers were reformist and middle class and the observed were working class. This 'very public espionage', as it has been described, continued throughout the war and its aftermath until 1947.

Comparable in its methods and objectives to Mass Observation, the 'Discover Your Neighbour' project which Judith Henderson was involved with (and which had necessitated the move to Bethnal Green) also concluded in that year. As the comprehensive diary entries from October 1946 to June 1947 about a neighbouring family demonstrate, Judith Henderson was most adept at this work and soon came to the attention of Tom Harrisson, who subsequently helped out by lending a typewriter and some financial assistance. The Samuels family, on which her attention was exclusively

The Samuels family, 1949–53.
The Samuelses lived at 31, Chisenhale Road, and became the subject of Judith Henderson's study of neighbourhood life in Bethnal Green.

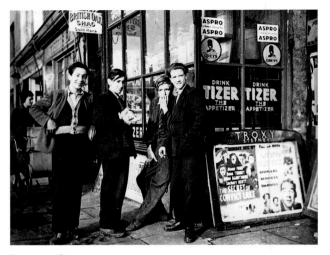

Teenagers, Stepney, 1949–53.

focused, lived at number 31, Chisenhale Road, and consisted of Leslie and Doreen Samuels and their school-age sons, some of whom were playmates to the Hendersons' own two daughters, Justin and Drusilla. In keeping with the strategies of Mass Observation, the Samuels family were oblivious to the role they were playing in Judith Henderson's work, and although, as Henderson's sister has recalled, this made her brother 'uncomfortable', Henderson himself acknowledged that this strange subterfuge also helped 'to preserve that necessary distance that is the uncomfortable price of setting anything down'.[61]

But although Henderson extensively photographed one of the classic types of event that drew Mass Observation attention, the 1953 street celebrations of Coronation Day, it would be a mistake to identify or confuse his photographs of East End life with Judith Henderson's project. For, while a clear agenda lay behind Judith's watchful note-taking of her neighbours for a project which appealed to her Quaker roots and anthropological training, Nigel Henderson was simply responding to the 'exotic' new environment he found himself in; an environment that not only soothed his nerves in its strangeness and fed his Surrealist imagination, but also effectively superimposed itself on a personal history which he was only too glad to be able to selectively edit with new images. As he wrote to Judith during the war, he desperately wanted to engage with life through the uncynical eye of a child, and in many respects this is what the streets of the East End made possible: 'There's also the wish to retain the "innocent eye" of childhood, the unblinking, guileless,

not self-deceived record of an eye not distorted by extraneous associations of false attitudes – "Tyger Tyger, burning bright" – what a vision! The genuine "innocent eye" at work.'[62]

In the same way that Henderson would assume an 'innocent eye' in the photographs he took of children amusing themselves and playing street games, so too, with childlike enthusiasm, would he also take odd friends on energetic discovery tours of the streets of the East End, pointing out this shop front, that twisted gutter and so on, until they too had become sensitized to the unexpected and apparently mundane. Among this small circle of initiates were the architects Alison and Peter Smithson, whom Paolozzi knew from the Central School of Arts and Crafts and had introduced to Henderson in 1951.[63] Recalling these 'absolutely incredible' walks, Alison Smithson retrospectively described Henderson as 'the original image-finder', while Peter Smithson observed that 'a walk with Nigel is to see the inanimate as animate, and this weird business of opening … other people's eyes to see – to have an affection between objects and people'.[64]

These outings had a tremendous impact on the Smithsons, for not only did Henderson share with them his idiosyncratic vision of the streets, he also presented them with the opportunity to witness at first hand the self-sufficiency and vitality of a community whose daily life of working, shopping and socializing all took place within a confined network of streets. In recognizing the value of this form of social cohesion, the Smithsons began to identify what they perceived as the fundamental mistakes of post-war urban planning

Roger Mayne, Nigel Henderson's kitchen at 46, Chisenhale Road, 1953. Collection Roger Mayne.

Roger Mayne, Nigel Henderson at 46, Chisenhale Road, 1953. Collection Roger Mayne.

which favoured the needs and demands of industry and commerce over those of the individual and community. In their reformulation of the essentials in urban planning, the concept of the street became their primary focus. As they would write: 'The "street" is an extension of the house; in it children learn for the first time of the world outside the family; it is a microcosmic world in which the street games change with the seasons and the hours are reflected in the cycle of street activity.'[65]

In 1953, the Smithsons presented their new philosophy to CIAM 9 (Congrès Internationaux d'Architecture Moderne) meeting at Aix-en-Provence. Founded in 1929 by Le Corbusier, Gropius and other major architects of the time, CIAM promoted, as Theo Crosby has noted, 'the clean rationalism of minimum housing, efficient mass transport, segregation of industry and wide park areas'. The Smithsons, in contrast, called for a 'reidentification' of the individual with his surroundings and, though appreciating that a revival of East End communities would be mere historicism, they emphasized the need to create modern equivalents of certain features that were fundamental to the creation of communal living. One example of this was the creation of the 'street deck' in high-rise housing: rather than the narrow concrete passage off which front doors to flats were accessed, the 'street deck' would be sufficiently wide to function like a street, where neighbours could meet and children play within sight of home.

In presenting their ideas to CIAM in 1953, the Smithsons produced a conceptual grid with sections divided into 'House – Street – Relationship' and 'House – Street – District – City'. Incorporating Henderson's photographs of children entertaining themselves by playing hopscotch, skipping, cycling and climbing street furniture, the grid demonstrated the kind of activity and social interaction being precluded by the new forms of housing construction and road building taking place across Europe.[66] On enlisting much support and sympathy for their ideas at the 1953 CIAM meeting, the Smithsons were subsequently invited by the CIAM board, with other young architects such as J. B. Bakema of Holland, to establish a new body, Team 10, which would prepare the agenda for the next CIAM meeting in 1956. In architectural history, the CIAM meeting of 1953 and the Smithsons' contribution with Henderson has been recorded as a key moment in the fragmentation of heroic Modern architecture.

Towards the end of 1954, the Hendersons left Bethnal Green and moved to Thorpe-le-Soken in Essex with their two daughters when Judith inherited the family home, The King's Head, at Landermere Quay.[67] They were soon followed by their close friends Freda and Eduardo Paolozzi and the Samuels family, who each moved into cottages adjacent to the Henderson property.

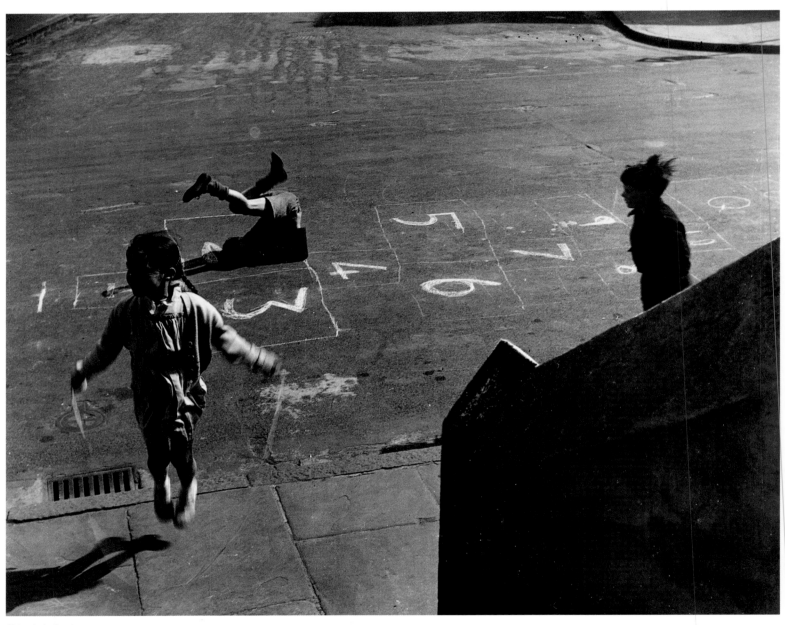

Chisenhale Road, 1951.

Preceding pages: Heads seen through pub window, East End, 1949–53.

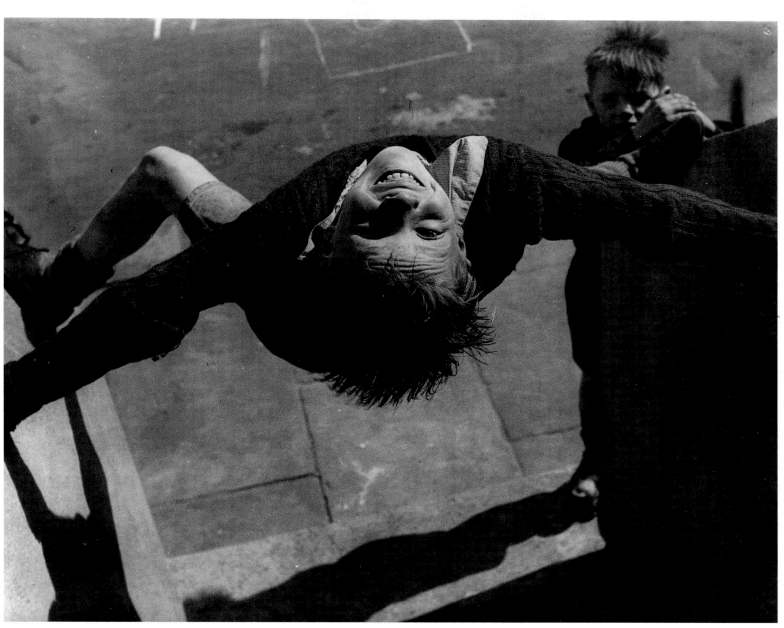

Chisenhale Road, 1951.

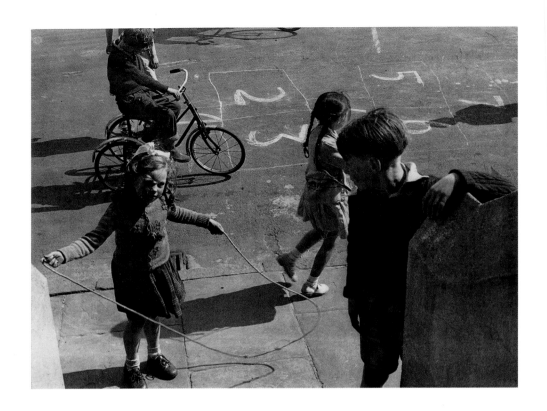

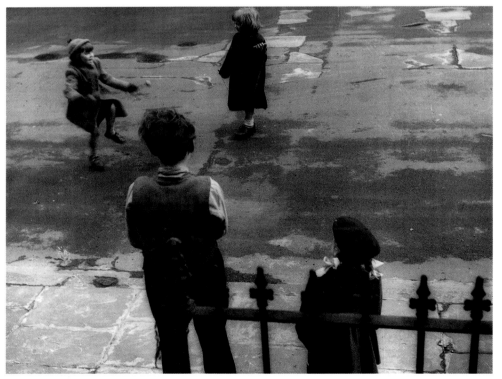

Above and opposite: Chisenhale Road, 1951.

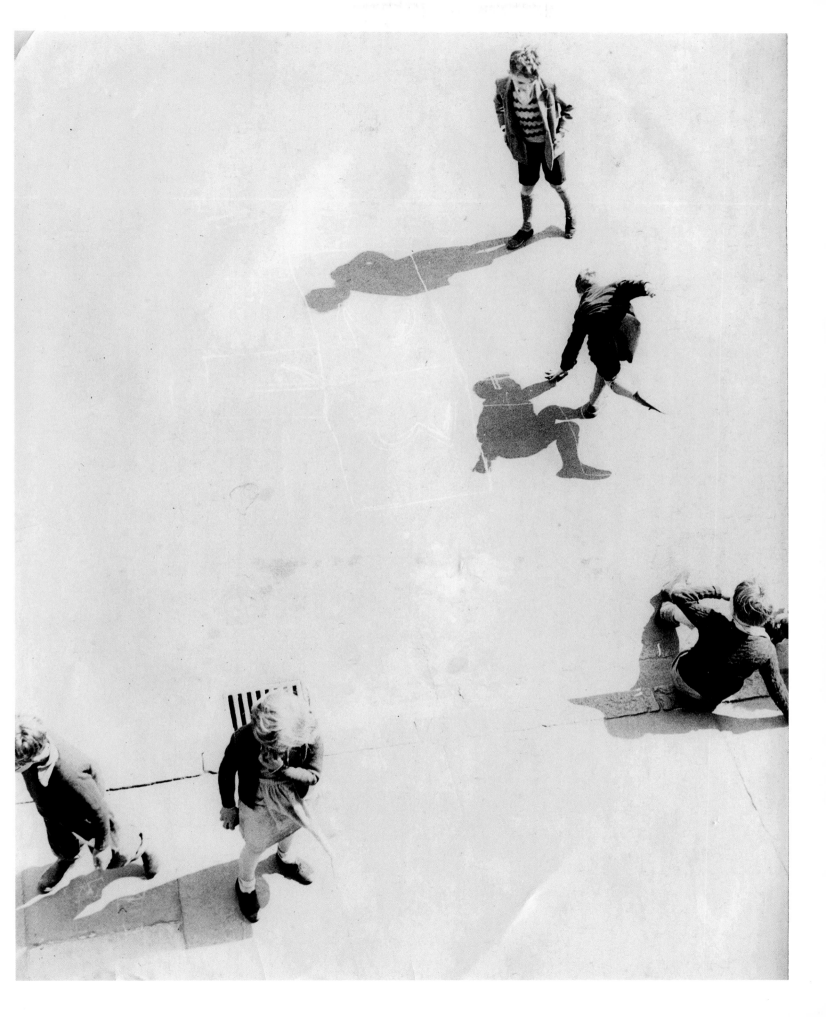

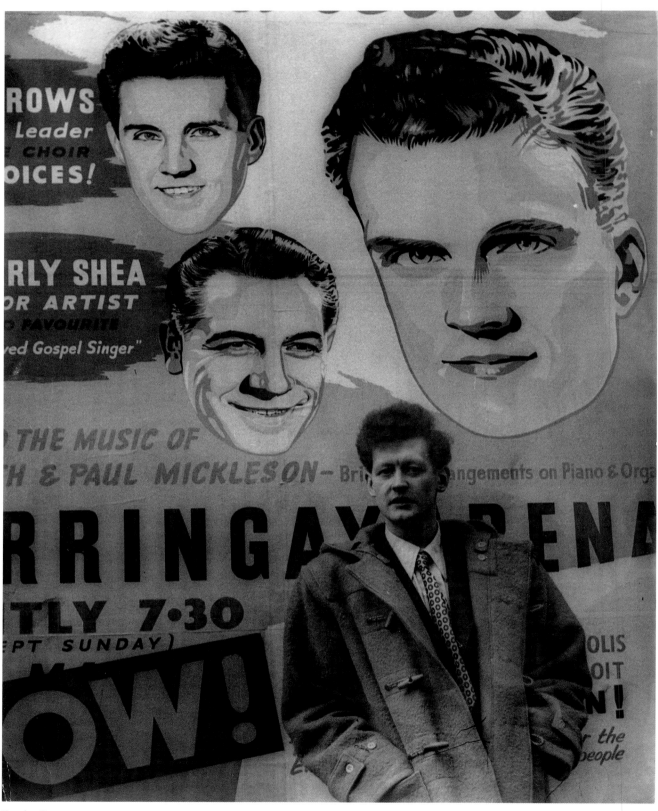

Douglas Newton, 1952.

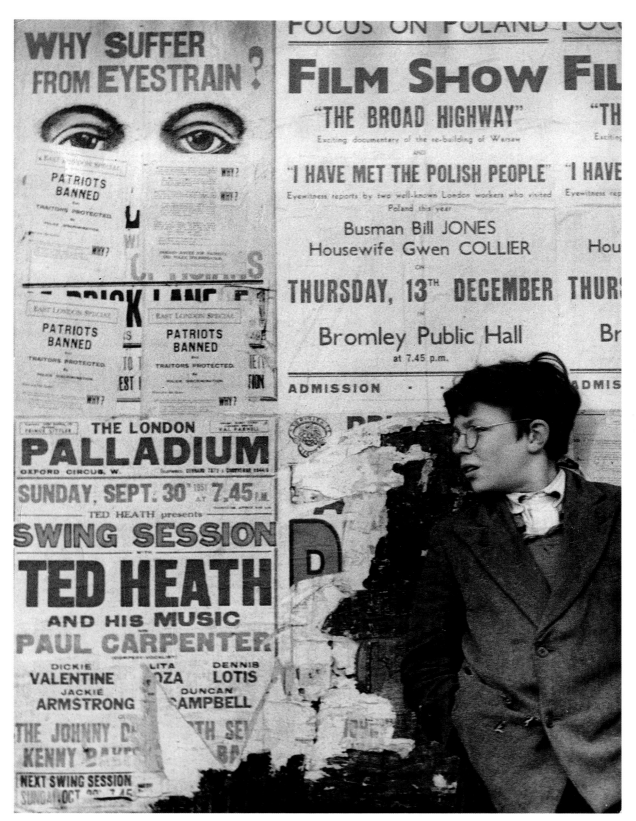

Peter Samuels, 1951.

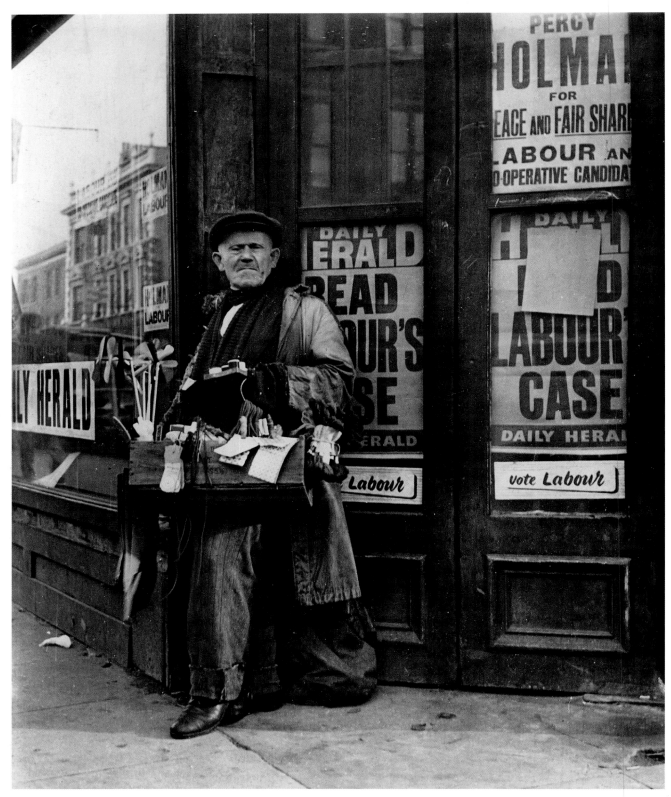

Street vendor near the 'Salmon & Ball', Bethnal Green Road, 1951.

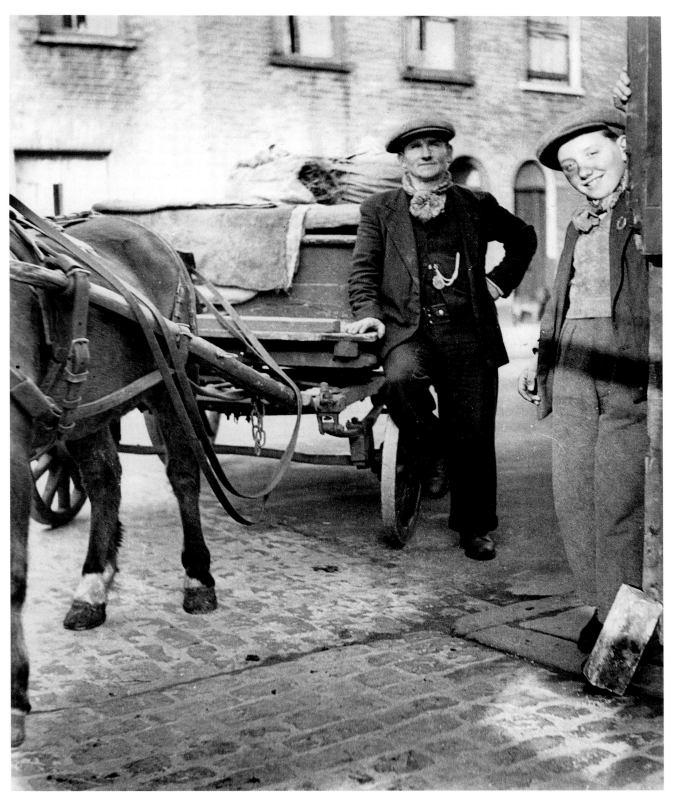

Merchants, 1949–53.

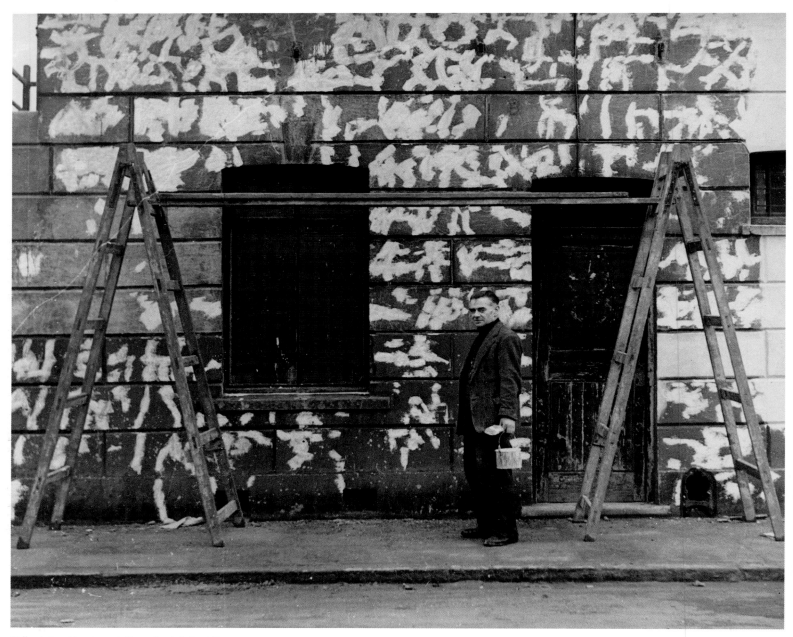

Wall painting. Stopping out. Grove Road, Bethnal Green, 1949–53.

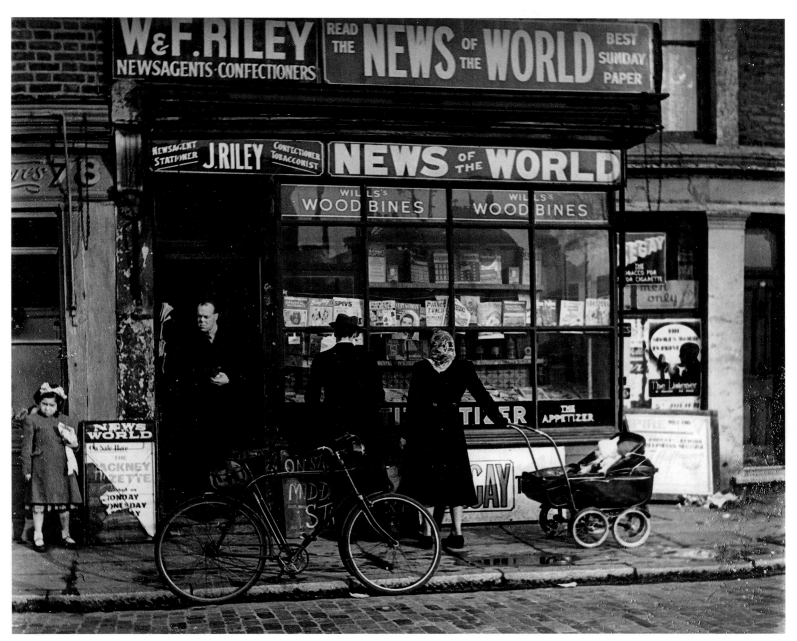

W. & F. Riley, newsagents and confectioners, 1949–53.

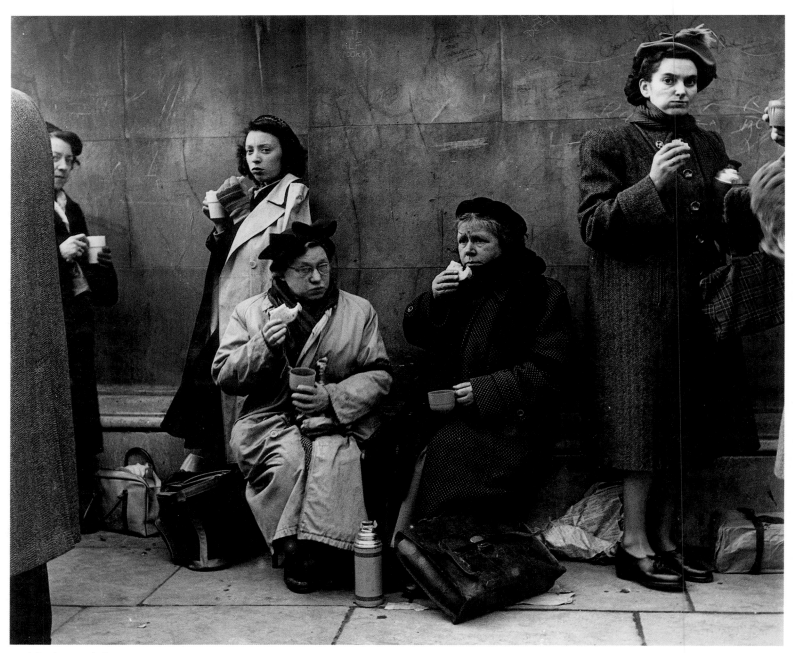

Lunch break. Funeral of King George VI, 1952.

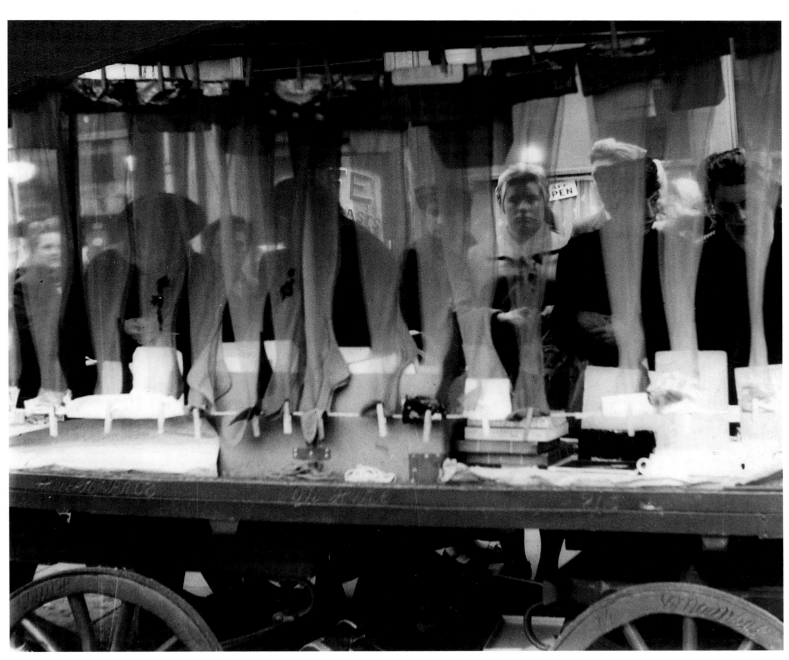

Petticoat Lane market, 1952.

Disabled ex-serviceman, 1949–53.

Kendow. Strong man, 1949–53.

Boys on bike, Chisenhale Road, 1949–53.

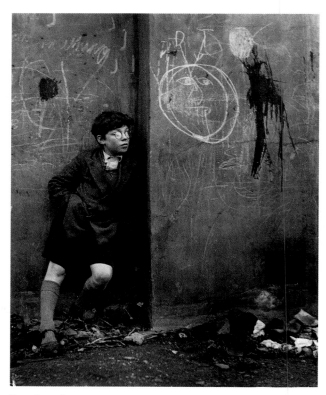

Peter Samuels, 1951.

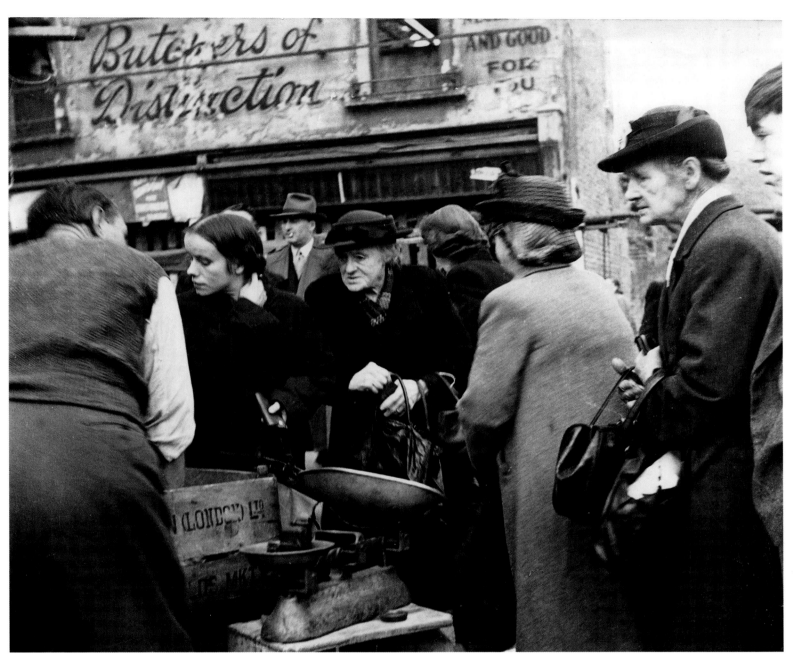

Roman Road street market, 1949–53.

Barber's shop window, 1949–53.

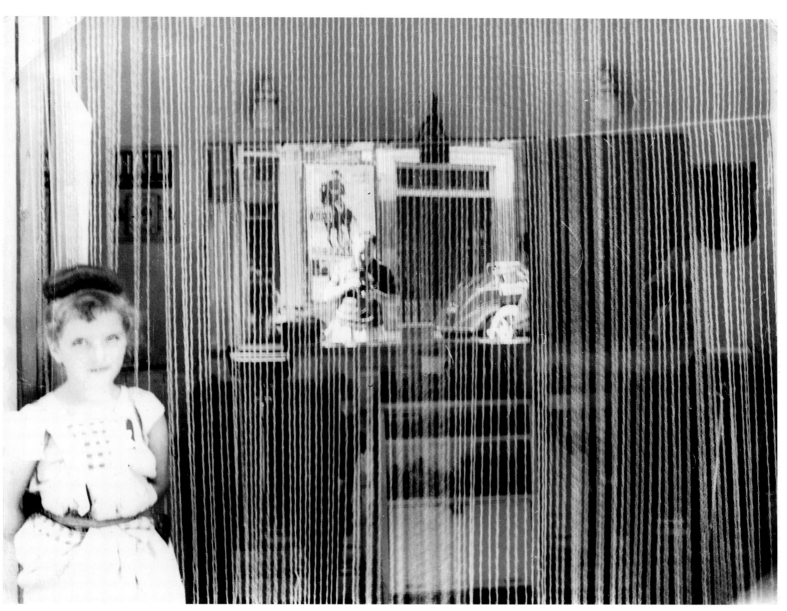

Shop entrance, 1949–53.

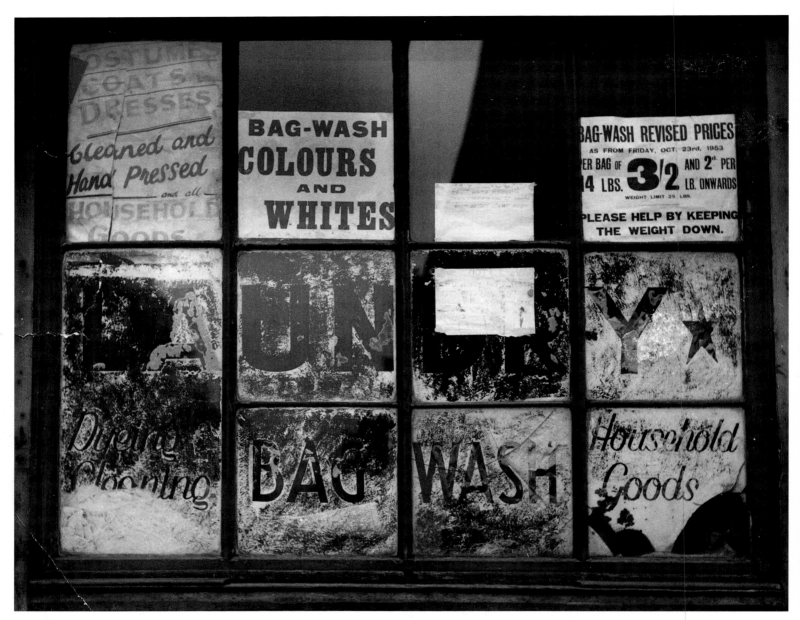

Bag-wash, 1949–53.

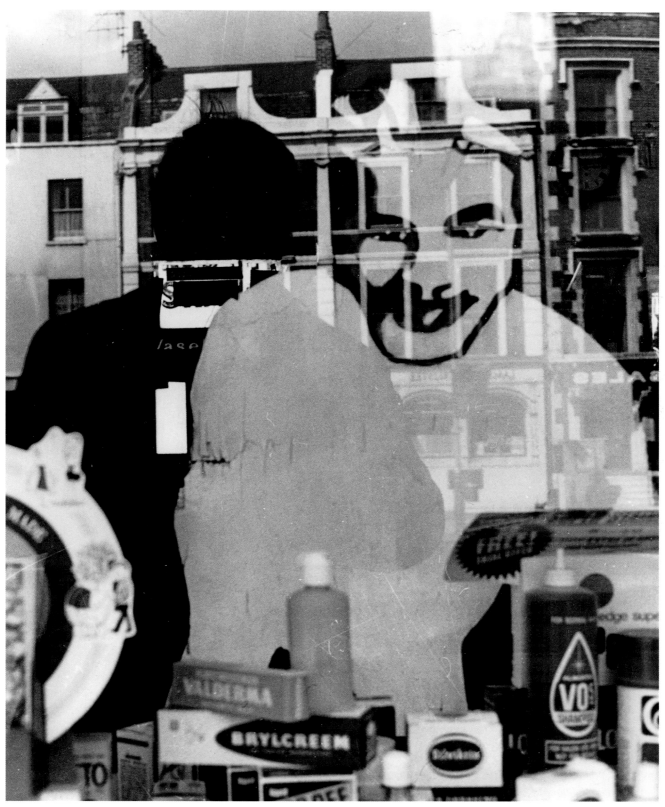

Barber's shop window, 1949–53.

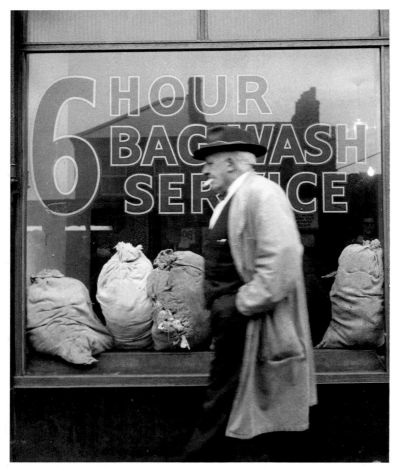

The bag-wash, c. 1949–53.
As A. Hyatt Mayor wrote to Henderson in 1962, 'I like your eye
for desolation – consistent and heart-felt. Your rubbish talks.'

Preceding pages, left: Distressed door, c. 1949–53.

Preceding pages, right: 'Sgraffiti on a Window', c. 1949–53.
Reyner Banham reproduced this photograph in his seminal essay
on Brutalism in 1955 as 'an image of human as well as formal value'.
Henderson later gave it the title 'Popular Art'.

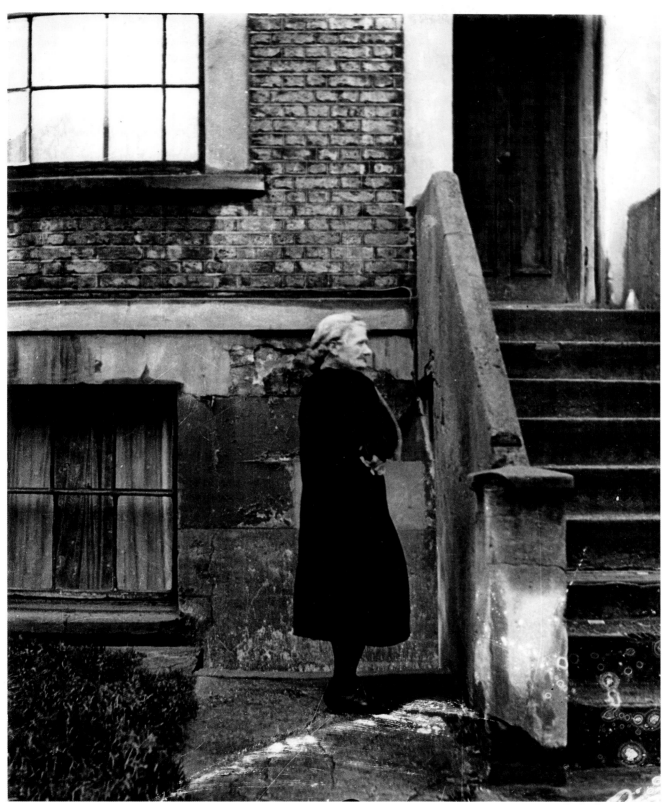

Old woman in front of her house, Bethnal Green, 1949–53.

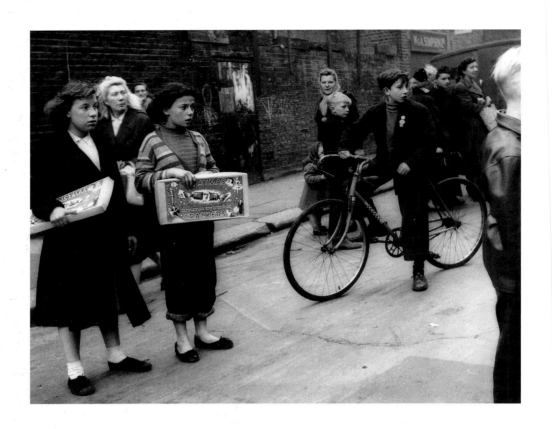

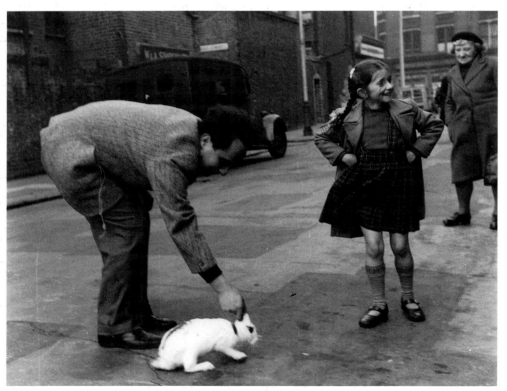

Above and opposite: Passers-by and crowd watching film-making in the street, 1950.

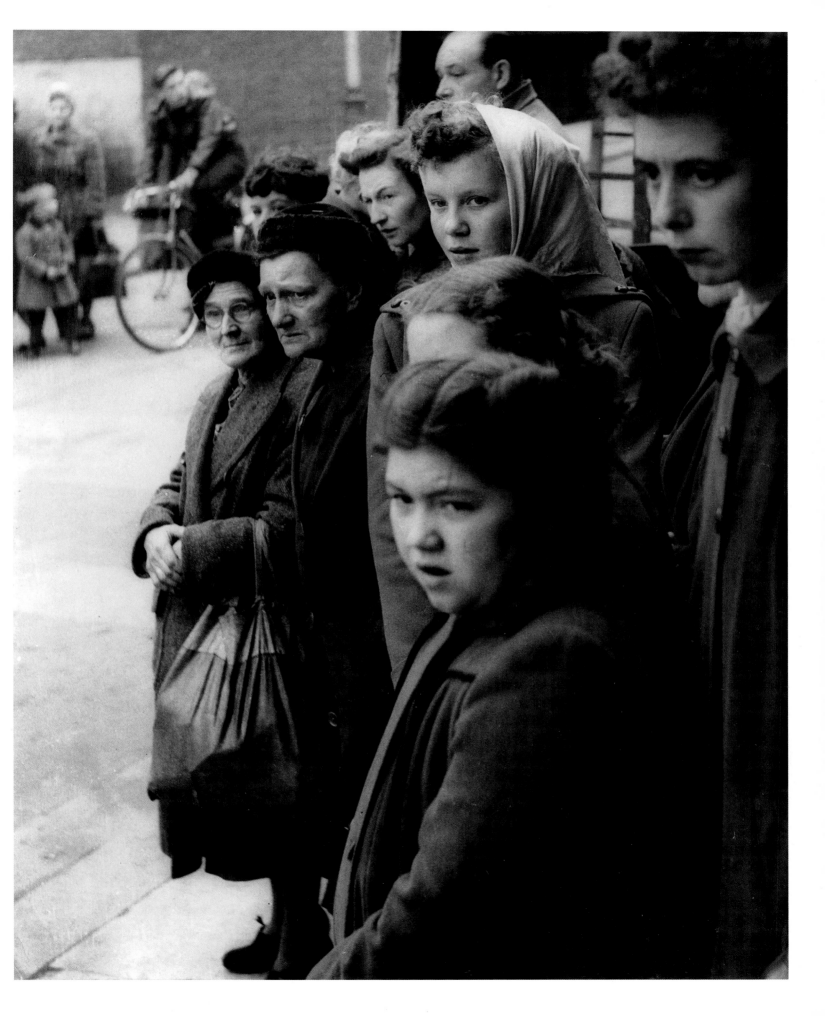

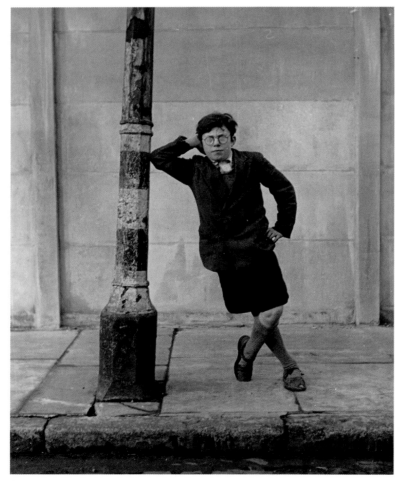

Peter Samuels, 1951.

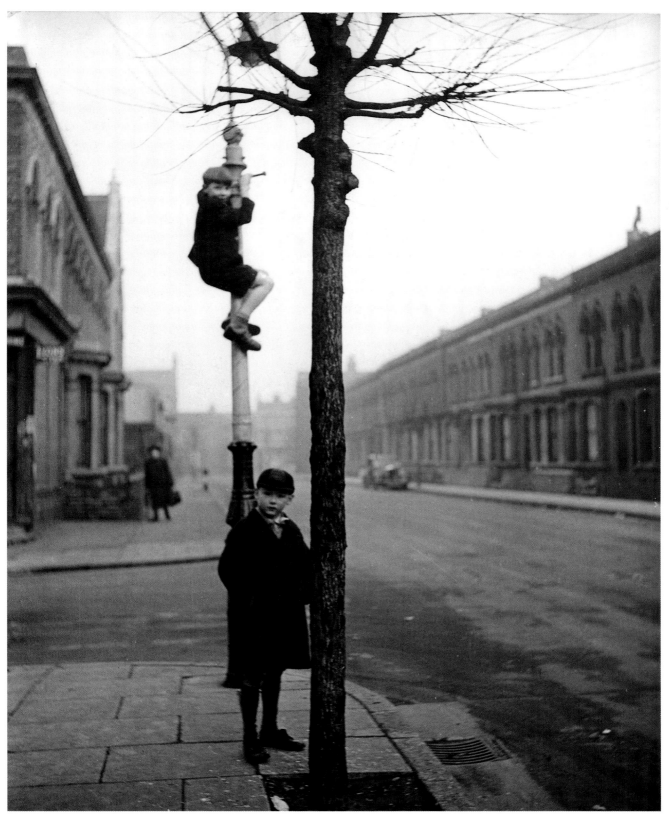

Street play, 1949–53.

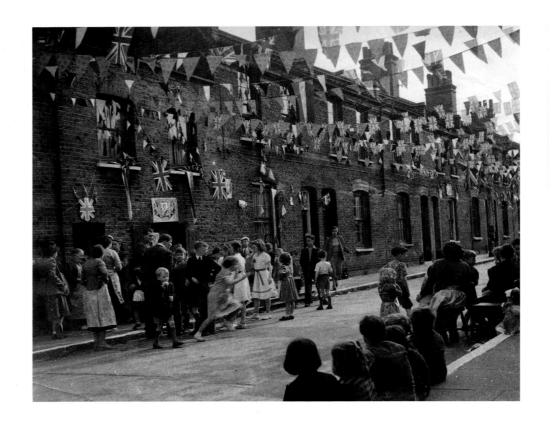

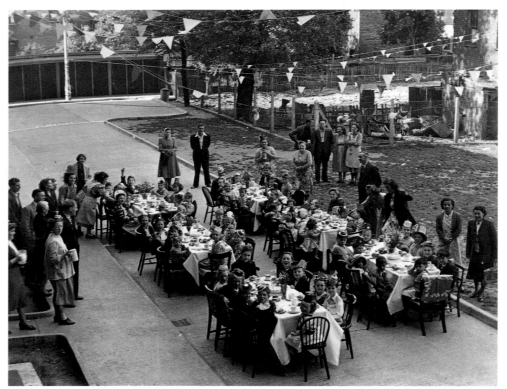

Above and opposite: Coronation Day celebrations, Bethnal Green, 1953.
Henderson took a large number of photographs documenting the celebrations of Queen Elizabeth II's Coronation.

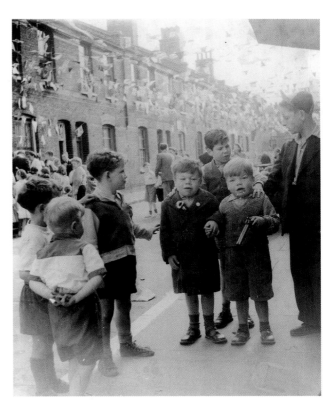

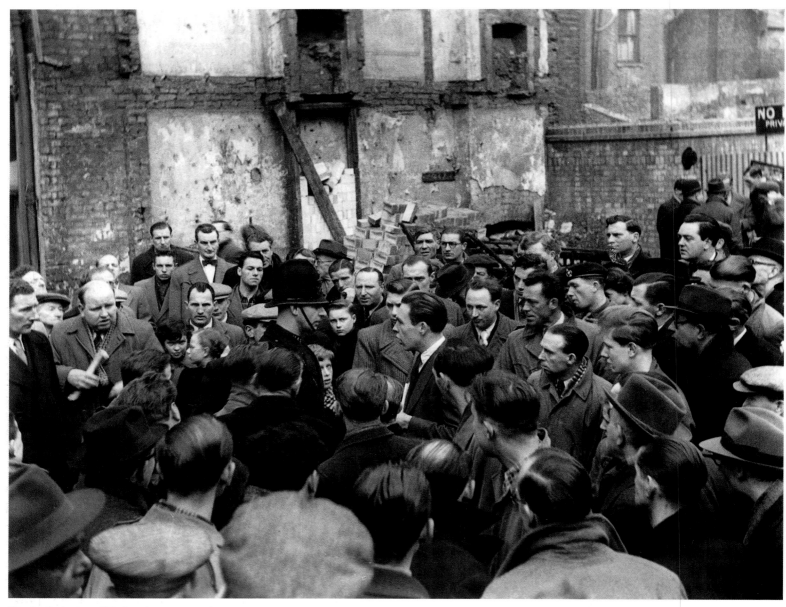

Crowd gathering just off Petticoat Lane street market, 1949–53.

Opposite: Window-cleaner's funeral in Chisenhale Road, 1949–53.
Henderson rarely took photographs of events such as this; his reticence is reflected in the fact that the
photograph was taken from an upstairs window of his home and was never printed during his lifetime.

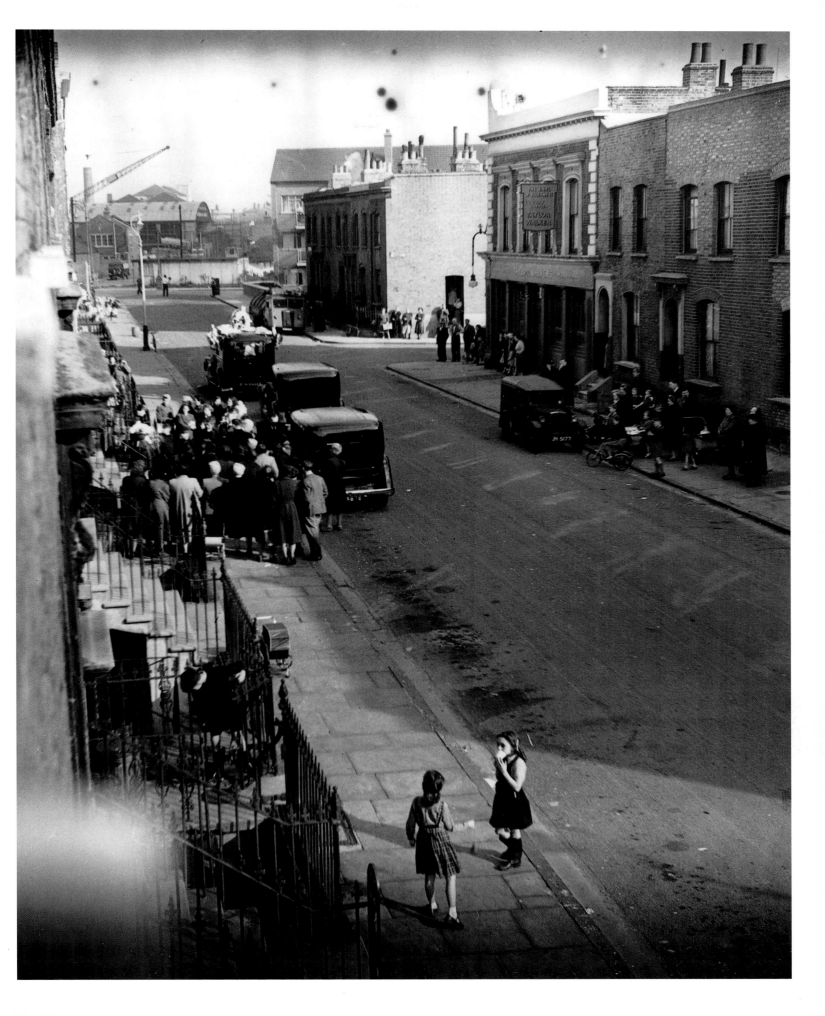

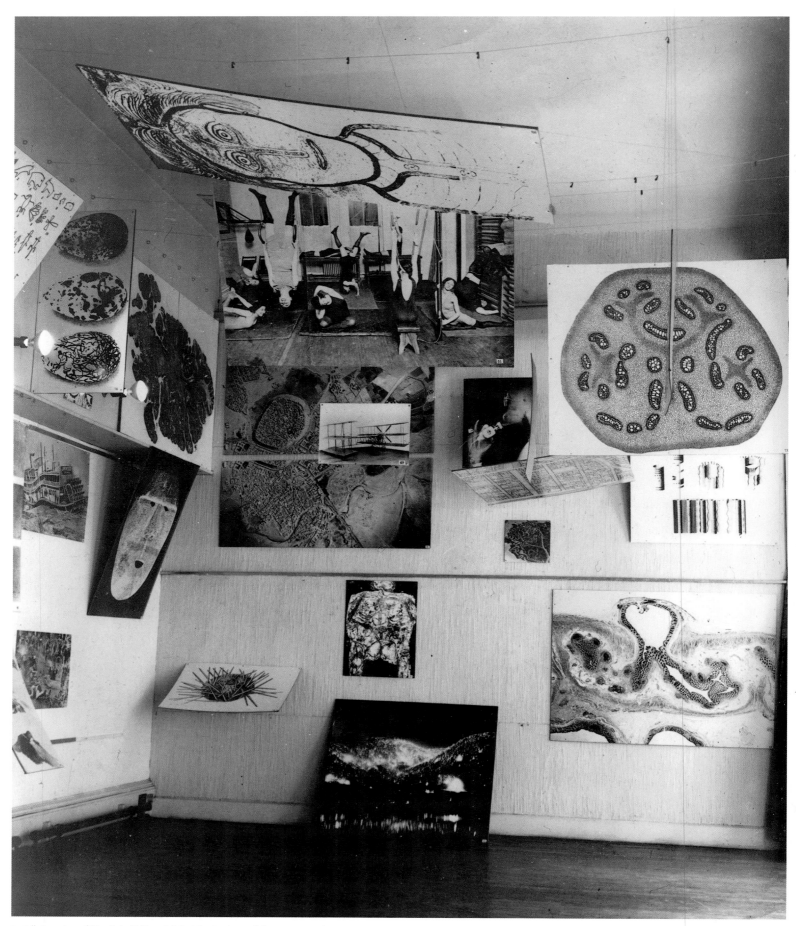

Installation view of 'Parallel of Life and Art' at the Institute of Contemporary Arts, 1953.

'Parallel of Life and Art' 1953

On 11 September 1953, 'Parallel of Life and Art' opened at the Institute of Contemporary Arts in Dover Street, London. The exhibition, arranged by Paolozzi, Henderson, the Smithsons and their engineer from Ove Arup, Ronald Jenkins, consisted of 122 photographic panels. Varying greatly in size, the panels not only lined the walls of the gallery in an unconventionally dense hang, but were also suspended at different heights and angles from a virtual ceiling created by an intricate network of wires. The panels themselves presented images photographically reproduced from an extensive range of sources and disciplines, often photographic in origin – such as newspaper photographs, medical X-rays, scientific photomicrographs, geological aerial views, archaeological documentation, metallurgical studies – but very few that directly belonged to the category of art. Many were instantly recognizable, but some were ambiguous and others unidentifiable because of the extent to which they had been enlarged and separated from their original context. Closely juxtaposed visual affinities between images from highly disparate sources that would not normally be encountered within the same field of vision were revealed. There were no labels by which to fix the images empirically, placing the onus on the viewer to decipher the visual mêlée which surrounded them. Each panel was, however, numbered and identified in a concertina-style guide which provided a description of the image and its original source. Within the guide, the images were broken down into eighteen categories: Anatomy, Architecture, Art, Calligraphy, Date 1901, Landscape, Movement, Nature, Primitive, Scale of Man, Stress, Stress Structure, Football, Science Fiction, Medicine, Geology, Metal, and Ceramic. As the hanging was not completed until after this was printed, the numbers did not always tally.

Although many reviewers were affronted by the arrangement and selection of predominantly non-art imagery, accusing the organizers of 'obfuscation' and 'esotericism', Bryan Robertson began his endorsement of the show by declaring, 'This beautiful and rewarding exhibition ... should be seen by everyone.'[68] He continued:

The enthusiasm of the organisers has given the exhibition a freshness and air of discovery which entirely surmounts the possible dangers of pigeon-holing or providing specious arguments or comparisons. There are, indeed, no arguments at all. The exhibition is presented in the most dispassionate manner.... Further, that the artist, the scientist and the technician are continually unearthing aspects of life and art, which relate to each other and are discovered sometimes simultaneously and sometimes at separate intervals.... The exhibition also leaves the spectator with the feeling that the barriers between the artist, the scientist and the technician are dissolving in a singularly potent way.... Its value is very great.

Tom Hopkinson shared Robertson's enthusiasm:

A dismembered typewriter and primitive alphabet; a ploughed-up airfield and locomotive; an enlarged engraving of a sea-urchin and a wide-angle photograph of sky-scrapers: the apparent correspondence between such disparates acts as a powerful stimulant to the imagination, arousing a sense of mystery and bewilderment, as if one had stumbled upon a set of basic patterns for the universe.... The five compilers ... have achieved between them a genuinely original exhibition. It is one which will appeal particularly to art students and designers and which proves – to judge from published comments – disturbing and even repulsive to my fellow-journalists.[69]

As Robertson rightly noted, there were no 'arguments' as such underpinning the selection of material or informing its arrangement, but rather the sense that exhibits were on display like specimens or artefacts to be examined, assessed and catalogued; an impression induced by images that clearly originated from a laboratory environment and enhanced by panels which protruded from the walls to be viewed from above like objects in a museum vitrine. Indeed, this intended aura of objectivity was clearly indicated in the exhibition's press release:

In this exhibition an encyclopaedic range of material from past and present is brought together through the medium of the camera which is used as recorder, reporter, and scientific investigator. As recorder of nature objects, works of art, architecture and technics; as reporter of human events the images of which sometimes come to have a power of expression and plastic organization analogous to the symbol in art; and as scientific investigator extending the visual scale and range, by use of enlargements, X-rays, wide angle lens, high speed and aerial photography.[70]

As the press release stated, the images on display would highlight the potential and role of the camera as a tool, but what it did not state was the criteria by which this

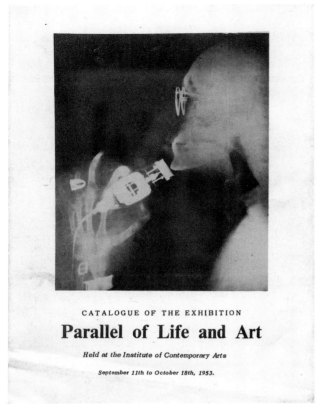

CATALOGUE OF THE EXHIBITION

Parallel of Life and Art

Held at the Institute of Contemporary Arts

September 11th to October 18th, 1953.

Front cover of the catalogue.

material had been selected. For, although the press release included a disclaimer of any unifying principle ('There is no single simple aim in this procedure. No watertight scientific or philosophical system is demonstrated'), it is clear from some of the exhibition's working documents belonging to Peter Smithson and Nigel Henderson that some fairly substantial ideas were worked through before the exhibition came to be realized in its final form. As an early proposal suggests, the Smithsons for their part initially envisaged an exhibition that would draw on the conventional disciplines with which each member of the group was associated, but which, combined, would mark out the ground for a new cross-discipline aesthetic. With great gusto they declared: 'The first great creative period of modern architecture finished in 1929 and work subsequent to this can be regarded as exploratory work for the second great creative period beginning now.... The second great creative period should be proclaimed by an exhibition in which the juxtaposition of phenomenon from our various fields would make obvious the existence of a new attitude.'[71] A subsequent statement, submitted as a working proposal to the ICA

Exhibitions Committee in 1952 under the title 'Documents 53', reveals, however, a shift in approach and a new focus on the relationship forged by the camera between the arts and the sciences:

The purpose of this exhibition is to present material belonging intimately to the background of anyone trying to look at things today. Much of it has been so completely taken for granted as to have sunk beneath the threshold of conscious perception. We feel a need to revalue these visual components of our contemporary way of thinking…. The exhibition will provide the first atlas to a new world, by which the discoveries of the sciences and the arts can be seen as aspects of the same whole. Related phenomenon, parts of the New Landscape which experimental science has revealed and artists and theorists created. The method used … will present a dramatic yet rational picture of the times, a kind of Rosetta stone.[72]

By March 1953, the articulation of this 'New Landscape' (a term lifted from Gyorgy Kepes's *Language of Vision* [1944]), had become noticeably more explicit, firmly placing photography and its processes at the very heart of the exhibition's concerns. As a memorandum distributed to the Exhibitions Committee on the show indicates, Henderson's own particular interests and knowledge of science and photography, and his applied reading of Kepes and Moholy-Nagy, had progressively gained ground and sympathy with his friends:

Technical inventions such as the photographic enlarger, aerial photography, and the high speed flash have given us new tools with which to expand our field of vision beyond the limits imposed on previous generations. Their products feed our newspapers, our periodicals, and our films, being continually before our eyes…. Today the painter may find beneath the microscope a visual world that excites his senses far more than does the ordinary world of streets, trees and faces.[73]

This is not to suggest, however, that the exhibition merely reflected Henderson's interests and influence, for as he himself was the first to assert, the exhibition was the result of a collaborative effort and as such followed an organic process. Indeed, Henderson specifically addressed these points in his opening comments at a panel discussion about the show at the Architectural Association in London on 2 December 1953. Organized to coincide with the exhibition being hung in the Association's galleries for the brief period of four days, Henderson's address to the audience from a prepared script talked them through the various stages by which this exhibition came into being:

There are ten ways, say the Chinese academicians, of depicting a mountain: by drawing wrinkles like the slashes of a large axe, or wrinkles like hair on a cow's hide; by brushstrokes wrinkled like a heap of firewood, or like the veins of lotus leaves. The rest are to be wrinkled like the folds of a belt, or the twists of a rope; or like raindrops, or like convoluted clouds etc.
Cited by Leo STEINBERG, The eye is part of the Mind.

Who shall criticise the builders? Certainly not those who have stood idly by without lifting a stone.
E. T. BELL, The Queen of Sciences.

One must be willing to dream and one must know how.
BAUDELAIRE

ARCHITECTURE

2

15. l'Arme de Salut, le Corbusier.
16. " " "
17. UNO Building. "Built in USA" MMA publication.
18. Temple of Neptune, Paestum.
19. Ilots d'Habitations particulieres Pompei. Gromert.
20. Erbil, ancient Assyrian city over 4,000 years old (air view). Aerofilms copyright.
21. Skyscrapers. Wide angle lens photo. George Strock, Life Magazine.
22. Detail, Mask of Quetzalcoatl. British Museum.
23. Dublin bus garage, Ove Arrup & partners. Irish Times.
24. Eskimo settlement at King Island, Alaska. National Geographic Magazine.
25. Macchu Picchu, Peruvian Andes. American Vogue.
26. Sun worshippers temple. Cassells Book of Knowledge Vol. 2.
27. Different types of vegetable cellular tissue. Thornton's Book of Vegetable Anatomy.

ART

28. Etruscan funerary vase.
29. Excavated figure, Pompei. F. Romano, Naples.
30. Tribal tattooing of Eskimo bride. "The Book of the North" 1922, Leipzig.
31. Minahassa ideographic script. "The Alphabet" David Diringer, Hutchinson's Scientific and Technical publications.
32. Funeral of the late King George VI. Newspaper image.
33. Corps de dame, B. Dubuffet, 1950. Collection of A. Ossorio.
34. Disintegrating mirror (contact print). Collection N. Henderson.
35. Painting, Burri. Arte Estive, 1953.
36. Jackson Pollack in studio. Hans Namuth, America.
37. Porous whalebone mask of a man's head. Vicinity of Point Hope, Alaska. Stanford University Press, California "Native Arts of the Pacific North West".
38. Racing cyclists crash (news photo) Keystone Press.
39. Radiograph of a cat batting a ball. Dr. Slack and L. F. Erhke, Westinghouse Electric Corporation, Lamp Division, Research Department, USA.

95

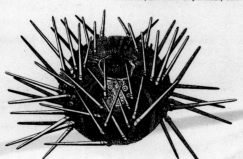

72

CALLIGRAPHY

40. Figures of men, animals, animated objects, and symbols from California, Arizona and the Bahamas. "The Alphabet", David Diringer. Hutchinson's Scientific and Technical publications.
41. Paul Klee, 1909, Verlassenen Garten. Pen Drawing.
42. Japanese writing.
43. Column of contemporary Japanese type. The Kenchiku-Bunka.
44. Patterns in mud, Grimsby (air view). Aerofilms copyright.
45. Proteus (stained). Micro-photo X1250. Mr. Smiles, Optics Section, Medical Research Council.
46. Iron nickel chromium alloy (Electron micro-photo). Courtesy of the Director, National Physical Laboratory, Teddington. Crown Copyright.
47. Ploughed up air-field (air view). Imperial War Museum. Crown Copyright.

Pages from the catalogue.

Photograph of a human head carved in whalebone, included in the exhibition.

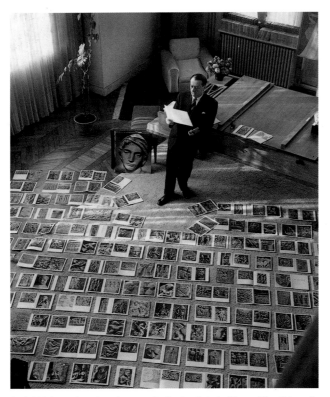

André Malraux choosing photographs for *Les Voix du Silence* (*The Voices of Silence*), *c.* 1950. Photograph by Maurice Jarnoux for *Paris Match*.

We had for sometime been interested in exchanging images from our own private 'imaginary museums'. You will remember that this is the way in which André Malraux discusses the assemblage of photographic material in printed form, gathered together from many points scattered in space and time, and representing the creative work of artists of all ages and civilizations. In our own case, however, the contents of these museums extended beyond the normal terms of art, to include photographs produced for technical purposes…. We often found that this exchange resulted in confirmation of our beliefs that we had happened upon something significant, that others too responded in the same way to the visual impact of a particular image. Up to a point, that is, we found that we had a common working aesthetic, although we could none of us formulate a verbal basis for it. Eventually we decided to pool the material we already had and to continue to collect more in an attempt to elucidate what we had in common and the nature of the material moving us. At this point certain groupings began to declare themselves … these terms … then began to play back on our selection and condition the choice of further images.[74]

The reference to Malraux was not a light one. In 1947, the year that Henderson visited Paolozzi in Paris, Malraux had published his essay 'Le Musée Imaginaire', subsequently reprinted in 1951 in *Les Voix du Silence*. In this essay, Malraux had described the confining strictures that the public museum had historically placed on the category of art. As Malraux noted, definitions of art were continually being formed on the basis of what was on display in the museum, but 'Of what is it necessarily deprived? Of all that forms an integral part of a whole (stained glass, frescoes); of all that cannot be moved; of all that is difficult to display (sets of tapestries); of all that the collection is unable to acquire.'[75] Moreover, the concentrated nature of inquisition and comparative analysis which the museum had fostered in the name of connoisseurship had resulted in 'a more intellectualized' approach to art, rather than a felt response. For Malraux, photography and the possibilities of mass reproduction presented an opportunity to retrieve the concept of art from the museum and to redefine it in relation to a wealth of new images, objects and cultures generally excluded: 'Nowadays an art student can examine colour reproductions of most of the world's great paintings, can make acquaintance with a host of second-rank pictures, archaic arts, Indian, Chinese and Pre-Columbian sculpture of the best periods, Romanesque frescoes, Negro and "folk art", a fair quantity of Byzantine art.'[76] In concluding his introduction, he announced: 'For a "Museum Without Walls" is coming into being, and

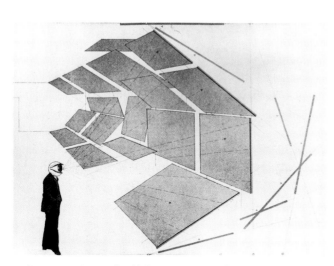

Herbert Bayer, *Diagram of Field of Vision*, catalogue of 'Deutscher Werkbund' section of 'Exposition de la Société des Artistes Décorateurs', Paris, 1930.

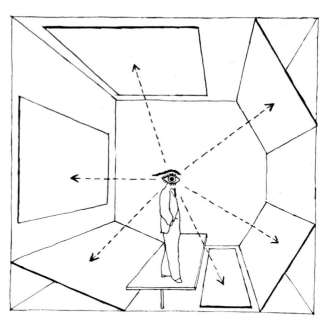

Herbert Bayer, *Diagram of 360° Field of Vision*, 1935.

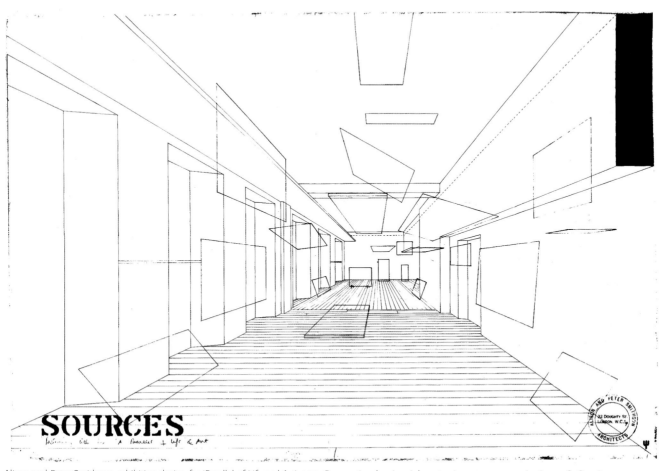

SOURCES

Alison and Peter Smithson, exhibition design for 'Parallel of Life and Art', 1953. Perspective drawing, ink on tracing paper, 22 x 33 in. (55.9 x 83.8 cm). Collection Alison and Peter Smithson.

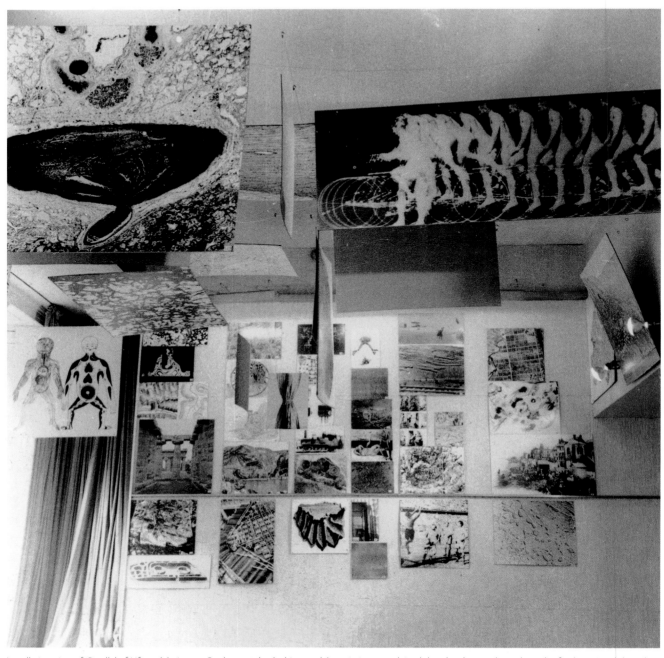

Installation view of 'Parallel of Life and Art', 1953. Students at the Architectural Association complained that the show embraced a 'cult of ugliness' and denied 'the spiritual in Man'.

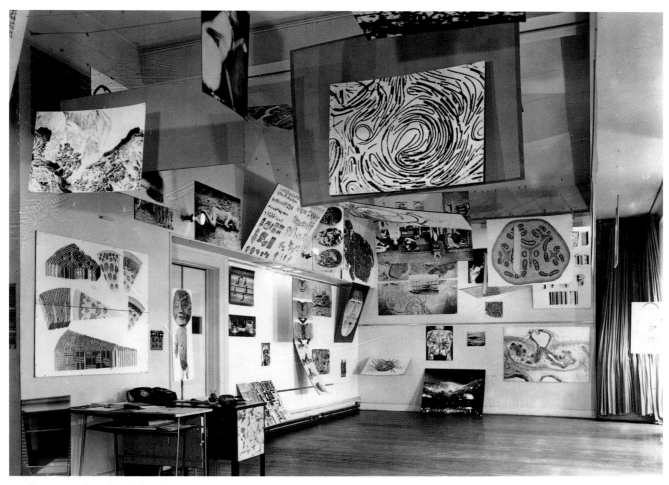

Installation view of 'Parallel of Life and Art', 1953.

(now that the plastic arts have invented their own printing press) it will carry infinitely farther that revelation of the world of art, limited perforce, which the "real" museums offer us within their walls.'[77]

For Henderson and Paolozzi, who had spent much of their student days visiting ethnographic and scientific collections in Paris and London, Malraux's essay vindicated their interest in objects and artefacts beyond the confines of traditional Western art and the teaching of the Slade. The extent to which they revered and embraced Malraux's ideas was perhaps best demonstrated by the fact that they invited him to open 'Parallel of Life and Art'. But whereas Malraux continued to write in his essay about the negative impact of photography on the perception and understanding of objects previously excluded from the canon of art – on account of its capacity to decontextualize and its propensity to reduce differences and exaggerate formal similarities between disparate objects – Henderson and

his collaborators looked upon these characteristics as positive attributes of the photographic medium. Indeed, the formal levelling of imagery, the dissolution of difference, and the misleading sense of scale which the photographic medium effected were the very reason why the group chose to reproduce all their source material photographically. It is perhaps also worth noting that, in photographing all these images for reproduction on to panels, Henderson employed the use of the plate camera which, for him particularly, enacted a sense of clinical detachment – as he described by drawing a comparison between it and his wartime duties: 'You get your head under the essential cloth and rack away at the bellows extension probing into the visual meat of what's before you. More like dive-bombing really.'

Formal analogies between disparate things were, however, not the exclusive, nor even the primary, concern of the exhibition, despite the fact that such a reading of the imagery seemed to be encouraged by its

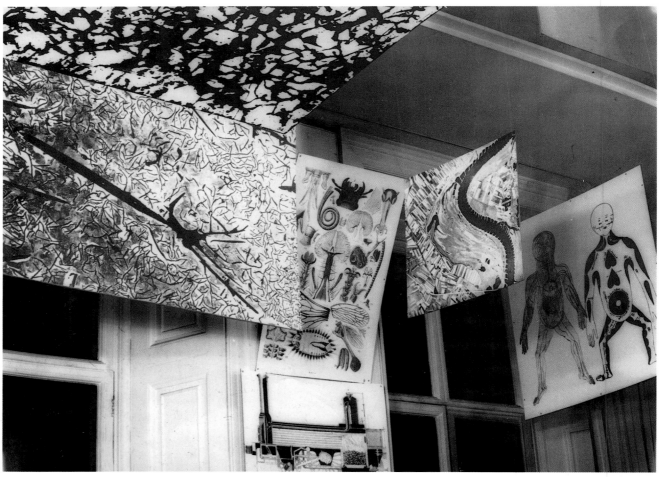

Installation view of 'Parallel of Life and Art', 1953.

title. As Henderson went on to explain to the audience at the Architectural Association:

I would like to say quite frankly that I now consider the title of the exhibition to be unfortunate; because it refers to only one of the ideas latent in our selection of material, and may give the quite false impression that we set out to make an exhibition specifically to illustrate a simple theme…. In fact, we have, as a principle almost, proceeded empirically at each stage of our decisions, both as to what we should include and how we should present it.[78]

Some striking visual analogies, or 'graphic equivalents' as Henderson chose to describe them, were of course displayed, such as the seemingly random markings of a guillemot egg with the drip painting of Jackson Pollock, or an image of torn knitting with a cross-section of a plant stem. But this kind of overt visual correspondence between a man-made and a natural object represented only one of five types

of parallels between images which the group found emerging in their selection of material. Under the title 'Ideas latent in the exhibition', Henderson's script for the evening at the Architectural Association lists the five types. One type was readily discerned in images which were dependent on the 'specific visual possibilities opened up by photographic techniques', such as X-rays, high-speed photographs, photomicrographs and photograms; hence the cover image of the guide was an X-ray of a man shaving (lifted from Moholy-Nagy's *Vision in Motion*). In stark contrast to these images drawn from specialist sources, another type was defined by the news photo in the public domain, the 'common throw-away image' or 'objet trouvé' of the modern world as Henderson saw it. These images, according to Henderson, 'may yet be of an overwhelming beauty, sometimes this is intrinsic in the organisation of the picture, sometimes in the ambiguous nature of a bad print', as in the chance moment captured on camera

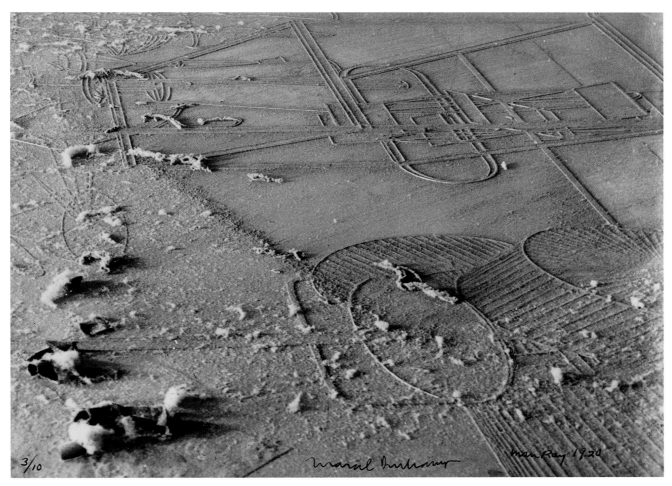

Marcel Duchamp, *Dust Breeding*, 1920. Photograph by Man Ray. From *The Bride Stripped Bare by Her Bachelors, Even (The Green Box)*, 1934. Philadelphia Museum of Art. Archives of the Louise and Walter Arensberg Collection.

of schoolgirls in uniform inhabiting unlikely positions in mid-air during a gym class.

Distortion by means of scale perhaps produced one of the most visually teasing sets of images in the exhibition, as more often than not it was impossible to perceive what the original source image was, but very easy to imagine by association something inherently different; for example, coffee grains could be easily misread as cells under a microscope. Although distortion of an object through the manipulation of scale, the confusion of the macro with the micro, was a recurring subject in many contemporary source books and indeed in Henderson's own work, as has been seen, it seems quite possible that this particular category might have originated from an image to be found in the Duchamp *Green Box* that Henderson owned, a gift from Peggy Guggenheim in the late 1930s, since among the items in the box is a photograph by Man Ray which at first sight appears like an aerial view of rough, rocky terrain,

partially cultivated by agriculture and a network of industrial roads, but which is in fact a photograph of 'dust breeding' taken in 1920. This view is perhaps also reinforced by the fact that at one point in his script Henderson refers to the exhibition as a 'Small Portable Museum'. Whatever Henderson's regrets over the title of the show, combined, the panels invariably lived up to the show's subtitle: 'Indications of a new Visual Order'.

Surprisingly, what is now one of the most oft-discussed aspects of the exhibition was not mentioned by Henderson during the course of his presentation at the Architectural Association: the installation. This could be accounted for by the fact that, as Henderson told Dorothy Morland in 1976, substantial practical issues had to be taken into consideration when the exhibition was hung:

We were probably hanging the material for about two or three days, and were trying to get it into a kind of spider's web above

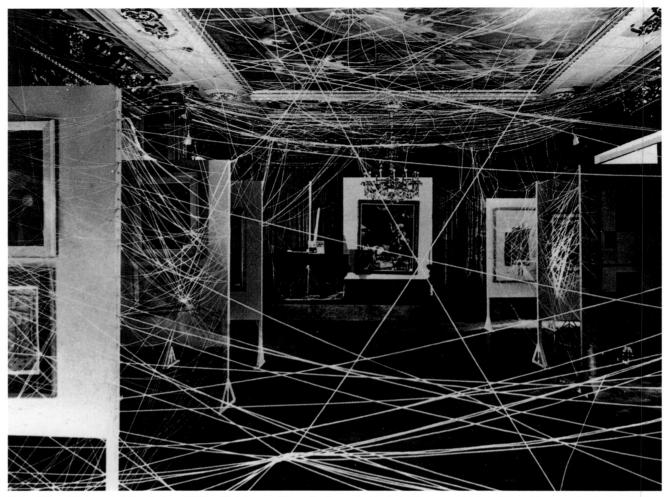

Sixteen Miles of String. Installation for the exhibition 'First Papers of Surrealism' organized by André Breton and 'his twine' Marcel Duchamp for the Coordinating Council of French Relief Societies, New York, 1942.

the heads of people, because the room had to be used for lectures during the exhibition; by the time we'd strung up an awful lot of wire and hooks and got out of line and back into line and so on, we'd built up a pretty good nervous tension which continued right up to the point when we decided that this was all we could do and we had to face the comments.[79]

Moreover, there were clearly some strong precedents in the design of exhibitions at the ICA which equally disrupted notions of the conventional hang on the line, and equally embraced a wide range of media and imagery beyond the usual genres of painting and sculpture. In 1951, the exhibition 'Growth and Form' had taken place, as previously discussed, and earlier in 1953, in March, the exhibition 'Wonder and Horror of the Human Head' had attracted a great deal of comment regarding its multifarious range of imagery and installation design.

This exhibition, which comprised more than two hundred works, brought together an exceptionally diverse range of objects and images from the Palaeolithic period to the twentieth century, such as a Mexican onyx mask from the 5th century AD, an emblem of the Sun Fire Insurance company, a mosaic from Ravenna, an Ashanti fertility charm, funerary statuettes from Papua New Guinea, all interspersed among works from the history of art by Bosch, Arcimboldo, Rubens, Géricault, Redon, and contemporary works by Max Beerbohm, Giorgio de Chirico, Alberto Giacometti, Max Ernst, Paul Klee, Joan Miró, Man Ray, Henry Moore, Reg Butler, George Melly and Nigel Henderson, among many others. Assembled by Roland Penrose 'and presented to the public in the hope that it may stimulate poetic reflexion upon our human condition', as he wrote in the catalogue, the exhibition was largely dependent on photographs of works rather than the works themselves, which it would have

been impossible either to borrow or to display. Instead, the emphasis was on the 'image' value of the works rather than on their physical presence. But, as the *Architectural Review* noted, the design of the exhibition was critical to its success and in this respect, 'A word must be said in praise of Mr. Richard Hamilton's skilful display of extremely heterogeneous material: the pictures and painted objects at his disposal were used in masterly fashion to break up the battleship grey of massed photographs.'[80]

Hamilton's adept handling of photographic material within the exhibition space generated both from his practical experience of exhibition design for trade events and from his familiarity with the work of notable predecessors in this art, El Lissitzky and Herbert Bayer. The exhibition design work of both these figures could be found in Alexander Dorner's *The Way Beyond Art: The Work of Herbert Bayer*, which was published in 1947 to promote the commercial design work of Bayer and revealed the various radical solutions which Bayer came up with when addressing the problem of displaying large-scale photomontage and graphic work.[81] Hamilton's enthusiasm for Bayer's installation techniques clearly filtered through to his contemporaries at the ICA and the impact of Bayer's designs is readily discernible if one compares 'Parallel of Life and Art' with such Bayer installations as the 'Deutscher Werkbund' section of the Exposition de la Société des Artistes Décorateurs in Paris in 1930 (conceived with Marcel Breuer, Walter Gropius and László Moholy-Nagy), the 'Road to Victory' exhibition or the 'Airways to Peace' exhibition, both held at the Museum of Modern Art in New York in 1942 and 1943 respectively.[82] While the impact of Duchamp's installations on Bayer is well acknowledged, it should also be taken into account in the thinking behind 'Parallel of Life and Art', given the likelihood that Henderson saw the remarkable *Twelve Hundred Coal Bags Suspended from the Ceiling over a Stove* which dominated the International Exhibition of Surrealism at the Galerie des Beaux-Arts in Paris in January 1938. Henderson, as much as his contemporaries, would also have been familiar with the now infamous Duchampian environment of *Sixteen Miles of String* (New York, 1942) and, given its timing, the layout of the show 'Dada/1916–1923', which took place at the Sidney Janis Gallery in New York from April to May 1953 and exploited the use of all available wall and ceiling space.

Apart from these more obvious precedents, others have come to light in the course of conversations with Peter Smithson which indicate that the thinking through

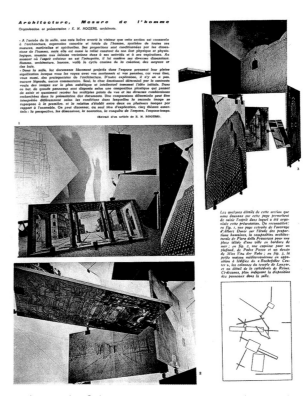

Tearsheet (unidentified source) on Ernesto Rogers's contribution to the Milan Triennale of 1951. Collection Alison and Peter Smithson.

of the installation of 'Parallel of Life and Art' was not quite as arbitrary or as practical as the organizers liked to suggest at the time. For within the archive files of the Smithsons is to be found a tearsheet from a French periodical regarding a contemporary installation by the Italian architect Ernesto Rogers which was created for the Architecture Triennale in Milan in 1951 and of which the particular theme was 'Architecture in movement'. The installation consisted of large photographic panels which, while directly related to architecture, were collected from an extensive period of history and included a Dürer diagram regarding the proportions of the human body, a painting by Piero della Francesca, a study for a building by Mies van der Rohe, a detail of Reims cathedral, a New York skyscraper and a photograph of the columns of a temple at Luxor. The panels were suspended from the ceiling at dramatically cutting angles to one another and similarly propped up against each other on the floor, forcing the visitor to physically negotiate the space in order to view the works. While Rogers's installation attracted considerable attention and positive reviews in the English architecture press, the special value of the tearsheet belonging to the Smithsons is an extract of writing by Rogers:

Charles and Ray Eames, *House of Cards Picture Deck*, 1952.

Dans la salle, les documents librement projetés dans l'espace prennent leur pleine signification lorsque vous les voyez avec vos sentiments et vos pensées, car vous êtes, vous aussi, des protagonistes de l'architecture. D'autre explication, il n'y en a pas, aucune légende, aucun commentaire. Seul, le choc émotionnel déterminé par le contraste voulu des images sur le plan esthétique et intellectuel transmet l'idée initiale. Dans ce but, de grands panneaux sont disposés selon une composition plastique qui permet de saisir et quasiment recréer les multiples points de vue et les diverses combinaisons recherchées dans la présentation des documents. Une comparaison déterminée peut être interprétée différemment selon les conditions dans lesquelles la seconde image se superpose à la première, et la relation s'établit entre deux ou plusieurs images par rapport à l'ensemble. On peut discerner, au seul titre d'explication, cinq thèmes essentiels: la perspective, les dimensions, la sensation, la conquête de l'espace, l'espace-temps.

[In the hall, the photographs that are freely scattered around the space take on their full significance when you see them with your feelings and your mind, because you, too, are protagonists of the architecture. There is no other explanation at all, no caption, no commentary. But the emotional shock brought about by the deliberate contrast between the images on the aesthetic and intellectual plane conveys the initial impression. To this end, large panels are so arranged as to allow the multiple angles of view and the various combinations intended in the presentation of the photographs to be understood and, as it were, re-created. A comparison that may already have been established can be interpreted differently, depending on the conditions under which the second image is superimposed on

the first and in which the affinity between two or more images develops in relation to the whole. All that can be made out by way of explanation are five essential themes: perspective, dimensions, sensation, conquest of space, and space-time.]

Like the photograph of the unframed Piero della Francesca propped up on the floor enticing the viewer to enter into its enhanced illusionistic space, Peter Smithson also recalls being particularly taken by an exhibition in Venice in 1949 of unframed original works by Giovanni Bellini. Designed by the Italian architect Carlo Scarpa, Smithson recalls being struck by the immediacy of his response at the sight of the works which, displayed as freestanding objects, were exposed to scrutiny from both front and back. Another reference point for the Smithsons was possibly Charles and Ray Eames's *House of Cards*, created in 1952, which, like the Rogers installation, also played upon the individual's sense of curiosity and surprise being provoked by unexpected couplings and encounters – although it should be noted that the Smithsons did not meet the Eamses until 1958 and only began playing with the *House of Cards* in the 1960s.

The emphasis in all these installations was evidently upon the power of the 'image' rather than the object and perhaps one of the most significant occasions for the group which embodied this emerging sensibility among artists and architects alike was Paolozzi's epidiascope show which he put on for a select audience at the ICA in April 1952, and which has historically been identified as one of the inaugural moments of the Independent Group. Culled together from his scrapbooks of magazine tearsheets, postcards, cigarette-packet covers, newspaper photos, book plates and much besides, Paolozzi placed the images one after the other in the epidiascope, to the amusement and consternation of his audience, as Henderson recalled:

Banham was very vociferous…. I thought it was largely because the visual wasn't introduced and argued (in a linear way) but shovelled, shrivelling in this white hot maw of the epidiascope. The main sound accompaniment that I remember was the heavy breathing and painful sighing of Paolozzi to whom, I imagine, the lateral nature of connectedness of the images seemed self-evident, but the lack of agreement in the air must have been antagonistic and at least viscous.[83]

Significantly, it was not so much the nature of the material that Paolozzi chose to project that seemed offensive, but the random organization of its presentation.

Installation view of 'Parallel of Life and Art', 1953, with Justin Henderson. The image above the entrance door would be later incorporated into a floor collage for the installation 'Patio & Pavilion', 1956.

Installation view of 'Parallel of Life and Art', 1953. The exhibition was hung to form 'a poetic-lyrical order where images create a series of cross-relationships'.

But in adopting this collage-style aesthetic, Paolozzi was quite clearly responding to the kinds of image organization that he had encountered with Henderson in such topical books as Sigfried Giedion's *Mechanization Takes Command* (1948), Amédée Ozenfant's *Foundations of Modern Art* (1928, but translated by John Rodker in 1952) and the ever-present *Vision in Motion* by Moholy-Nagy. It is perhaps also worth noting that such seemingly random ordering of material would also have not been so unfamiliar to Paolozzi's eye, whose own family's shop window in Edinburgh would have similarly displayed such a mixed arrangement of imagery in the form of magazine covers, advertisements, ice-cream signs and so on.

What all the exhibition designs cited above had in common was a radical rethinking of the role of the spectator and of the public's relation to both the work and the exhibition space. Whereas convention had generally allocated the spectator a passive and reflective role determined by a fixed position in front of the work which was hung 'on the line', these exhibitions not only encouraged but demanded the active and imaginative participation of the viewer. That the notion of an active viewer inherently underpinned these exhibitions can be best seen in the design drawings of Bayer and Rogers, which bear a striking resemblance to the Smithsons' design for 'Parallel of Life and Art' in the drawn figure of the viewer and the various lines of vision available from any one position within the fractured exhibition space: a true manifestation of Moholy-Nagy's notion of 'vision in motion' and 'space-time'. In addition, gone were the empirical supports of captions or labels and, more often than not, the descriptive or guiding words of the catalogue or handlist, leaving the onus firmly on the viewers to 'experience' the works or images as they encountered them. In all these respects, 'Parallel of Life and Art' embraced the changes in approach. As Toni del Renzio observed in an account of the ICA exhibition, 'The

structure of pattern common to different abstractions at different scales is here put to the test of comprehension; but the spectator has to participate, has to order for himself these abstractions, to manipulate these signs.'

In concluding his presentation to the Architectural Association, Henderson, however, stressed the perceptual experience of the images on display over and above an intellectual engagement with them:

To end, I may have given a rather deliberately vague and informal approach to the exhibition. It is true that we looked at the material to reveal its own principles of selection – that we ourselves were concerned first of all with the subjective impression, the impact upon our senses rather than upon our intellects. This may explain our un-digestive attitude to the whole thing, and our appreciation of the need of the active participation of the spectators. We should like to bring about a situation in which people felt like undergoing a strong visual experience, without too much reliance on intellectual handrails for their support. And we value the fact that their experience will necessarily differ from our own, being ground in a different soil. It might be truer of this exhibition than of many to say that you can get out of it exactly what you put into it.

This aversion to an overdetermined or intellectualized response to the exhibition's images was clearly pointed to by the concluding and isolated statement of the press release which, having described the arrangement of the images on display, stated: 'In short it forms a poetic-lyrical order where images create a series of cross-relationships.' The attribution of the qualities of poetry to a collection of images of which so few were aesthetic in origin may seem tendentious in trying to invite such a reading, but a clue to this claim, or aspiration, can be found in the inclusion of two images by Paul Klee, an artist much admired and revered by both Henderson and Paolozzi, and in references in Henderson's Architectural Association script to the 'multi-evocative image'.

For the 'multi-evocative image' was, by Henderson's own admission, derived from the concept of 'multi-evocative sign', a term specifically conceived by the art critic and shared friend of his and Paolozzi, David Sylvester. Duly summarizing Sylvester's concept of the multi-evocative sign, Henderson noted in a manuscript from this time that 'it stood for a punchy visual matrix that triggered off a number of associational ideas'. Most potently applied by Sylvester to the work of Paul Klee in an essay published in 1951 in *Les Temps Modernes*, his discussion of Klee's abandonment of a single focal point in favour of an all-over treatment culminated in a series of statements regarding Klee's use of the 'multi-

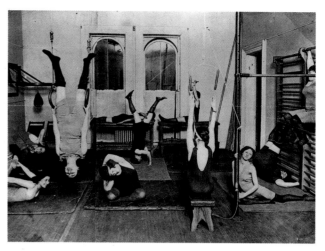

Photograph included in the exhibition.

evocative sign'. These statements are quite striking when considered in relation to many of the scientific and enlarged images found in 'Parallel of Life and Art', both independently and in juxtaposition with others, which equally hold no focal or comprehensible reference point:

… he was also unsurpassed in the creation of signs with multiple significations, that is, signs which signify two or more species of objects by abstracting and exhibiting their common features…. No other artist has used the multi-evocative sign … to establish associations so unconventional and unexpected or to make his associations appear so inevitable…. So it must surely have been because he was less concerned with the objects that man experiences than with the process of experiencing them that … Klee juxtaposed signs for a variety of objects which could never be juxtaposed within the field of vision but could certainly be met in the course of a few hours in a normal day. The function in this system of the multi-evocative signs is to draw attention to resemblances between diverse objects … while that of the primordial signs is to reveal elements common to a wide range of experiences, just as in life we seek to generalize from particular events as to the nature of existence … it may well be that Klee intended to depict the dream-world or memory where the identity of objects is uncertain and things are frequently transformed into other things….[84]

Importantly, in an earlier essay on Klee (published in 1948 in the avant-garde New York review, *Tiger's Eye* and presented as part of a series of papers gathered under the heading 'What is Sublime in Art?'), Sylvester observed that the artist's affinities lay with 'Mexican picture-writing, Egyptian hieroglyphics, Sumerian cuneiform signs, Chinese ideograms and German Gothic illumination', generic examples of which could be found

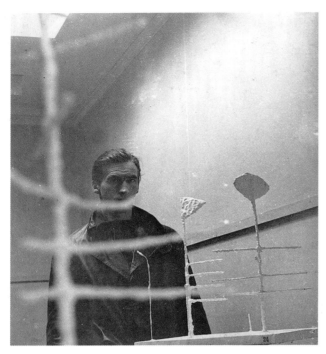

William Turnbull at the Hanover Gallery, 1950.

in 'Parallel of Life and Art'. Furthermore, in this essay, Sylvester elegantly unravels the journey to be taken by the spectator to reach an aesthetic appreciation and understanding of Klee's late work, reiterating throughout the special relation between the absence of any focal point in the work and the committed involvement of the spectator: 'To find an overall order, you must look for it yourself by taking hints from the given sensation. It is useless to wait for the order to affect you. You must commune with the picture and its order will become manifest – not in space but in space-time.' Although in neither of these essays did Sylvester adopt the term 'afocal' to describe the all-over nature of an image's construction, he did refer to this emerging aesthetic in relation to the sculpture of both Paolozzi and Turnbull in the catalogue which accompanied their joint exhibition at the Hanover Gallery in London in 1950.

Such a tacit understanding as was required of the selection of the imagery and installation of 'Parallel of Life and Art' was, however, not forthcoming from the students at the Architectural Association nor from some critics, who instead 'complained of the deliberate flouting of the traditional concepts of photographic beauty, of a cult of ugliness' and of 'denying the spiritual in Man', as Reyner Banham recorded two years later in his seminal article 'The New Brutalism' which appeared in the *Architectural Review*.[85] Now deemed a key moment

in the history of post-war British art and architecture, the impact and implications of Banham's article, particularly within the discourse of architectural theory, were further increased when he expanded the central thesis of his article into a book titled *The New Brutalism: Ethic or Aesthetic?*, published in 1966. In setting down the terms in 1955 by which the New Brutalism in art and architecture could be identified and understood, Banham homed in on 'Parallel of Life and Art' as one of the most visible manifestations of this revitalized aesthetic:

As a descriptive label it has two overlapping, but not identical, senses. Non-architecturally it describes the art of Dubuffet, some aspects of Jackson Pollock and of Appel, and the burlap paintings of Alberto Burri – among foreign artists – and say, Magda Cordell, Eduardo Paolozzi and Nigel Henderson among English artists. With the last two, the Smithsons collected and hung the I.C.A. exhibition Parallel of Life and Art, which, though it probably preceded the coining of the phrase, is nevertheless regarded as a locus classicus of the movement.

In the book of 1966, however, he went further in identifying the exact features of the photographic panels in the exhibition which had prompted its positioning within the controversial debate on Brutalist art and architecture, a debate partly defined and fuelled by the opening in 1954 of the Smithsons' new school building at Hunstanton in Norfolk, which had begun construction in 1952:

Many offered scenes of violence and destruction, distorted or anti-aesthetic views of the human figure, all had a coarse grainy texture which was clearly regarded by the collaborators as one of their main virtues. These coarse textures were obviously easy for superficial critics to relate to the exposed concrete and brick surfaces in Hunstanton, and thence to suppose that the other qualities of the exhibition were an intentional part of Hunstanton's architecture, which was damned as antihuman, repulsive and 'brutal' in the sense of sub-human.[86]

The catalyst for this reading and mapping backwards and forwards of an anti-aesthetic in the exhibition and Hunstanton was not so much the inclusion of scientific images of unpleasant conditions, such as cancerous cells, nor of oppressive imagery, such as a photograph of the funeral of King George VI, but rather those images which celebrated a primal, seemingly unmediated, form of expression which could be found in the drawings of children and madmen, the painting practice of Jackson Pollock (as caught by Hans Namuth) and the work of Jean Dubuffet, represented by his *Corps de dame* series of 1950. For what must be understood is the way in which

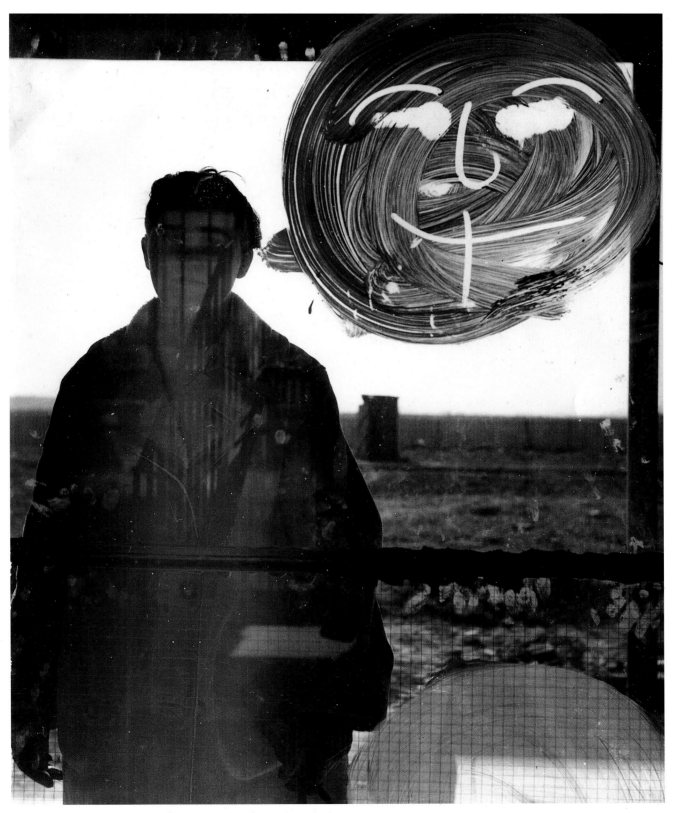

Alison Smithson on the building site of Hunstanton Secondary Modern School, *c.* 1953.

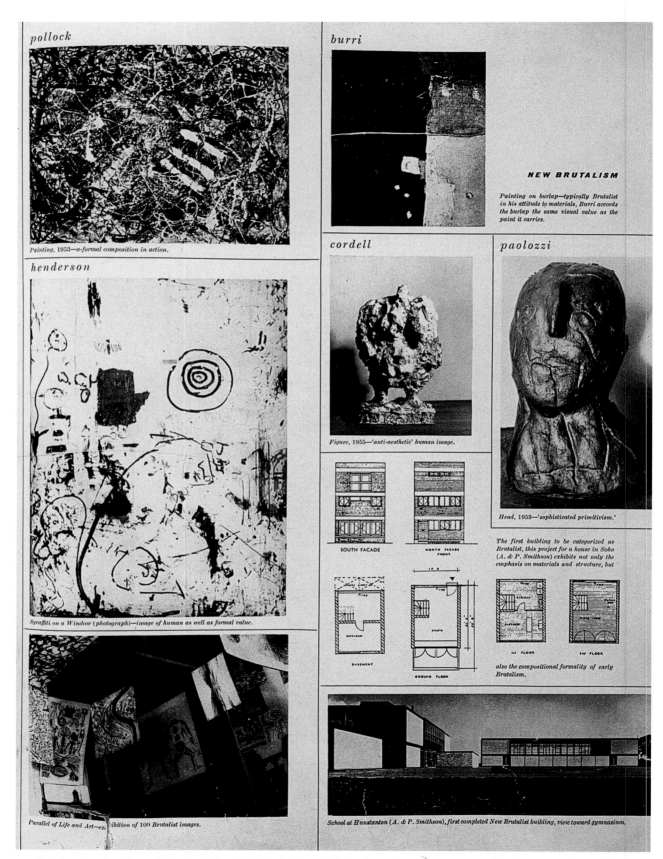

New Brutalism. Page from Reyner Banham's article published in *Architectural Review*, December 1955, illustrating parallels between Brutalism and the contemporary arts and incorporating Henderson's 'Sgraffiti on a Window'.

the work of Dubuffet and Pollock had been assimilated into a discursive framework which conflated the qualities of the raw treatment of an image and its oft-associated feature of afocalism (as Sylvester termed it) into a Brutalist anti-aesthetic. This can perhaps be succinctly seen in a review of the work of Renato Guttuso and Dubuffet in 1955, in which Robert Melville wrote:

The taste for violence is one of the most respected attributes of the modern painter, but recently, and especially in the work of the abstract expressionists, the very act of painting has become a violent, mindless exercise and the pictures that result from this activity are formless demonstrations of yearning to besmirch and deface.... Jean Dubuffet, too, is a brutalist and an adherent of the a-formal heresy.[87]

Moreover, a direct link between the work of Pollock and the Brutalist images of 'outsider art', as they were perceived, was forged in English minds when Pollock's work was first exhibited in England at the ICA in January 1953 as part of a show, 'Opposing Forces', which took its impetus and three of the artists directly from a show previously seen in Paris, 'Véhémences confrontées', which had been organized by Michel Tapié. Friend and champion of Dubuffet, Tapié was known in England primarily as the author of *Un Art Autre* (1952), which called for a radical overthrow of conventional forms and values in art. Significantly, among the artists included in this book was Paolozzi. For Banham, the opportunity to create a conceptual shorthand for the same phenomenon he identified in architecture as in the works of Tapié's *Un Art Autre* proved too good to resist, and hence he established the term 'Une Architecture Autre'.

One of the prevailing issues which Banham also turned his attention to in his analysis of 'Parallel of Life and Art' was the status given by its organizers to the 'image', of which Banham wrote in 1966: 'Henderson, an experimental photographer, is little known outside Britain though his influence on the other three was considerable and admitted by them (if, indeed it was he who had invented their special use of the word "image" then his influence was probably crucial).'[88] 'Image' was indeed a word that Henderson particularly applied to his photographic work and, as seen earlier, Alison Smithson enthusiastically accredited her friend with being 'the original image finder'. In this respect, it is not surprising that, among the layout of images on one of the article's pages which includes photographs of 'Parallel of Life and Art', Hunstanton School and works by Jackson Pollock, Alberto Burri, Magda Cordell and Eduardo

Paolozzi is a Henderson East End photograph of graffiti on a window with the accompanying annotation by Banham: 'Sgraffiti on a Window – image of human as well as formal value.' As Banham tried to grapple with various explanations of what defined this new 'image', he proposed the following critique:

Ultimately, however, it [the image] means something which is visually valuable, but not necessarily by the standards of classical aesthetics ... for the New Brutalists' interests in image are commonly regarded, by many of themselves as well as their critics, as being anti-art, or at any rate anti-beauty in the classical aesthetic sense of the word ... what moves a New Brutalist is the thing itself, in its totality, and with its overtones of human association.

How apposite this observation of Banham's was he could hardly have foreseen, but as the next collaboration between Henderson, Paolozzi and the Smithsons in 1956 would demonstrate, human association would form the bedrock of their thinking. Likewise, Banham's carefully surmised evaluation of New Brutalism could also be extended to this next collaboration: 'In the last resort what characterizes the New Brutalism in architecture as in painting is precisely its brutality, its *je m'en-foutisme*, its bloody-mindedness.'

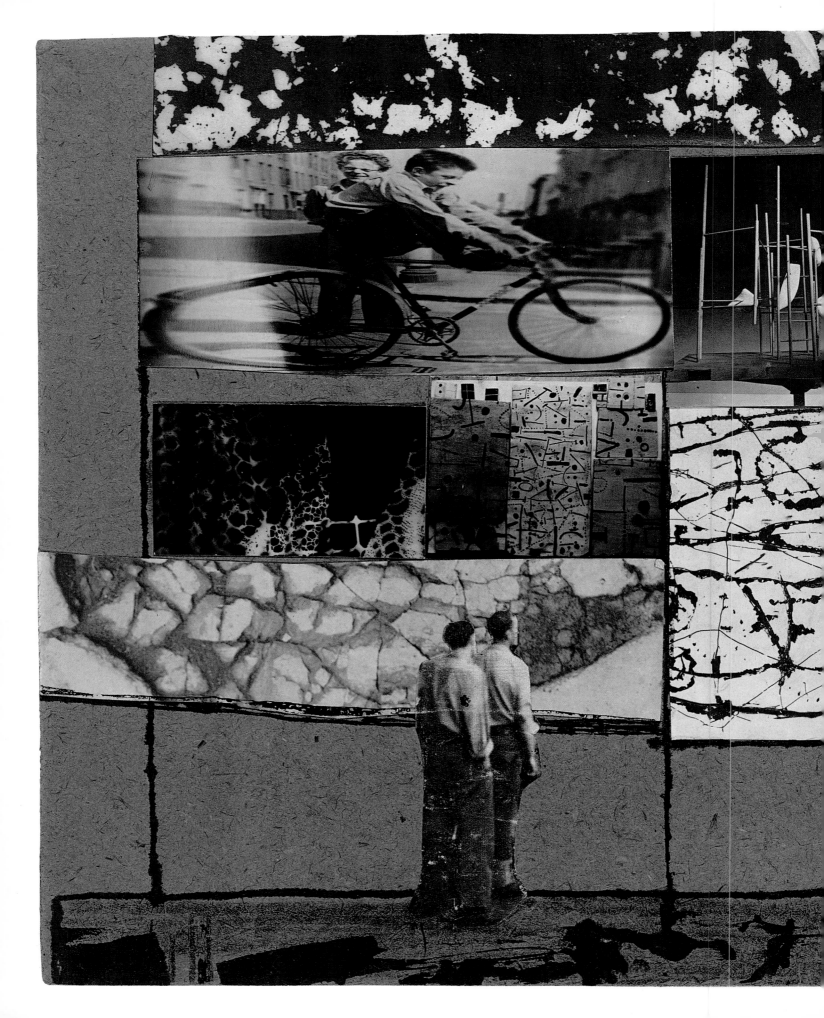

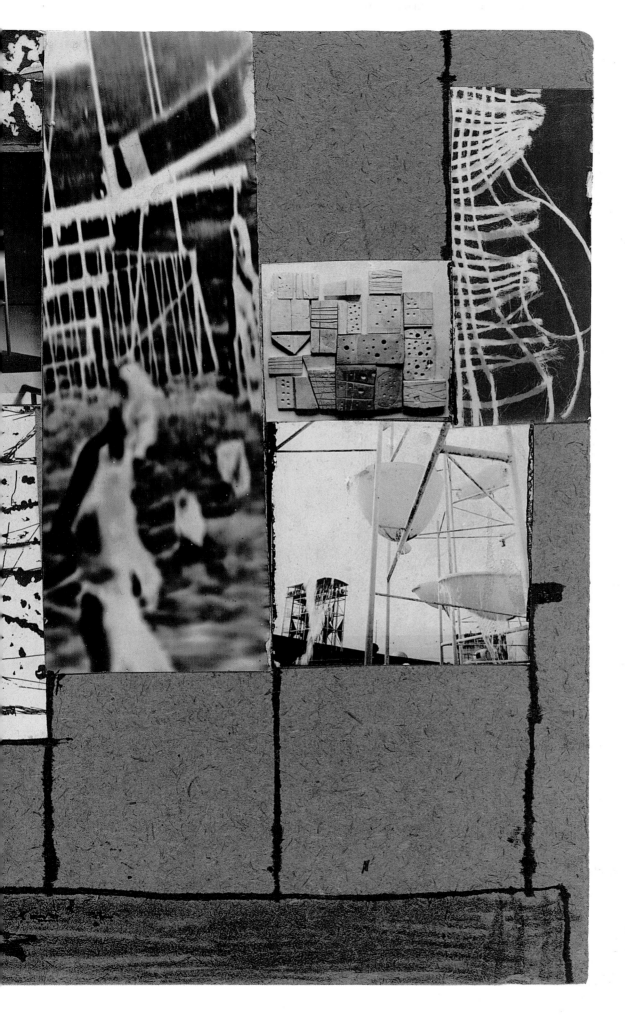

Nigel Henderson, Untitled
(study for 'Parallel of Life and Art'),
1952. Photographs, pen, pencil on
card, 8½ x 12 in. (21.6 x 30.5 cm).

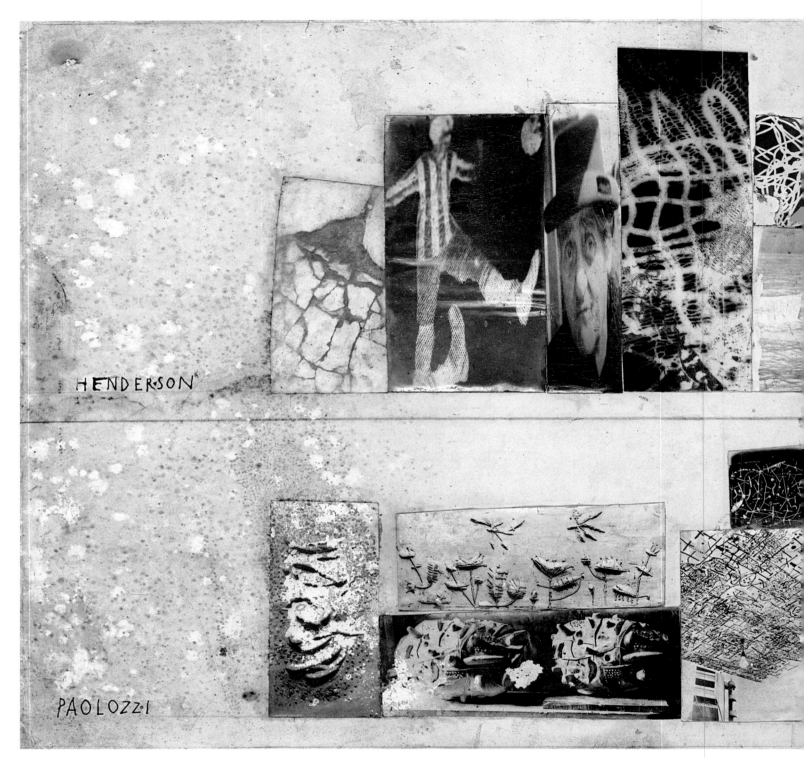

Nigel Henderson and Eduardo Paolozzi, Untitled (study for 'Parallel of Life and Art'), 1952. Photographs, pen, pencil on board, 14 x 30 in. (35.6 x 76.2 cm).

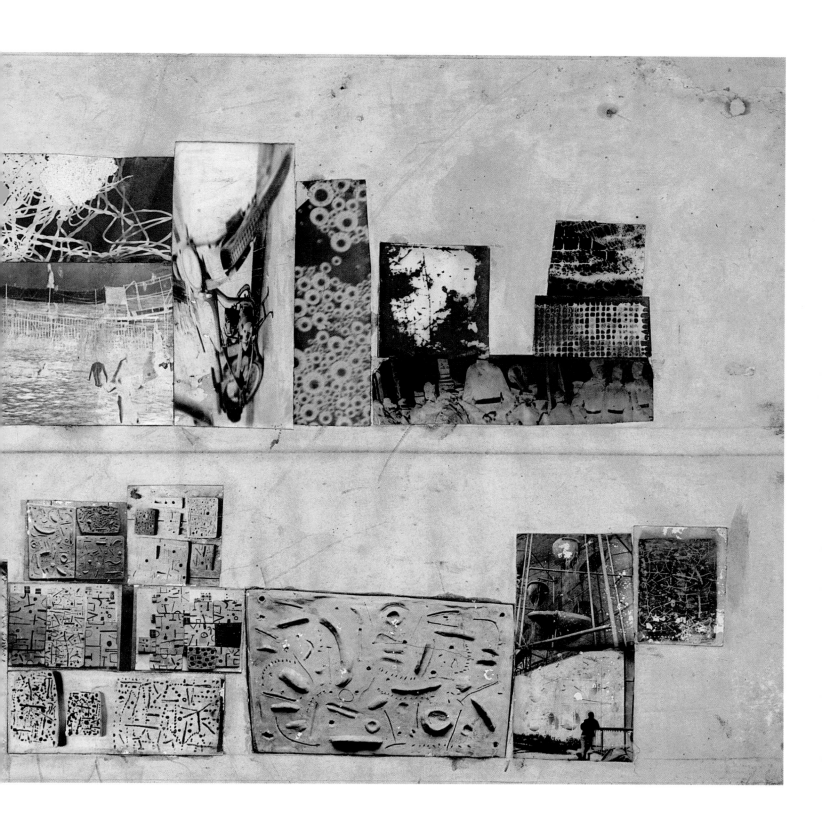

Above and opposite: Hunstanton Secondary Modern School under construction, *c.* 1953.
Designed by Alison and Peter Smithson.

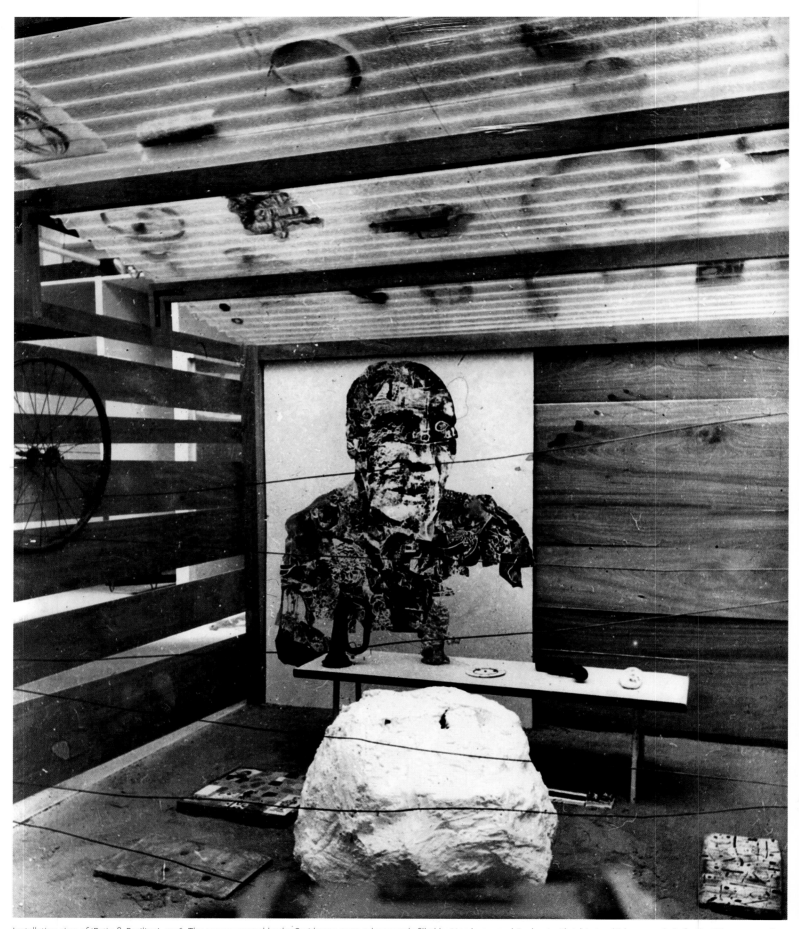

Installation view of 'Patio & Pavilion', 1956. The spaces created by the Smithsons were subsequently filled by Henderson and Paolozzi with 'objects which are symbols for the things we need'.

'Patio & Pavilion' in 'This Is Tomorrow' 1956

On 9 August 1956, the exhibition 'This Is Tomorrow' opened at the Whitechapel Art Gallery in London. Organized by Theo Crosby, it included twelve 'environments', each created by a group of artists and architects with shared interests and ideas. Collectively, through a Bauhaus-infused approach, the ambition of the exhibition was to present a range of environments that would reflect the 'notion of antagonistic co-operation' by overcoming the specialization of the arts and, in particular, the professional separation between the disciplines of art and architecture.[89] Among the artists and architects of these groups were William Turnbull, Richard Hamilton, Victor Pasmore, Ernö Goldfinger, James Stirling and Colin St. John Wilson. Identified as 'Group 6', Henderson, Paolozzi and the Smithsons created an installation which they named 'Patio & Pavilion'.

Given the implicit idea of progress in the exhibition's title, as most saw it, the construction of 'Patio & Pavilion' was an anomaly among the other environments, which embraced new technology, new forms of popular imagery and new theories of communication. For, as Banham wrote in his review, Group 6's contribution 'showed the New Brutalists at their most submissive to traditional values'.[90] A-temporal, 'Patio & Pavilion' comprised a shed-like wooden structure contained within a fenced-in area of ground on which a floor collage of seemingly prehistoric, fossilized animal life, partly concealed by sand, was positioned. Around the enclosing walls of the installation was affixed aluminium-faced plywood mutely reflecting the strange ceramic objects and tiles that were placed beneath like archaeological relics dug up and waiting to be registered. On a side wall at the far end, a collage representing plant life was pinned up. The whole installation was dominated by the 'pavilion' structure, within which was contained, on the back wall, the menacing but strangely remorseful image of the upper torso and head of a male body, the surface fractured and craggy in appearance. Laid out like items of evidence on a simple table in front of this looming presence were an old trumpet, a disfigured sculpture (by Paolozzi), a gun and two unidentifiable round items. On the ground were more Paolozzi ceramic fragments and a large boulder. Suspended on the side wooden panels was a wheel, while the roof, made of corrugated plastic, allowed the eerie semitranslucent shapes of various man-made objects and found debris of industrial material to be felt inside,

like earlier Hendograms. Combined with the fact that the pavilion was sealed off by old metal wire across its front, the meticulous placing of objects throughout the installation suggested a presence now removed, leaving the spectator to dwell in the space like a late witness at the scene of a terrible event. This disconcerting sense of a past disinterred and left exposed permeated the installation for Banham, who a decade later noted that 'one could not help feeling that this particular garden shed, with its rusted bicycle wheels, a battered trumpet … had been excavated after the atomic holocaust'.[91] The Smithsons also recalled this pervasive atmosphere of the installation, writing in 1994 that it felt like 'walking into a house abandoned by the owners during the course of the evening meal, or into a ruined mine-working shut down by impending disaster and never re-opened'.[92] Like 'Parallel of Life and Art', it was an ambiguous installation which provoked ambivalent responses. The spectator was not let into its secret history.

Unlike 'Parallel of Life and Art', however, the group was open to describing the ethos behind the installation. In a script written for the BBC's Third Programme in 1956, the Smithsons outlined their approach:

In the group exhibit 'Patio and Pavilion' we worked on a kind of symbolic habitat in which are found responses, in some form or other, to the basic human needs – a view of the sky, a piece of ground, privacy, the presence of nature and of animals when we need them – to the basic human urges – to extend and control, to move. The actual form is very simple, a 'patio', or enclosed space, in which sits a 'pavilion'. The patio and pavilion are furnished with objects which are symbols for the things we need: for example, a wheel image for movement and for machines. The method of work has been for the group to agree on the general idea, for the architects to provide a framework and for the artists to provide the objects. In this way the architects' work of providing a context for the individual to realise himself in, and the artists' work of giving signs and images to the stages of this realisation, meet in single act, full of those inconsistencies and apparent irrelevancies of every moment, but full of life.[93]

In stark contrast to the other catalogue entries, for which each group was invited to put forward text and images, the three double-page spreads of Group 6 were not beautifully laid out with typed print or graphic formality, two of them being taken up by a one-point

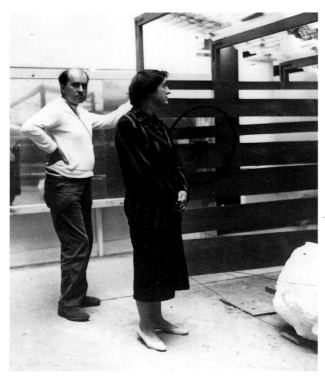

Alison and Peter Smithson in the 'Patio & Pavilion' exhibit on their return from Dubrovnik, 1956. Photograph by Richard Hamilton.

perspective, bird's-eye view of the installation on to which a crude and random arrangement of seemingly banal images of primitive sculptural objects and other items from the installation were placed. Both these sets of pages carried simple annotations in Henderson's childlike writing, all in uppercase, describing the installation and the objects with the words: 'The head – for man himself – his brain & his machines'; 'The tree image – for nature'; 'The rocks & natural objects for stability & the decoration of manmade space'; 'The light box – for the hearth & family'; 'Artifacts & pin-ups – for his irrational urges'; 'The wheel & aeroplane – for locomotion & the machine'; 'The frog & the dog – for the other animals'. The other double-page spread was the photograph chosen by the group for their individual poster to the exhibition (equally distinct from the other group posters), which presented the four of them casually sitting on chairs in the middle of a residential street like a rather motley crew of individuals. Two of the chairs on which they sat were, however, no ordinary chairs, arbitrarily selected, but, like the objects in the installation, symbolic.

Designed by Charles and Ray Eames, the chairs served a clear purpose for the group, or perhaps more accurately, for the Smithsons. For the Smithsons, the

chair design of the Eameses, particularly of the wire construction sort, spoke of a new era and a new attitude, which held the individual at the heart of its conception. As the Smithsons wrote:

Now chairs have always been the forward-runners of design change. They have for some mysterious reason the capacity for establishing a new sense of style almost overnight. Rietveld established a whole new design mode with a chair. So did Mackintosh with his…. In a sense both the machine-aesthetic and the Eames-aesthetic are art forms of ordinary life and ordinary objects seen with an eye that sees the ordinary as also magical…. Eames' chairs are the first chairs which can be put into any position in an empty room. They look as if they had alighted there … the chairs belong to the occupants, not to the building.[94]

Moreover, the mutual concern among the group for an honesty of materials, for declared structures and for material transparency was also encapsulated within the wire chair design on which Peter Smithson and Henderson sat. In choosing to pose in a residential street, the group were also clearly stating and advocating their shared belief in the value of the street and their vision of its role in the future of tomorrow. Whether in retrospect or true at the time, the Smithsons have also aligned, by contrast, their design for 'Patio & Pavilion' with a house designed and built by the Eameses in 1949 in Santa Monica, California, and which, 'seen from Europe … was something wonderful … to set in contrast with the very

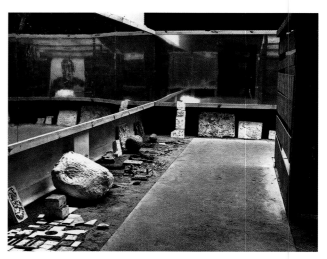

Installation view of 'Patio & Pavilion', 1956.

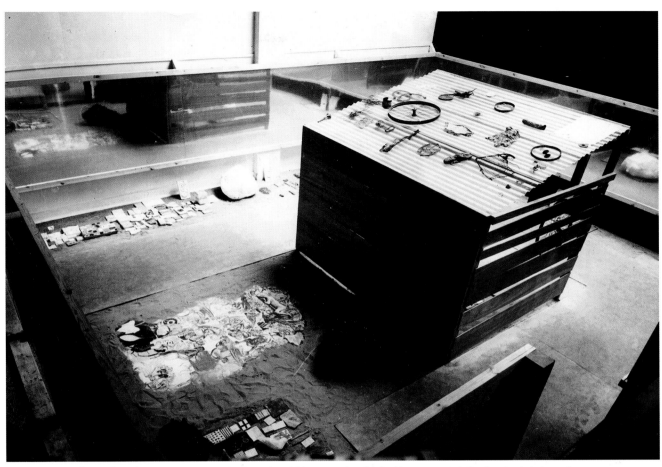

Installation view of 'Patio & Pavilion', 1956. For Reyner Banham, the exhibit appeared as if it 'had been excavated after the atomic holocaust'.

concrete, very European, Patio and Pavilion' which could be 'considered as phenomena in parallel'. However, they drew the conclusion that their own interpretation of the patio was imbued with more associational potential than the Eameses': 'In Patio and Pavilion, the vagueness of the images reflected back from the enclosing patio walls allowed a multitude of interpretations … [it] is a picture of the art-processes of a period – thinking about it, the period of Beckett/Dubuffet/Pollock/Brecht. The Eames House is a picture of the Eames.'[95]

Although it is generally believed that the Smithsons' 'pavilion' was based on the garden shed at the bottom of the Hendersons' house in Bethnal Green, Peter Smithson dismisses this as 'an art-historical fiction', perhaps fostered by Banham. Whoever was responsible, however, it was an idea that clearly took hold among Henderson's contemporaries and encouraged Robert Melville to observe that the installation 'returned us safely to the bicycle shed at the bottom of the garden in a singular tribute to

the pottering man'.[96] Whether the Smithsons ever specifically entertained this notion of the garden den, where a man might escape the trials of the home to tinker among such of his gathered bits and pieces as were assembled inside and on the roof of the pavilion, it is hard to know, since having established the design, both architects departed for a CIAM congress in Dubrovnik, leaving Henderson and Paolozzi to invest it with significance. And the kind of significance that Banham detected in the assembled objects and artefacts of this 'backyard' rested 'in the objects, images, shards of real and imaginary civilizations dredged up from the subconscious of Eduardo Paolozzi, Nigel Henderson…. A kind of personal archaeology which you just had to stand and look at.'[97] Certainly, what Colin St. John Wilson retrospectively regarded as the key work of the entire exhibition (having at the time felt antagonistic to the actual installation) could secure a mesmeric effect, but, although Wilson went on to buy Henderson's giant photomontage/photocollage *Head of a Man*, he was the

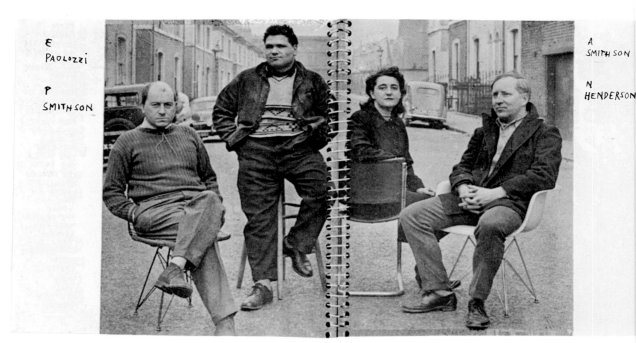

E PAOLOZZI

P SMITHSON

A SMITHSON

N HENDERSON

From Group 6's section, 'This Is Tomorrow' catalogue, 1956.

first to admit, 'What the hell it was doing in a potting shed I never understood.'[98]

Broodingly presiding over the small territory that it dominates so powerfully, *Head of a Man* is neither man nor beast, nor a synthesis of the two, but rather a tormented and unresolved co-existence of one with the other within a fragile shell; as unresolved as the Cartesian split of mind and body, though physically harnessed within the same entity. An elusive and compelling image, *Head of a Man* seamlessly juxtaposes photographic fragments of landscape, rock strata and other natural forms through a process of collage followed by photomontage followed by collage. At a distance, the work appears as a homogeneously composed image, but on closer inspection the variety of material becomes evident, almost disconcerting. In its composition and dependency on progressive assimilation it shares many affinities with work included in the 1953 ICA exhibition 'Wonder and Horror of the Human Head', and in particular the work of Dubuffet (most notably his image of a head made up of butterflies, *Chevaux de Sylvain* of 1953) and Arcimboldo, whom the Surrealists had enthusiastically resurrected from history. As Henderson later described *Head*, now in the Tate Collection:

… as in my Tête à Tate where the body is crudely made of bits of photomaterial (my prints of things that interested me at the time like turnips and old boots) … the face is like a

cratered field, one eye is suggestive of a 'worm in a bud' … I sometimes think of Heads I've seen of Archimboldi [sic] … and of those composites the surrealists liked made of intertwined nudes.[99]

While this later description captures more potently the process of decay and putrefaction which the head seems on the verge of succumbing to, Henderson submitted a more literal and pragmatic description of the work to his friend and patron Colin St. John Wilson in 1975 under the heading 'Objective':

The image largely filled one wall of a rather diagrammatic hut or shed which stood in a compound. This was to suggest a working shed or even a 'summerhouse' where a Head worker might cultivate his intelligence and imagination or a Hand worker his 'garden'. Each would impose his presence. The visor-like element was to symbolise this Head projection or Head protection role. The face was heavily textured to underline the association with hide or bark and the bust/shoulders adumbrated with bits of photo-material like stone or leaf to further his association with nature.[100]

For as apocalyptic and self-annihilating as this image may be, Henderson's two further collages in the installation spoke of regeneration through the cycle of decay and rebirth represented in the floor collage of the pond and the plant growth and seed dispersal of the wall collage, both of which were composed out

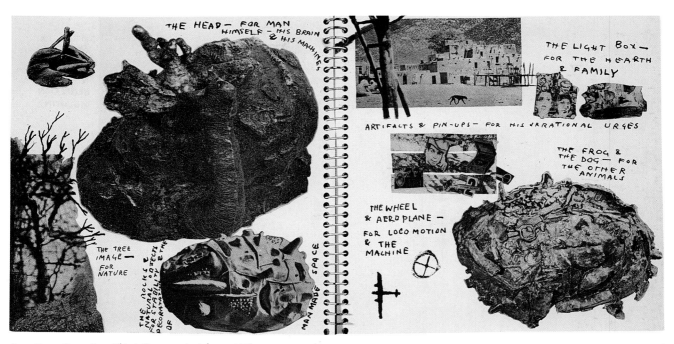

THE HEAD — FOR MAN HIMSELF — HIS BRAIN & HIS MACHINES

THE LIGHT BOX — FOR THE HEARTH & FAMILY

ARTIFACTS & PIN-UPS — FOR HIS IRRATIONAL URGES

THE FROG & THE DOG — FOR THE OTHER ANIMALS

THE TREE IMAGE — FOR NATURE

THE ROCKS & NATURAL OBJECTS FOR STABILITY & THE DECORATIVITY OF

THE WHEEL & AEROPLANE — FOR LOCOMOTION & THE MACHINE

MAN MADE SPACE

From Group 6's section, 'This Is Tomorrow' catalogue, 1956.

of lithographic printed material. True to the surrealist aesthetic which embraced ideas of ambiguity and metamorphosis, Henderson challenged the perceptual habits and imagination of the audience in the collage of the pond. More like an archaeology of the underworld, the collage brought together strange animals and water creatures, some lifted from Diderot and d'Alembert's *Encyclopédie* and some from *Wonder Books of the Natural World*. Similar to the *Head*, the collage called upon the spectator to play out an alternative version of the surrealist game of finding faces in puzzle pictures of the woods. A potential dreamscape, Henderson's creation of a pond may have been suggested by the works of Max Ernst, which he admired very much and had seen with Paolozzi at Roland Penrose's house. As Paolozzi recalls, Penrose 'had some classic Max Ernsts, including one I used to stare at which was made up of cuttings out of a natural history book of sort of biology, and he had cut them all out and made a new kind of landscape'. Furthermore, the ICA had also staged a large exhibition of Max Ernst's drawings in 1952 and Penrose had written about such works of the artist as *Histoire Naturelle* (1926) and *La Joie de Vivre* (1936) in which Ernst had 'invented birds, beasts, insects, and plants of indeterminate origin. They have coverings which are a mixture of leaves, feathers, scales or the grain of woods, but this amalgam still gives the appearance of belonging to an authentic species.' In setting out a quasi-installation of a pond by

surrounding the collage with sand, Henderson may also have borne in mind the International Exhibition of Surrealism held in Paris in 1938, in which an artificial pond was constructed surrounded by ferns.

How the Smithsons reacted to the 'inhabitation' of their patio and pavilion when they returned from Dubrovnik after the exhibition had opened is undocumented, but in the true collaborative spirit of the exhibition and its aspiration to bring architect and artist closer together, Peter Smithson warmly looked upon the installation 'as a celebration of friendship … it seemed to me that we chose the people who we were fond of, and that fondness includes the images that they were able to make'.[101]

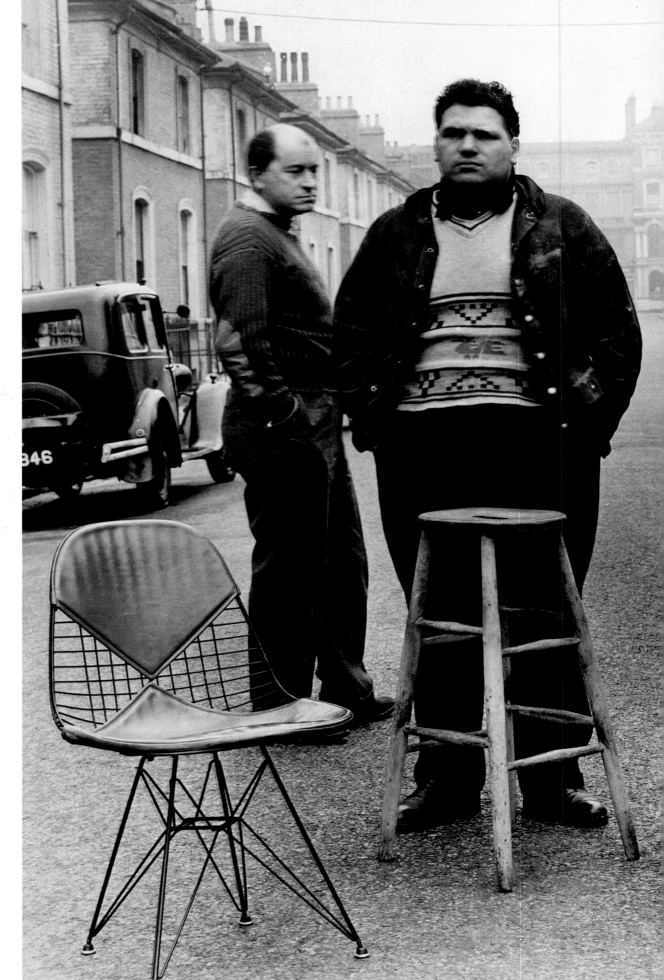

Left to right: Peter Smithson, Eduardo Paolozzi, Alison Smithson and Nigel Henderson. Unused photograph from the 'This Is Tomorrow' catalogue, 1956. At the Smithsons' suggestion, the photograph was taken outside the front of their house, 46, Limerston Street, Chelsea, at the intersection with Camera Place, a coincidence that would have appealed to Henderson. Note the two Eames chairs. Collection Victoria & Albert Museum.

120

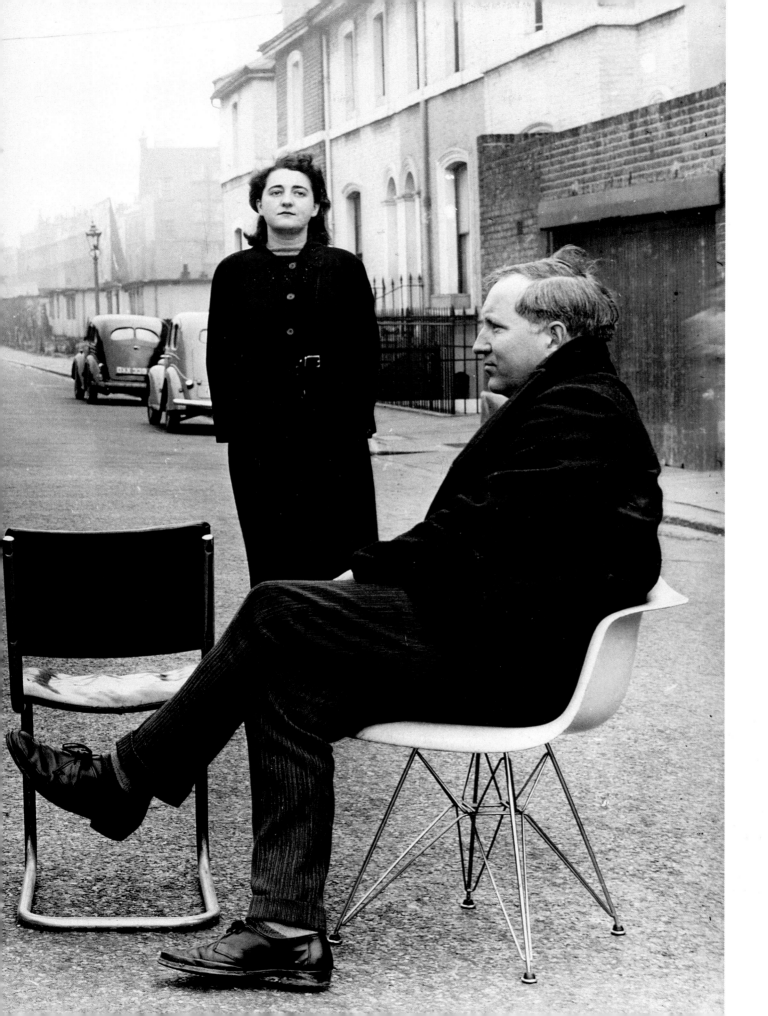

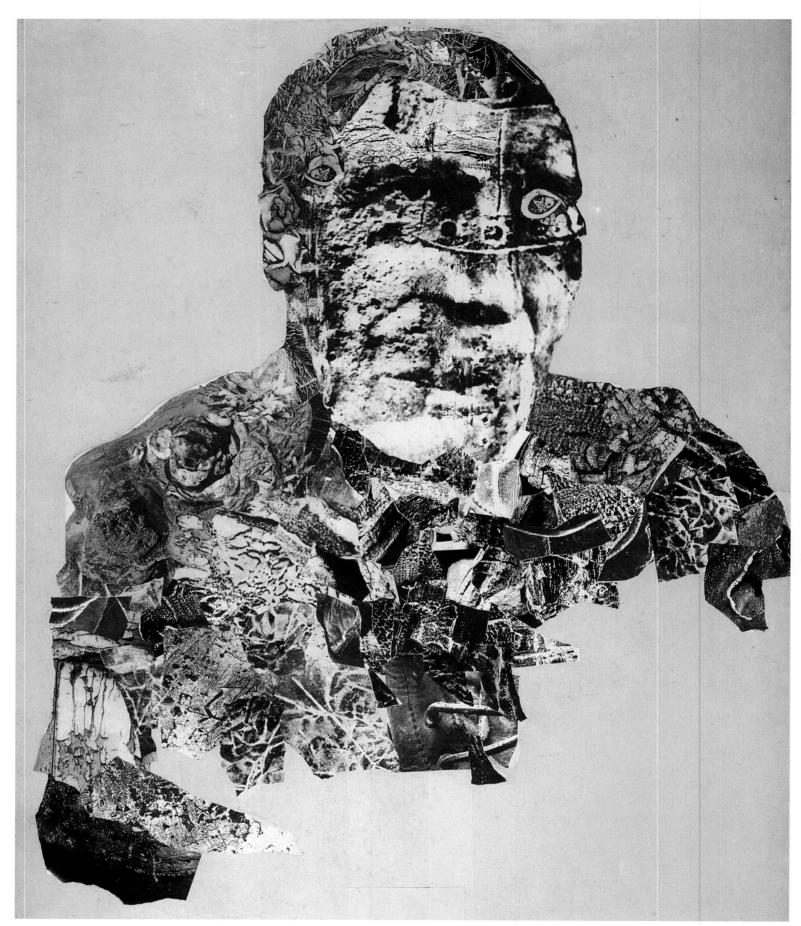

Head of a Man, 1956. Photograph on board, 62⅞ × 47⅞ in. (159.7 × 121.6 cm). Tate Collection.

Collages 1949–1982

In 1936, Max Ernst offered up his thoughts on 'What is the mechanism of Collage?' in the French magazine *Cahiers d'Art*, observing that 'the complete transmutation, followed by a pure act, as that of love, will make itself known naturally every time the conditions are rendered favourable by the given facts: the coupling of two realities, irreconcilable in appearance, upon a plane which apparently does not suit them …'.[102] He went on to describe an experience in 1919 when he fell upon the pages of an illustrated technical catalogue 'showing objects designed for anthropologic, microscopic, psychologic, mineralogic and paleontologic demonstration' and which, so assembled on the page, 'provoked a sudden intensification of the visionary faculties in me and brought forth an illusive succession of contradictory images … piling up on each other with the persistence and rapidity which are peculiar to love memories and visions of half-sleep'. Compelled to engage with the page before him, Ernst added some pencil markings creating a new relationship between the images and 'thus I obtained a faithful fixed image of my hallucination and transformed into revealing dramas my most secret desires …'.

Two years later, Henderson had the opportunity to enjoy some of Ernst's subsequent collage work when it was included in an exhibition of Surrealist collages at Guggenheim Jeune, which also included examples by Picasso, Braque, Gris and Tanguy. Significantly, two collages by Henderson were also included in the show as a result of his mother's alacrity in promoting her son's endeavours. Although Henderson was familiar with Surrealist collages prior to this show, and indeed Ernst would become a prime source of inspiration in the future, the impetus behind his own collage work was at this time derived from the work of Laurence Vail and, in particular, Len Lye, whom his mother had commissioned to design book covers when she worked at the Hours Press. As Henderson recalled, 'Len Lye was a strong influence on me. He'd made an … arrangement of beetle-buggered wood and cork and sand and cottons strung from pins. The front cover was at one scale, the back another. Printed in brown it really shook me …'.[103]

In 1954, however, Henderson was reunited with his Surrealist mentors in Laurence Alloway's exhibition 'Collages and Objects', held at the ICA, when he was invited to contribute two works, one a *Head*, the other, now lost, a four-foot-square collage titled *Atlas*.[104]

Reproduced in the show's catalogue and still known from a glass negative in the Tate Archive, Henderson described how he 'formed a "map" rather like Africa in shape, of real images (electron-microscope readings, metal and charred wood seen under the plate camera etc.) but juxtaposed as if abstract'.[105] A natural progression from the kinds of photographic material assembled in 'Parallel of Life and Art', *Atlas* can be seen as a direct forerunner to *Head of a Man*, created for 'Patio & Pavilion' in 1956, although it was the result of collage and not photomontage.

By Henderson's own admission, however, his 'real love', from his first experiments in collage to his last works, was the photomontages of the Dadaists Raoul Hausmann, Hannah Hoch and Kurt Schwitters, although his own photomontages never formally reflect their compositions in the same way that his later collages do. But in developing a penchant for the Dadaists' work, Henderson was arguably drawn by its characteristic features as described and interpreted by Moholy-Nagy in *Vision in Motion*: 'Photomontage – like superimposition – also attempts to develop a technique for the recordings of events occurring on the threshold between dream and consciousness; a tumultuous collision of whimsical detail from which hidden meanings flash; visual poetry with bitter jests and sometimes with blasphemy.'[106] The potential of collage, the juxtaposition of unlikely elements, to stimulate a psychic aura and significance resonating with the artist's own imaginative reality and desires appealed to Henderson, who equally imbued with psychic significance the very material he incorporated into such works; as he wrote:

I really think that for me the found fragment, the objet trouvé, works like a talisman. It feels as if it has dropped from outer space at that precise spot to intercept your passage and wink 'its' message specifically at & for you. … I greatly enjoy incorporating things I've found this way. I like the feeling of being 'plugged in' to my universe; that it has signals laid for me like a paper chase (a cosmic nudge, a muffled snigger). You'll 'come to' in a genial environment of humour and well-wishing to find your life actually was passed in a flash of time, the whole thing manipulated by a sorcerer or a hypnotist. Perhaps I'm being a bit free with the term 'objet trouvé' although I feel I'm true to the basic idea. What I mean is I'm generally dissatisfied with forms and shapes I've consciously drawn or cut, or whatever. I get bored with, distrust, the direct

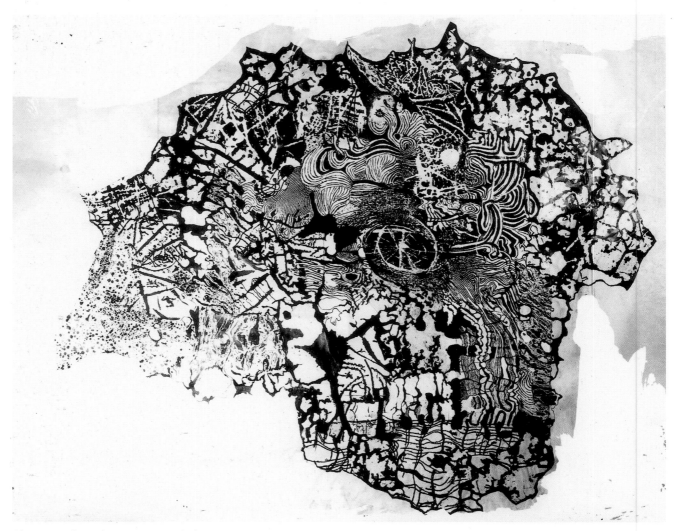

Atlas, 1954. Collage (glass negative). Tate Archive.

manipulations of my hands, the projections of my brain unless they are lent some feeling of authority by a strong sense of RECOGNITION (I feel I am making an awful admission of inadequacy here) almost from outside me.[107]

Henderson's passion for collecting ephemera such as cigarette cards, tobacco labels and bus tickets, which could be detected in his early collage work exhibited at Guggenheim Jeune in 1938, was extended after the war to include book spines, newspaper cuttings and other printed material which allowed him to create textual puns with images and introduce the added dimension of humour and irony. As he wrote in the catalogue that accompanied an exhibition of his work at the ICA in 1961, 'I want to release an energy of image from trivial data', but, as he noted, such trivia inherently carried a sense of impending loss through their essentially fragile

nature and transient place in a material culture. For although he would 'feel happiest among discarded things, vituperative fragments cast casually from life, with the fizz of vitality still about them', his own identification with the material was equally subject to the stages of decay and curtailment that such ephemera were vulnerable to, as he reflected on the changes in design of a Player's cigarette pack: 'And every time they change the pack you want to go and assassinate them because they're buggering about with bits of your private mythology.'[108]

'The John Betjeman of rubbish', as he was once called, Henderson, however, perhaps overcame this paradoxical relationship with his collage material and imagery by perpetually recycling it until, like a Wagnerian motif, it assumed a significance which

Right: Floor collage created for 'Patio & Pavilion', 1956.
96 x 48 in. (244 x 122 cm).

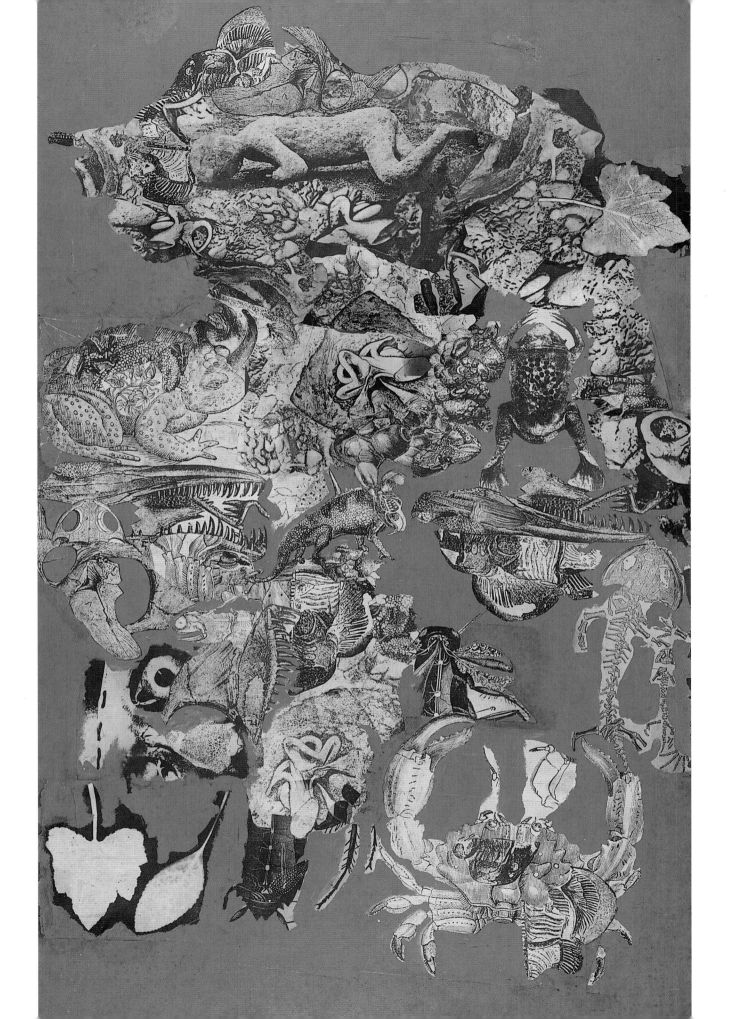

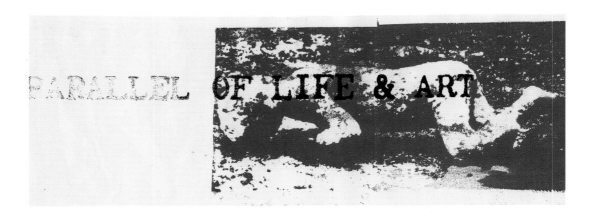

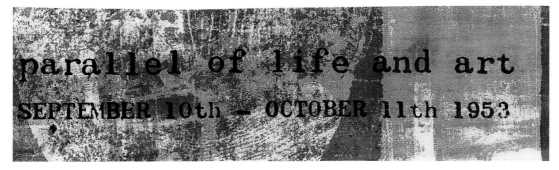

Nigel Henderson/Eduardo Paolozzi, posters for 'Parallel of Life and Art', 1953. 4¾ x 16⅛ in. (12 x 41 cm).
Collection Alison and Peter Smithson.

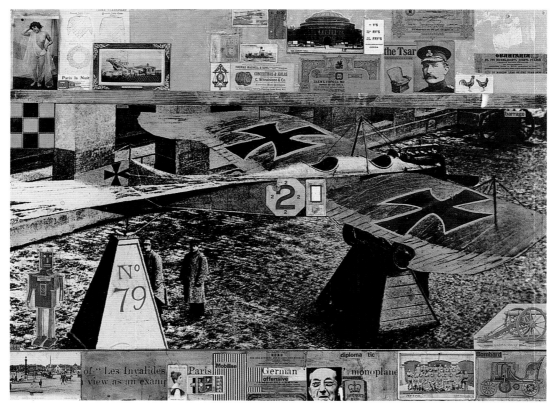

Untitled ('No. 79'), 1960s. Collage mounted on board, 28⅞ x 38¾ in. (73.3 x 98.3 cm).
Photo: Betty Fleck.

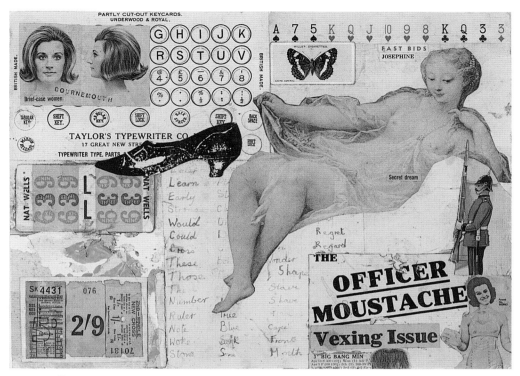

Untitled ('Officer Moustache'), 1960s. Collage on board.
Photo: Betty Fleck.

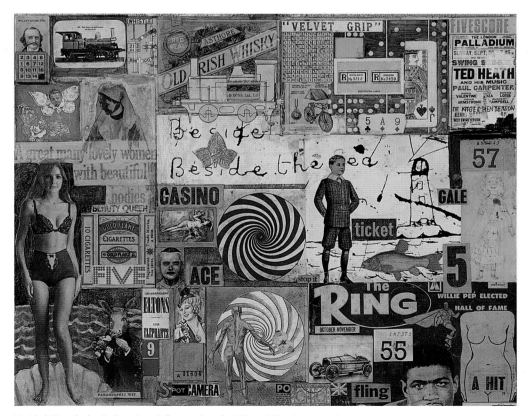

Untitled ('Beside the Sea'), 1960s. Collage on board, 16½ x 20⅞ in. (42 x 53 cm).
Photo: Martin Harrison.

Willy Call-Up, 1979. Photomontage, oil and collage, 16 x 20⅛ in. (40.6 x 51.1 cm). Collection Norfolk Museums Services (Norwich Castle Museum).

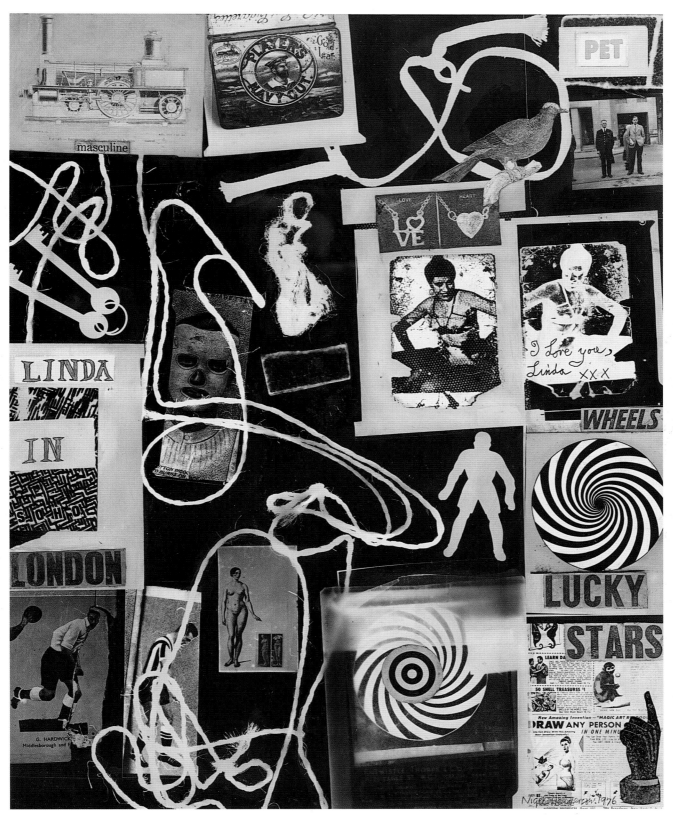

Untitled, *c.* 1970s. Collage and photograms on board, 20⅞ x 16½ in. (53 x 42 cm).
Photo: Martin Harrison.

Hammer Prints Ltd. Ceramics, 1954–61. Photo: Martin Harrison.

Hammer Prints Ltd. Fabrics 1954–61. Photo: Martin Harrison.

Black Landscape, 1960. Collage and paint on board, 36¼ x 35 in.
(92 x 89 cm). Collection Colin St. John Wilson.

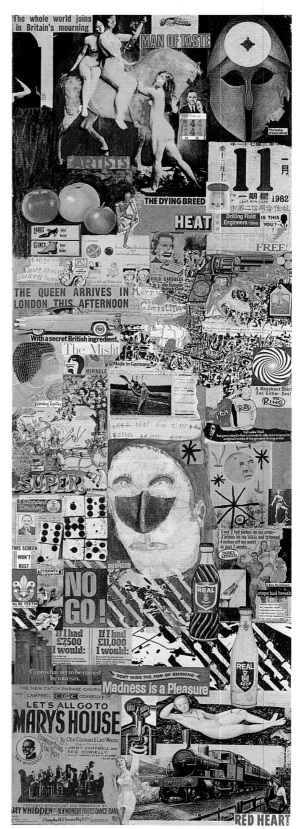

The Whole World Joins Britain's Mourning, undated. Collage,
71⅝ x 24 in. (182 x 61 cm).

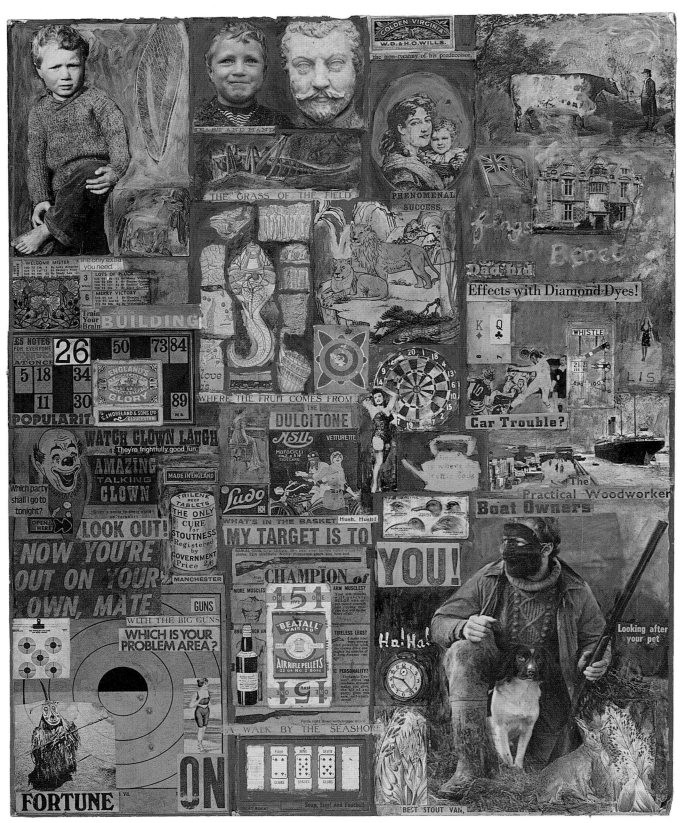

Untitled, *c.* 1970s. Collage, 25 x 20⅛ in (63.5 x 51 cm). Photo: Martin Harrison.

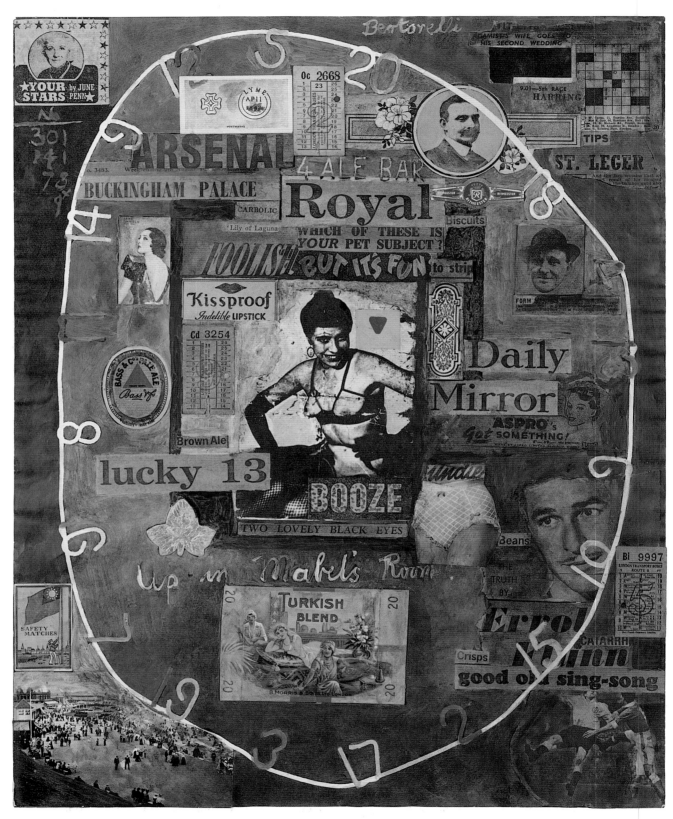

From the *Lovely Linda* series, *c.* 1977. 19¾ x 15¾ in. (50.2 x 40.0 cm). Collection Barry Flanagan.

transcended time and circumstance to become a trove in which his private mythologies could rest safe. But such collage-making was not a simple attempt to create a visual autobiography, but rather a testing-out, even a teasing-out, of unknown moments of the self, as Henderson reflected:

There is something a bit secret and shuttered about making an image. I am almost ashamed and very unsure. Assurance seems almost fraudulent where the light airs of conviction flip around in a jerky vortex. Fear and hesitation attend every step for me, and this is why I like a medium such as collage. You can strip bits away, reallocate them, glaze them down, overthrow them. The thing is perpetually tentative, evasive, ephemeral. So there you have me – like a rat on a pipe caught in a torchbeam. This is why I like to talk, sometimes I feel on the verge of an epileptic fit, and still tearing off words and images like so much bog roll to arabesque into oblivion. It's the irony of the thing and some kind of anti-longing to building up a monument to oneself.[109]

The King's Head at Thorpe-le-Soken, Essex. The family home which Judith Henderson inherited and returned to with her husband in 1954.

Not so much a monument, but rather a comprehensive record of his working practice and sources, *Screen* is a four-panel collage that Henderson began working on in 1949, but subsequently extended from two to four panels when his great friend Colin St. John Wilson asked to purchase it in 1960. An index of imagery that punctuated Henderson's life for just over a decade, the screen remains one of Henderson's most remarkable creations in its formal fluency and beguiling juxtapositions. While it is often perceived as a forerunner, if not a direct example, of Pop art, what is most notable about the screen is its pervasive sense of nostalgia as opposed to a sense of celebration of the here and now. This is not necessarily due to the time lapse between imagery, but rather, as Chris Mullen has observed, to its connotation of Victorian

screens – screens designed to first conceal and then reveal a change in appearance. Such a connotation is also enhanced by the fact that, prominently positioned in the right-hand corner of the end panel, is a selection of late-Victorian pornographic images of naked women posing for the camera and therefore directly looking at the spectator. The only other prominent image to confront the spectator head-on is that of Henderson himself, menacingly watching you looking at him and surveying his personal territory.

Essentially urban, as Surrealist-orientated collage is, the move from London to Essex in 1954 deprived Henderson of his unique sources of material, as he later lamented:

The cottages adjacent to The King's Head at Thorpe-le-Soken to which Eduardo and Freda Paolozzi, and later the Samuels family, moved in the mid-1950s.

What I miss about London is the cheap old books of every description I used to buy to look at and cut up. Old catalogues of all kinds, cook books, plumber's manuals, piano catalogues, Illustrated London News, tastefully posed nudes 'Mes Modeles', Modern Bridge, Sports and Pastimes, Wonder Books, the 'Miracle of this and that', Eddison, Eddystone, Euclid, Eucryl, Flags of all Nations, Manuals of Brewing….[110]

But what came about in its stead was a tendency by Henderson to latch on to a single new image which he would tenaciously put through a series of scenarios until he had fully exhausted his imaginary relations with its subject. The first example of this new approach came about in the late 1970s in what is known as the *Lovely Linda* series, when a student of Henderson's showed him a print of a woman he had found on the floor of a bus and of which Henderson imagined that 'it must have fallen from a wallet, where it had been conserved lovingly, gazed upon from time to time to provide a

Christmas card designed by Nigel Henderson, 1954. Tate Archive.

momentary lift – like a double whisky'. Enlarging the print, but careful to keep all the nuances of an image once handled many times, as its creases suggested, Henderson set about various strategies to distort and 'stress' the image, subsequently adding collage elements until it matched his own fantasy of the woman portrayed. As he wrote to his mother:

I am trying to get a collage to work. It incorporates a timeless whore (call girl, fun girl, artist's moll) in the centre of the picture, ringed by a dartboard ring of numbers (pushed out of shape to act like a garland [up in Mabel's Room is a dart player's euphemism] for double one) – so perhaps she's 'Mabel'. Around are scenes – or bits rather suggesting a sexy escapade to Brighton for a day or weekend. There is, among number cards, (Bingo [binge], Race Track card, playing cards) the word Ludo – which you know is the Latin for I play. *The girl smiles and says with her eyes – Come on! … Eye play! There is the odd dalliance going on and a detail of a Renaissance/Baroque to suggest a Restaurant cum Casino. Am I recreating the somehow idyllic (!!) visit to Brighton at the warm and friendly request of the two tarts who rescued me from the RAF cads in 'Smokey Joe's' just before the war….*

The second major series, *Face at the Window*, was, however, less flippant and less playful – more disturbing and apparently confessional. Strangely for Henderson, it was a series which went into full realization based on a Wills's cigarette card that he had come across some thirty years before in the 1950s, when he lived in the East End. The series variously incorporated the image of a bandaged head, which had been presented as part of a card campaign to explain the appropriate first-aid action to take in the event of burns to the body. Having produced this series, in one instance juxtaposing 'Lovely Linda' with the bandaged face, Henderson felt the need to return to the actual cigarette-card image which had set off this chain of work. It had maintained, by all accounts, a haunting hold over his consciousness: 'I was staring at it; it was coldly looking back at me.' In a move to

confront the image and 'unmask' by 'understanding my identification with it', Henderson produced the collage *Willy Call-Up*, a pun on the telephone dial that he included in the work as an indication of his attempt to communicate directly with the image. As he wrote:

I imagined the figure sitting in the cubicle or cell of a public lavatory, sharing the smelly brotherhood of common need and the raving sexual phantasies scrawled on the walls. There are fag packets, tickets and other ephemera on the floor. The graffiti temporarily derange him and he becomes in turn phantasy rapist, and seducer seduced, obscene telephone calls, universal lecher…. This is the feeling many of us had in adolescence (have in delayed adolescence) when emerging from the emotional incubator of a darkened cinema, momentarily out of your mind and expectant of 'God-knows-what' adventure.[111]

As if seeking salvation, or perhaps more accurately redemption, through visual articulation, Henderson took this work, *Willy Call-Up*, as the starting point for the last great series of his life, *Heads*. Dividing this large series of collages into 'Blocks', as he termed them, each collage contained a frame of six images arranged three by two. Explicitly biographical, Henderson, in seeking to 'unmask' the bandaged face, offered up a literal reading of each of the seven blocks in the catalogue which accompanied the exhibition of these works in 1982. Collectively, the images suggested the life cycle of a trapped, caged beast – at times raging to break out, at times deflated and withdrawn. Physically transformed through various means, the unmasked face was revealed as normal, disfigured, putrefied, split and ultimately remasked. In its various guises, it echoed many of the images from the 1953 exhibition 'Wonder and Horror of the Human Head' at the ICA, but also summoned up associations with Van Gogh's interrogative self-portraits, Dubuffet's heads, the screams of Francis Bacon's stretched figures, and the howls of the *Battleship Potemkin*. Often imprisoned behind bars, or arranged like mugshots for police records, the images also embodied Henderson's own private reflection in a letter to one of his students a decade earlier in which he wrote that what he had learnt from his 'bleak childhood' was 'an instinctive understanding and identification with the criminal, the rebel and the schizophrenic'.[112]

Heads, like its crowning predecessor *Head of a Man* (1956), tenaciously resists any single reading, while simultaneously cajoling the spectator to find one. The clue to this lies in Henderson's conscious manipulation of his viewer, his audience, in his tireless desire to tease and please, conceal and reveal. In a letter to Colin St.

John Wilson, Henderson responded to his friend's enquiry about what would constitute an 'ideal commission'.[113] His answer was the reception area of a restaurant 'where you might have a drink while waiting for a table and find yourself beguiled and diverted and possibly find your mind teased into playful activity'. As he concluded in his writing about the *Heads* series in 1982, however, 'But ultimately I baffle you with my masks as I baffle myself.' Perennially playing out the role bestowed on him by dint of his birth date (1 April), Henderson was the first to confess: 'The Fool is mercurial and is quick to adapt. He plays many roles including buffoonery – and despises himself for it. He moves quickly like a cat burglar; and only a flash gun catches him.'

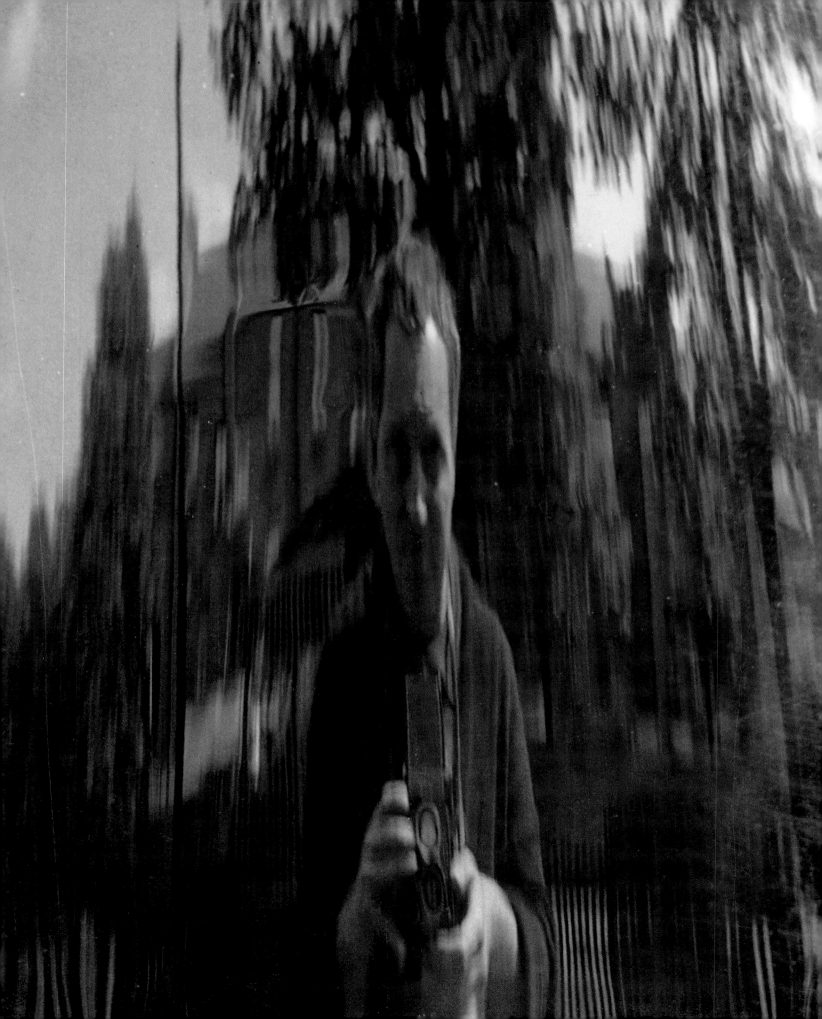

Towards a Conclusion

Hammer Prints

In 1954, when the Hendersons moved to Thorpe-le-Soken in Essex, Freda and Eduardo Paolozzi also moved down to live in a cottage adjacent to the house that Judith Henderson had inherited from her parents. Having forged, by all accounts, an extraordinarily close friendship and having happily collaborated on two exhibitions, Henderson and Paolozzi decided to work together once more. Forming a creative partnership with the ambition of producing wallpaper, textiles, ceramics and furniture, they set up in 1954 their own company under the name of Hammer Prints Ltd, for which Judith Henderson was appointed bookkeeper and Freda Paolozzi's skills as a designer were employed.

By this time, Paolozzi was already an established designer of wallpapers and fabrics in his own right, having been teaching textile design at the Central School of Arts and Crafts since 1949, where he had experimented with various silk-screening techniques. In addition, he had already enjoyed substantial success for his designs when, with the Smithsons, he was commissioned in 1952 to decorate the London offices of Ronald Jenkins at Ove Arup and Partners, for which he covered the ceiling with a new wallpaper of abstract markings. This was soon followed by a further commission by Jane Drew for the architecture practice Fry Drew in London, and another for her own private living room at home, one of the designs for which was reproduced on the front cover of the *Architectural Review* in March 1952. Further exposure of Paolozzi's designs was also forthcoming in the October issue of the same magazine later that year, when an extended article on contemporary wallpapers was published by D. Dewar Mills. Significantly, this article also carried designs by Terence Conran, whom Paolozzi had taught at the Central School of Arts and Crafts and who, according to Richard Hamilton, 'used to follow Henderson and Paolozzi around everywhere'. Conran, though still very young, was a designer in the ascent, and in 1952 Henderson photographed for the July issue of *Architectural Review* his first major show of new furniture, which opened at Simpson's in Piccadilly.

In this climate of new and experimental work in decorative art design, Henderson and Paolozzi were confident of the potential success of their initiative, although Henderson would retrospectively comment

Eduardo Paolozzi, *c*. 1954.

that they were both 'quite long on art and a bit short on craft'. In a press release that they issued to shops and retailers, they openly declared that 'it is not always possible to attribute designs to either', for:

A motive may be suggested by Paolozzi, then taken over by Henderson for manipulation with the help of camera, enlarger, and a whole range of technical processes, to produce a large number of variations on the original theme, for further development by one or both. Or the underlying theme may be supplied by an illustration in a book, a child's drawing, a photograph; but its final integration into the design will be the result of considerable experimentation, using photographic methods in a non-mechanical way to reveal new aesthetic possibilities.

The designs, in effect, were not just a continuation, but rather a manifestation of the different kinds of imagery and processes which had concerned both Henderson and Paolozzi for some years, in the sense that through experimentation they pushed their chosen imagery as far as they could until it would surrender no more nuances or stylistic cadences. The extent to which they drew on these concerns, such as the 'multi-evocative image', the 'all-over aesthetic' and the Brutalist aesthetic in relation to images that they had consistently worked with, such

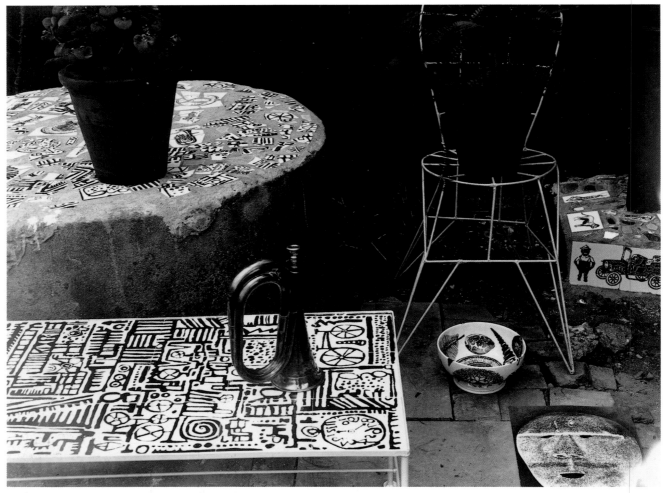

Photograph of furniture and ceramics produced by Hammer Prints Ltd, taken at Thorpe-le-Soken 1954–61.

as street hoardings, children's drawings, natural and urban textures, is declared not only by the products themselves, but also in the descriptions used to promote the products:

Hessian *is a demonstration of a monotype principle, pieces of inked canvas arranged and rearranged to form a multi-evocative pattern.*

Coalface *is derived from a piece of plywood engraved and worked upon with red-hot wires to form a design evocative of the world of geological stratification.*

Newsprint, *which was originally called 'Paris Walls', has its origin in a large number of photographs of hoardings, wall drawings, and so forth taken during a visit to that city.*

Barkcloth *has an affinity with the semi-abstract designs of some primitive peoples, in which man's own products are rendered into their simplest forms and incorporated as elements in a geometrical design.*

Townscape *is a more complex attempt to bring together some of the many conflicting images of the urban scene, using children's drawings and lettering among other material in a closely [arranged] pattern.*

Moreover, while the ceramic objects would also carry some of the same children's motifs, they were predominantly characterized by the edition known as 'Sea Beasts', which were prints lifted from Diderot and d'Alembert's *Encyclopédie*, which would also be used by Henderson in his pond collage for 'Patio & Pavilion'.

Sadly, although by 1961 they had found a reliable distributor and agent in Hull Traders (for whom Leslie Samuels, the father of the family which Judith Henderson had documented in Chisenhale Road, worked) and their client list looked fairly propitious – Fry Drew, Drake and Lasdun, Johnny Dankworth, Theo Crosby, Conran Furniture, Liberty of Regent Street,

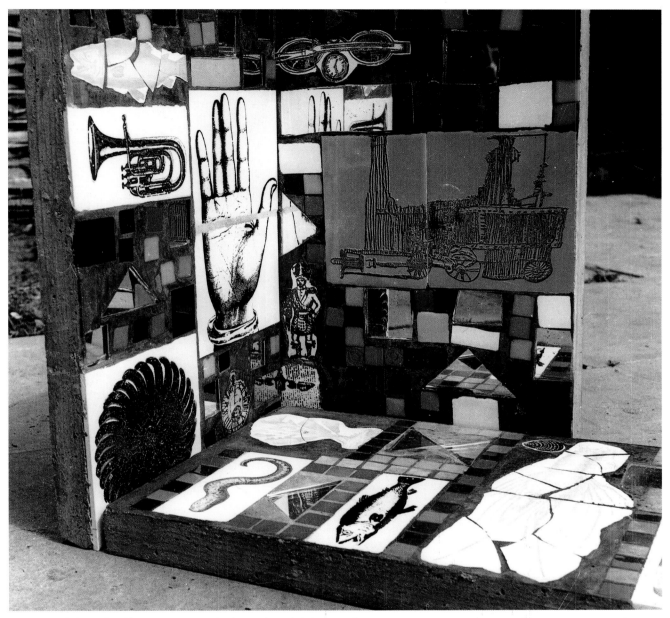

Photograph of tiles produced by Hammer Prints Ltd, taken at Thorpe-le-Soken 1954–61.

De Bijenkorf in Amsterdam, the Bristol Old Vic theatre, the ICA in London – their method of production was too work-intensive, too time-consuming and too materially expensive to sustain a viable business. And so Hammer Prints was dissolved in 1961, but not without a certain sense of recrimination on the side of each business partner. As Freda Paolozzi recalls, a sharp discrepancy in the approach to the work and the business also emerged between Henderson and Paolozzi, Paolozzi's attitude to the business being marked by a seriousness and earnestness in terms of a solid work ethic, whereas Henderson, by his own admission, looked upon the enterprise as a form of 'occupational therapy' which kept boredom and depression at bay. Moreover, Paolozzi's very conscious choice and collecting of imagery was increasingly drawing on popular culture, in what Henderson looked back upon as his friend's first attempts to construct a 'compendious image-bank', 'a storage and retrieval system of imagery', none of which was 'really my scale of operation at all'.[114]

Stressed photograph, *c.* 1954.

Henderson and the Legacy of the Independent Group and Pop Art

The nature of the ultimate divide between Henderson and Paolozzi perhaps best explains why Henderson is mistakenly viewed sometimes as a precursor of British Pop art. For, while Paolozzi was perpetually enthralled and seduced by the kinds of pictures and advertisements he discovered within the pages of contemporary magazines, particularly American, Henderson looked upon them with contempt and disdain, finding little, if anything, of personal interest or significance for his work. Whereas for Paolozzi these magazines presented a world more colourful, more exciting, more dangerous and altogether different to the impoverished one he had grown up in, for Henderson they stood for all that was loathsome about contemporary life: the loss of craft and skill, the rise of materialism, the celebration of personal

ambition, the loss of ambiguity in favour of brash sexuality, and so on. Such magazines simply did not relate to Henderson's life, neither in terms of the past nor of the present, and certainly not of the future in the heart of the Essex marshland. Although, in part, this progressive discrepancy in taste between the two friends could be explained by the seven-year age gap, another core reason can perhaps be found in an interview with Paolozzi by Frank Whitford in 1993, during which the former reflected on the Hendersons:

But they had this house … and it seemed quite exotic from the point of view of its extreme poverty in a sense, but they rather liked all that, that had big meaning for them, the cracked mugs and so on…. I gave some drawings for either a year's subscription to American Harper's, which I liked, and

The Ronnie Scott Orchestra, *c.* 1954.

American Vogue, and they were sent to the country, and of course, the Hendersons in their bizarre puritanical way just thought it was a hoot, and they opened all these rolls of magazines and they thought it was all terribly funny. They were curiously snobbish about that kind of thing....[115]

This was not to say, however, that Henderson was not, as he put it, 'plugged in' to contemporary culture, as he most clearly was, being commissioned to photograph not just fashion shoots for *Vogue*, but also jazz performances and events for *Flair* and *Melody Maker*. Indeed, Henderson's involvement with the London jazz scene before moving down to Essex in 1954 was quite notable. This involvement directly came about through his meeting the American Sam Kaner in 1951, who joined one of Henderson's classes in Creative Photography at

the Central School of Arts and Crafts. Vividly recollecting 'this very likeable personality', Henderson recounted how Kaner practised 'a sort of scaled down Jackson Pollockry making use of the hot plate available to keep the developer and fix up to temperature. He would splatter and shake up a clear piece of printing paper heating it at the same time and super adding more until he'd had enough with it when he'd fix it.'[116] Previously a drummer in a US services band, Kaner had made contact with some of the leading jazz bands in London on his arrival and had secured various jobs photographing the bands in performance. Having established a basic friendship, Kaner invited Henderson to work with him on the Ronnie Scott Orchestra, which had just been created by several

members who had broken away from Jack Parnell's band at the time. As their work took off, Kaner briefly moved into the Henderson home in Chisenhale Road, which allowed the two to work through the night printing up the many negatives they had accumulated and producing colour posters to advertise future events. The photographic sessions of Ronnie Scott's Orchestra were, however, a great disappointment to Henderson because of Scott's interference:

They were a brilliant bunch of musicians, musically very hip but visually square to the point of cuboid. Of course I wanted to give them a visual presentation to match their musical inventions. It's a shame we fail to see the equivalence readily across the barriers of specific needs. They could have done with any ham photographer. Ronnie Scott was particularly schmalzy and Stamford Hill in his 'ideas' and when I set up a pretty interesting set he laughed at it, set the lads against me and imposed his own pathetic ideas wherein he had the lads lined up in rows like circus ponies and dressed like doormen outside the Dominion Cinema.[117]

Although these sessions were so disillusioning, Henderson clearly derived great fun from working with both Kaner and Paolozzi, whom he brought along as his assistant and who helped to hold up the improvised reflectors in the form of two baking tins from Woolworths.

This was the kind of contemporary culture that Henderson found exciting and which sustained his curiosity far more than the interests that would become associated with Pop art through the work of his friends Paolozzi and Hamilton. Indeed, while science fiction held the promise of a future to come for Paolozzi and some of his contemporaries at the ICA in the mid 1950s, Henderson could never summon up much enthusiasm for the genre, as he later explained: 'I'm some kind of a moralist. Somewhere along the line (God presumably) said "You'll not get up from the table (let alone get some more) until you've eaten what's on your plate."'[118] This could also be explained by the fact, as Chris Mullen succinctly put it, that Henderson's imagination had been so remarkably stimulated by the likes of J. D. Bernal as a youngster before the war that it 'made the Independent Group's image of the robot look positively Aga/Belling'.[119]

But for as much as Henderson can not be seen as a precursor of Pop art, nor should he be overly integrated into the history of the Independent Group, although he held sympathy with the frustrations and aspirations of the many younger friends who defined and composed it.

As he himself recalled, the Independent Group 'dotted a few "i's" and set-up some sort of bridgehead', but 'I was certainly not a central member of the group. If I had some value it was because of my unusual experience of the world of art before the war.'[120] Moreover, Henderson particularly held a distaste for the intellectualization of art, as he saw it, by various members of the group:

The transactions of the various able members of the subsequent 'Think-Tank' were of little interest to me personally as I have never regarded myself as an intellectual and also tend to suffer a sense of the betrayal of the 'real' as the persistent little shunting engines of the intellect go about their rather impertinent task of tidying up the marshalling yards, juggling the passenger and freight carriages reallocating their order etc.[121]

This did not prevent him, however, from sharing and participating if he had something specific to contribute, as was demonstrated as early as 1950 when his new friend Richard Hamilton organized what is now seen as the inaugural exhibition of the group: 'James Joyce: His Life and Work'. To this exhibition Henderson lent his mother's copy of Joyce's *Ulysses*, which she had smuggled back from Ireland shortly after it was published in a false cover by Mikhail Larionov. Familiar with Joyce's work through his mother's friendship with him as a publishing agent, Henderson also produced three posters for the exhibition.

What the Independent Group did bring Henderson was a place in the history books of post-war British art, without which his early work may have remained essentially unknown and invisible, although it is curious to consider what the impact on his reputation would have been had David Sylvester, as he recounts, included Henderson's work (space permitting), along with Edward Wright and Bill Chataway, in the exhibition he organized of Paolozzi's and Turnbull's sculpture at the Hanover Gallery in 1950. As his obituary in *The Times* acknowledged, however, Henderson 'was an artist interested in too many things and talented in too many different directions ever to be pigeonholed in quite the way that brings fame and critical favour'.[122] Moreover, unlike Roger Mayne, who inherited the mantle of the British street photographer (and with whom Henderson became friends through Sam Kaner), even Henderson's photographs did not sit easily in any particular category within the history of photography, having almost become synonymous with the 'great mass of unsigned photography' that was Henderson's own especial love.

But Henderson himself was also aware of the factors that would contribute to his relatively neglected place in accounts of post-war British art. Firstly, his removal from the urban context of London and the cessation of regular contact with friends clearly impacted on the level of engagement that his work could hold with contemporary debates, as he seemed to bitterly reflect in 1982: 'I personally feel myself still buoyed up by what I take to be the Dada spirit essentially. But in fact they "fought" in cadres, in cities, whereas I in my essential passivity, have dug into the dung of the ground into which Fate had stranded me.' But for all this, Henderson's ferocious aversion to the driving forces of ambition and personal celebration ('the elephantiasis of the ego that seems to go with art') which he witnessed in his friends equally left him content to be removed from the professional dynamics and 'cultural supermarket' of the art world in London. And ambition was something that Henderson never entertained, and perhaps never understood, having been relieved enough to discover that, through his practice of art, he had found a means by which to soothe his nerves and postpone the onset of boredom from which deep depressions sprang – depressions which could turn him into a stranger to himself and force him to consider, 'I wonder what my own chances of staying out of prison would have been without the saving life line of Art?'[123]

As he also confessed to Frank Whitford in 1977, 'One of the many things that makes me doubt myself is my relative indifference to Art. I can't make a study of it. I'm surprised that I have put as much time and effort into my work as I have.'[124] Consistently modest, almost self-effacing in discussions of his oeuvre, Henderson nonetheless offered up the observation that 'I have tried, I think, to fuse a small private vision in praise of the world as far as I can sense it and make some sense of it. If I'm right (?) mine is quite a small but idiosyncratic talent, lyrical.' Perhaps most important of all, however, was the fact that Henderson was so deeply reconciled with his own working practice per se, of which he joyfully wrote, 'And I've still ... this very strong amateur passion. It's a very rude word now for some reason and I'm sorry because I like the word. It means doing things for the love of it and I can't see anything wrong with that.' And it was this passion, this 'bloody-mindedness' that Reyner Banham ascribed to the New Brutalists, that, combined with the extraordinary diversity of life that he encountered through first his mother, Wyn, and second, his wife, Judith, produced a small but vital collection of work from a man who played a large and

Janet Henderson (née Murray), *c.* 1952 (photographer unknown).

undeniable role in the formation of some of the more interesting examples of post-war British art. As Colin St. John Wilson wrote to Janet Henderson, the artist's second wife and widow, on the occasion of his death:

Nigel was dreadfully underrated but if you did try to push him into the limelight he would as likely as not kick your foot out from under you – and then roar with laughter…. Time will sort all that out and will have to take account of Nigel's enormous elder brother influence on most of us at a time when, just after the war, he was one of the few who had pre-war contacts and memories outside the dreadfully closed world of wartime/postwar London. And he wrote marvellously. He was a great man ….[125]

Freda Paolozzi being photographed by Nigel Henderson with the help of Eduardo Paolozzi, seen holding up an improvised light reflector in the form of a baking tin from Woolworths, *c.* 1956.

Notes

1 MS, Henderson Collection, Tate Archive.

2 Letter to Chris Mullen, n. d., but all letters to Chris Mullen written during 1981 and 1982.

3 Letter to Chris Mullen, n. d.

4 Letter to Chris Mullen, n. d.

5 Letter to Chris Mullen, n. d.

6 Letter to Chris Mullen, n. d.

7 *Nigel Henderson: Paintings, Collages and Photographs*, Anthony d'Offay, London, 1977.

8 Charlie Jackson, 'Nigel Henderson', dissertation, Hornsey College of Art, 1973.

9 Letter to Chris Mullen. Henderson also recalled later how much like W. C. Fields Guggenheim looked at the opening of the gallery and how she wore earrings made out of half a dozen curtain rings. See James King, *The Last Modern: A Life of Herbert Read*, London, 1990.

10 'Machines in Art', *News Review*, 14 July 1938, p. 36.

11 Letter to Judith Henderson, *c*. 1940, Tate Archive.

12 Letter to Chris Mullen, n. d.

13 Charlie Jackson, 'Nigel Henderson', dissertation, Hornsey College of Art, 1973.

14 Letter to Chris Mullen, n. d.

15 Eduardo Paolozzi interviewed by Frank Whitford, Scottish National Gallery of Modern Art Archive, 1993.

16 Letter from Eduardo Paolozzi to Nigel Henderson, 12 August 1947, Tate Archive. Also present in Paris at this time were the art critic David Sylvester, the curator and critic Bryan Robertson and the artist Raymond Mason.

17 Eduardo Paolozzi interviewed by Frank Whitford, Scottish National Gallery of Modern Art Archive, 1993. Henderson's bemusement at Guggenheim's lifestyle at this time is recorded in a letter to Judith in which he writes, 'We've seen something of Peggy Guggenheim whose absurdity shows to its true proportions in the setting of the De Crillon hotel. Besides her combination jewelled watch and Lorgnette she has two little "sacred Tibetan dogs" which she likes to take around with her.' Letter to Judith Henderson, 28 August 1947, Henderson Collection, Tate Archive.

18 As Paolozzi pointed out to Sue Lawley on 'Desert Island Discs' on BBC Radio 4 in 1991, all the artists he wanted to meet were in the phone book.

19 See letter to Judith Henderson, 28 August 1947, Tate Archive, and *Nigel Henderson: Paintings, Collages and Photographs*, Anthony d'Offay, London, 1977.

20 Henderson was completely absorbed by the museum's collection and layout and wrote that he had visited it twice and intended to visit 'again and then again'. Letter to Judith Henderson, 28 August 1947, Henderson Collection, Tate Archive.

21 Letter from Henderson to Frank Whitford, 12 October 1971, Henderson Estate.

22 See letter from Paolozzi to Henderson, 20 September [1949?], Henderson Collection, Tate Archive.

23 This was the term Henderson adopted to describe his experimental work in photography.

24 Unpublished MS, Henderson Estate.

25 See Graham Clarke, *The Photograph*, Oxford 1997, p. 195.

26 See *Nigel Henderson: Photographs of Bethnal Green 1949–52*, Nottingham 1978. As with the majority of Henderson's photograms, the final print was reversed from the original negative image.

27 Gyorgy Kepes, *Language of Vision*, New York, ed. 1964, pp. 149–50.

28 László Moholy-Nagy, *Vision in Motion*, Chicago, 1947, p. 197.

29 László Moholy-Nagy, *Vision in Motion*, Chicago, 1947, p. 31.

30 Frank Whitford, *Nigel Henderson: Photographs, Collages, Paintings*, Kettle's Yard, Cambridge, 1977. The Hendersons were the only family in their street with a bath after Henderson persuaded the War Damage Crew to install a bath and a sink.

31 László Moholy-Nagy, 'Space-Time Problems in Art', *American Abstract Artists*, New York, 1946.

32 Letter to Chris Mullen, n. d.

33 Letter from Nigel Henderson to Frank Whitford, 12 October 1971, Henderson Estate.

34 This script is now held in the Henderson Collection, Tate Archive.

35 See above note.

36 See *Growth and Form*, ICA exhibition catalogue, London, 1951. In the Foreword, Read also made reference to Gyorgy Kepes's work in identifying new visual landscapes revealed by developments in technology and science. Although a catalogue was planned and begun, it soon outgrew its original function and in its place Lund Humphries, in conjunction with the ICA, published a volume of essays, *Aspects of Form*, by ten scientists and one art historian, E. H. Gombrich, whose contribution was 'Meditations on a Hobby Horse or the Roots of Artistic Form'.

37 See Graham Whitham, *The Independent Group: Postwar Britain and the Aesthetics of Plenty*, ICA, London, 1990, p. 17. The exhibition formed part of the ICA's contribution to the Festival of Britain celebrations.

38 Although Hamilton had suggested early on that Paolozzi might like to be involved in the exhibition, like Henderson he withdrew during the early stages since 'he didn't really take to Hamilton's cut and dried, chapter and verse, intellectualizations'.

39 See 'Italian Scrapbook', *Architectural Review*, February 1952, p. 83. The image was also accompanied by a text by Paolozzi.

40 The photograph is also accompanied by extensive notes profiling Paolozzi's home town and outlining his family background and history. From these notes a contrast is invariably created between the rustic life of Paolozzi's family in Viticuso, where they are respected and 'important'

members of the community, with his own upbringing in Leith, Edinburgh, which is characterized by 'tenements, slate pavings, granite kerbs, cast-iron gratings, cobbles, etc. etc. etc.'.

41 *Nigel Henderson: Photographs of Bethnal Green 1949–52*, Nottingham, 1978, p. 5. It is perhaps worth also noting that in a conversation with the art critic David Sylvester he recalled that Francis Bacon, a mutual friend, had been very taken by Henderson's 'drawings' of boys on bikes. In the catalogue to Henderson's show at Anthony d'Offay's in 1977 it was then noted that Sylvester recalled these drawings as being 'Léger-like'.

42 Letter from Michael Pearson to Henderson, 3 December 1956, Henderson Estate.

43 László Moholy-Nagy, *Vision in Motion*, Chicago, 1947, p. 153.

44 Letter from Michael Pearson to Henderson, 3 December 1956, Henderson Estate.

45 '1.10.51', Notebook, Henderson Collection, Tate Archive.

46 László Moholy-Nagy, *Vision in Motion*, Chicago, 1947, p. 115.

47 Although Henderson freely spoke about the processes of his art, he rarely attributed meanings and found it difficult to write about the subject. He did, however, provide an eloquent reason for his aversion to such writing:

I thought I would try to write directly to illuminate my work. But found I couldn't do it. It involved me in using words like a critic – in the pretension for me of exact word-usage. Word – Brick; Wall – Sentence; Room – Paragraph; House – Concept; and the totality of the relationship of houses to houses and to environment.

A philosophy in short. Uppercase 3, London, 1961

48 Dubuffet wrote:

J'ai reçu des mains de Rosalind Constable vos admirables photographies et c'est une grande joie pour moi. Je les trouve plus belles encore que le souvenir que j'en avais. Il faut que vous en fassiez d'autres, nombreuses, dans la manière des baigneurs et aussi dans la manière du navet. Je vous remercie bien vivement. Je suis bien conscient d'avoir payé pour ces photographies un prix extrêmement inférieur à leur valeur et j'en ai un peu honte.

[I have received your wonderful photographs from Rosalind Constable and that is a great joy to me. I find them even more beautiful than I had remembered. You must create more, many more, of them in the style of the bathers and also in the style of the turnip. Thank you very much indeed. I am only too conscious of having paid far less than their real value for these photographs, and I am rather ashamed of that.]

Letter from Jean Dubuffet to Henderson, 'Paris, 12 June 1954', Henderson Collection, Tate Archive.

49 Undated MS, Henderson Estate.

50 In a letter to Judith (Tate Archive) written during the war, Henderson wrote, 'I'm glad you see me as Naturalist Explorer – a role I've often considered myself' and again in 1956, on composing a biographical entry for a new collector, he observed, 'In a street, I feel like a naturalist in a jungle.' Letter to Michael Pearson, 29 January 1956, Henderson Estate.

51 As he told Ann Seymour, 'he liked the freshness and innocence of bad prints', *Nigel Henderson: Paintings, Collages and Photographs*, Anthony d'Offay, London, 1977.

52 See George Orwell, *The Road to Wigan Pier*, London, 1937. Orwell was commissioned by the publisher Victor Gollancz to write on the depressed areas of the North of England, and when the book was first published it included 32 plates which documented the hardships that the working classes were subject to all over England, including Bethnal Green, Poplar and Stepney. Of the very few negatives that do exist of a funeral in the East End, Henderson's clear unease with intruding on such a private occasion is revealed by the position he took up to take the photograph: an upstairs window of his house.

53 'London', 1949, MS, Henderson Collection, Tate Archive. This was later published in a greatly simplified, shortened and more poetic form as 'Memories of London 1949 (For Eduardo Paolozzi)' in *Uppercase 3*, edited by Theo Crosby in 1961, and later reproduced in *Nigel Henderson: Photographs of Bethnal Green 1949–52*, Nottingham, 1978, p. 3.

54 Paolozzi's grandfather, Michelangelo, had emigrated to London around 1902 in the hope of establishing a new life, but having pushed a 'barrel organ through provincial English towns', he returned to Viticuso, where he subsequently fathered five children, including Alfonso, Eduardo Paolozzi's father. Alfonso Paolozzi emigrated to Edinburgh in 1920, where he met his wife, also from the same village in Italy, Viticuso, and together they set up an ice-cream, tobacco and sweet shop there. On 'Desert Island Discs' in May 1991, Paolozzi recalled the ice-cream shop in Edinburgh, noting that, though it was busy in summer, during the quiet winter months his father earned a living by making radios. From the age of ten, Paolozzi was sent back to Viticuso for three months every year until war broke out, and therefore had a clear impression of the contrast between life in Italy and life in Britain.

55 David Mellor, 'Nigel Henderson', in an edition of *Camerawork* dedicated to Mass Observation, September 1978.

56 See *The Street Markets of London*, photography by László Moholy-Nagy, text by Mary Benedetta, London, 1936. That Henderson was familiar with this publication is suggested by the fact that among the photographs reproduced there is a strikingly similar image of the stocking stall. In addition, Henderson also owned another book for which Moholy-Nagy was commissioned to take photographs when he was in London: *Eton Portrait*.

57 Undated notebook, Henderson Collection, Tate Archive.

58 *Nigel Henderson: Photographs of Bethnal Green 1949–52*, Nottingham, 1978, p. 5. Earlier in 1961, Henderson also named Klee, along with Duchamp and Dubuffet, as an artist creating 'light-tissues jingling in the mental wind. Sign-maker.'

59 In a letter to Judith written during the war, Henderson reflects on Eliot's imagery and notes, 'All that imagery Eliot fixes so masterfully in his poems – his "property". These grey, uncompromising objects I take to be the external symbols of a childhood which managed to be very lonely and emotionally rather void …'. Undated letter, Henderson Collection, Tate Archive.

60 See 'Mass Observation' edition of *Camerawork*, September 1978, p. 1.

61 Undated MS, Henderson Estate. In advocating the need for distance and objectivity in the gathering of factual evidence, Thomas Madge had also noted in one of the Mass Observation bulletins (1937) that Duchamp was a real modernist, since he had successfully adopted a 'scientific' frame of mind.

62 Letter to Judith, n. d., Henderson Collection, Tate Archive.

63 In 1951, when Henri Cartier-Bresson was commissioned to photograph the East End for *Illustrated*, Henderson took him on a tour, but very deliberately avoided his own special 'haunts'.

64 Quoted from transcripts of an interview of the Smithsons by Reyner Banham for an Arts Council film, 'Fathers of Pop', 1979.

65 Alison and Peter Smithson, *Ordinariness and Light*, London, 1970, p. 5. Excerpt originally written in 1952.

66 The Smithsons subsequently reproduced these photographs in full with annotations in their book *Urban Structuring*, London, 1967, which chronologically documented their rethinking and reformulation of the fundamentals of urban planning from the beginning of the 1950s.

67 In 1958, the Samuels family which Judith had taken as the subject of her neighbourhood study were also persuaded to move down to Thorpe-le-Soken, where the children of both families became good friends. According to Justin Henderson and Freda Paolozzi (the Paolozzis also moved down to the same row of cottages adjacent to The King's Head), however, the family only became aware of the role they had played in Judith's work when Henderson published excerpts from her diary to accompany an exhibition of his East End photographs in 1978. See *Nigel Henderson: Photographs of Bethnal Green 1949–52*, Nottingham, 1978, for these excerpts.

68 Bryan Robertson, 'Parallel of Life and Art', *Art News and Review*, 5, 19 September 1953.

69 Tom Hopkinson, *Manchester Guardian*, 22 September 1953.

70 Press release for 'Parallel of Life and Art', 31 August 1953, Henderson Estate.

71 MS, 'Parallel of Life and Art' File, Archive of Peter and Alison Smithson.

72 MS, 'Documents 53', 'Parallel of Life and Art' File, Archive of Peter and Alison Smithson.

73 'Memorandum – Institute of Contemporary Arts, March 27th, 1953', Henderson Collection, Tate Archive.

74 MS, Henderson Collection, Tate Archive.

75 'Museum Without Walls', *The Voices of Silence*, London, 1956, p. 15.

76 'Museum Without Walls', *The Voices of Silence*, London, 1956, p. 16.

77 'Museum Without Walls', *The Voices of Silence*, London, 1956, p. 16.

78 MS, Henderson Collection, Tate Archive.

79 Dorothy Morland interviewing Nigel Henderson, 17 August 1976, ICA Collection, Tate Archive.

80 'Exhibitions', *Architectural Review*, no. 677, May 1953, pp. 338–39.

81 See Alexander Dorner, *The Way Beyond Art: The Work of Herbert Bayer*, New York, 1947.

82 See Gwen Finkel Chanzit, *Herbert Bayer and Modernist Design in America*, Ann Arbor/London, 1987.

83 'Notes written in response to Peter Karpinski', 'The Independent Group 1952–55', B.A. dissertation, Leeds, 1977. Reproduced in *The Independent Group: Postwar Britain and the Aesthetics of Plenty*, ICA, London, 1990, p. 21.

84 See 'Late Klee' in David Sylvester, *About Modern Art: Critical Essays 1948–97*, London, 1996.

85 Reyner Banham, 'The New Brutalism', *Architectural Review*, December 1955, pp. 355–61.

86 See Reyner Banham, *The New Brutalism: Ethic or Aesthetic?*, London, 1966, p. 41.

87 Robert Melville, 'Exhibitions', *Architectural Review*, July 1955, p. 50.

88 See Reyner Banham, *The New Brutalism: Ethic or Aesthetic?*, London, 1966, p. 61.

89 See Theo Crosby, 'This Is Tomorrow', *Architectural Design*, September 1956, p. 302. For an overview of all the installations, see *The Independent Group: Postwar Britain and the Aesthetics of Plenty*, ICA, London, 1990, pp. 135–59.

90 Reyner Banham, 'This Is Tomorrow', *Architectural Review*, September 1956, pp. 186–88.

91 See Reyner Banham, *The New Brutalism: Ethic or Aesthetic?*, London, 1966, p. 65.

92 Alison and Peter Smithson, 'Eames' dream', *Changing the Art of Inhabitation*, London, 1994, p. 99.

93 Alison and Peter Smithson, 'The Smithsons', *Changing the Art of Inhabitation*, London, 1994, p. 109.

94 Alison and Peter Smithson, 'Eames' dream', *Changing the Art of Inhabitation*, London, 1994, pp. 73–74.

95 Alison and Peter Smithson, 'Eames' dream', *Changing the Art of Inhabitation*, London, 1994, p. 99.

96 Robert Melville, 'Exhibitions', *Architectural Review*, November 1956, p. 334.

97 Reyner Banham, recorded in 1976 as part of 'Fathers of Pop', Arts Council Film, 1979, but not used.

98 Colin St. John Wilson, *The Independent Group: Postwar Britain and the Aesthetics of Plenty*, ICA, London, 1990, p. 37.

99 Letter to Chris Mullen, n. d.

100 Letter from Nigel Henderson to Colin St. John Wilson, 9 February 1975, Archive of Colin St. John Wilson.

101 Peter Smithson in conversation with Reyner Banham for 'Fathers of Pop', Arts Council Film, 1979. In a recent interview, Peter Smithson also recalled of the completed installation, 'We were knocked down by it coming back – without any discussion, from nothing to the complete thing was miraculous.' J. Millar, 'This Is Tomorrow', *The Whitechapel Art Gallery Centenary Review*, London, 2001, p. 70. Smithson is, however, the first to acknowledge in conversation that retrospective memory can rewrite history at every turn.

102 Max Ernst, *Cahiers d'Art*, no. 6–7, Paris, 1936. Quote taken from the translation by Dorothea Tanning in *Max Ernst, Beyond Painting*, New York, 1948, pp. 13–14.

103 Letter to Chris Mullen, n. d.

104 See '1954', *Nigel Henderson: Paintings, Collages and Photographs*, Anthony d'Offay, London, 1977.

105 The exhibition was extraordinary in its diversity of work and range of artists, which included Kurt Schwitters, Pablo Picasso, Georges Braque, Juan Gris, Henri Laurens, Stuart Davis, Max Ernst, Tristan Tzara, André Breton, Hans Arp, Marcel Duchamp, Man Ray, Jean Dubuffet, René Magritte, E. L. T. Mesens, Roland Penrose, George Melly, Eduardo Paolozzi, Victor Pasmore, John Piper, Le Corbusier and John McHale.

106 See László Moholy-Nagy, *Vision in Motion*, Chicago, 1947, p. 212.

107 Letter to Chris Mullen, n. d.

108 David Mellor, 'Nigel Henderson', in the 'Mass Observation' edition of *Camerawork*, September 1978, p. 12.

109 Charlie Jackson, dissertation, Hornsey College of Art, 1973, p. 8.

110 Frank Whitford, *Nigel Henderson: Photographs, Collages, Paintings*, Kettle's Yard, Cambridge, 1977.

111 See *Nigel Henderson*, Norwich School of Art, 1982, p. 5.

112 Charlie Jackson, dissertation, Hornsey College of Art, 1973, p. 2.

113 Letter from Nigel Henderson to Colin St. John Wilson, 2 August 1969, Archive of Colin St. John Wilson.

114 Letter to Chris Mullen, n. d.

115 Eduardo Paolozzi interviewed by Frank Whitford, Scottish National Gallery of Modern Art Archive, 1993.

116 Letter to Chris Mullen, n. d.

117 Letter to Chris Mullen, n. d.

118 Letter to Chris Mullen, n. d.

119 See *Nigel Henderson*, Norwich School of Art, 1982, p. 28.

120 Letter from Nigel Henderson to Peter Karpinski, 22 January 1977.

121 From a notebook held in Tate Archive.

122 'Mr. Nigel Henderson', *The Times*, 24 May 1985.

123 See *Nigel Henderson*, Norwich School of Art, 1982, p. 6.

124 Frank Whitford, *Nigel Henderson: Photographs, Collages, Paintings*, Kettle's Yard, Cambridge, 1977.

125 Letter from Colin St. John Wilson to Janet Henderson, 21 May 1985, Archive of Colin St. John Wilson.

Page of a letter from Nigel Henderson, in Paris, to Judith Henderson, 28 August 1947. Tate Archive.

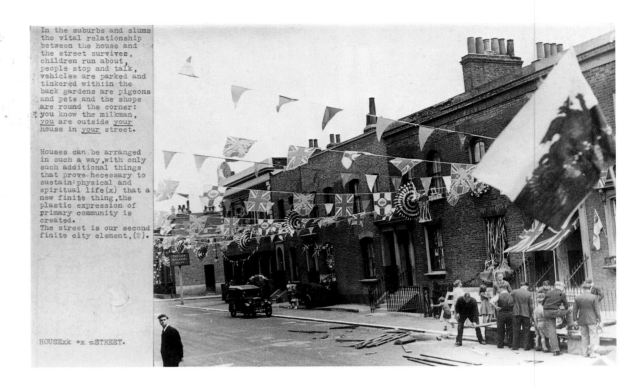

In the suburbs and slums the vital relationship between the house and the street survives, children run about, people stop and talk, vehicles are parked and tinkered with: in the back gardens are pigeons and pets and the shops are round the corner: you know the milkman, you are outside your house in your street.

Houses can be arranged in such a way, with only such additional things that prove necessary to sustain physical and spiritual life (x) that a new finite thing, the plastic expression of primary community is created.
The street is our second finite city element. (2).

HOUSExk +x =STREET.

Afterword

Of course, those who know something of the 'shift to the specific' which occurred in the manifestos and work of young architects in the 1950s will be already conscious of the way that both Nigel and his wife Judith, unknowingly, were party to that shift.

There is, in Victoria Walsh's story, a description of the observation work of Judith Henderson in the East End ... sociology had begun to emerge from the rain-forest into the streets.

But it had to be made visible for architects to be conscious of that as a general emergence, and this happened for Alison and myself at CIAM 9 at Aix-en-Provence in 1953.

There was at Aix metre-upon-metre of drawings on the walls from the groups around Écochard ... the urbanist of Casablanca.

They were revelatory in content and presentation.

That the work was in parallel with our own, and the shock it gave, can still be experienced from two images: one the woman in the courtyard ... life-lived, body posture, equipment, ambience; the other ... air-views of the pattern of the 'collective'.

La dissimulation aux rues
est une obligation tradi-
tionnelle pour l'habitat
des musulmans. Cet impera-
tif s'atténue mais avec
une lenteur qui oblige ac-
tuellement d'en tenir le
plus grand compte.

Hiding themselves from
exterior looks is a tra-
ditionnal obligation in
mussulman housing. This
obligation is decreasing
but so slowly that, at the
present time, the greatest
consideration must be taken
of it.

The latter image making the parallel more striking by being taken from the 1953 Casablanca presentation is, therefore, in the same format as our own *Grille*, and has the parallel observation 'things are changing, but slowly' (be vigilant about past forms?).

One speculates ... in our work, part certainly of 'life of the streets' — from Nigel and Judith Henderson, and the looser-linked forms in which we began to formulate these street ideas, again, certainly, in part, from the graphics of Eduardo Paolozzi in that period.

Behind all this, in Écochard and ourselves, an echo of Patrick Geddes?

Peter Smithson

Nigel, Judith and Drusilla (Jo) Henderson in the garden at 46, Chisenhale Road, *c.* 1952.

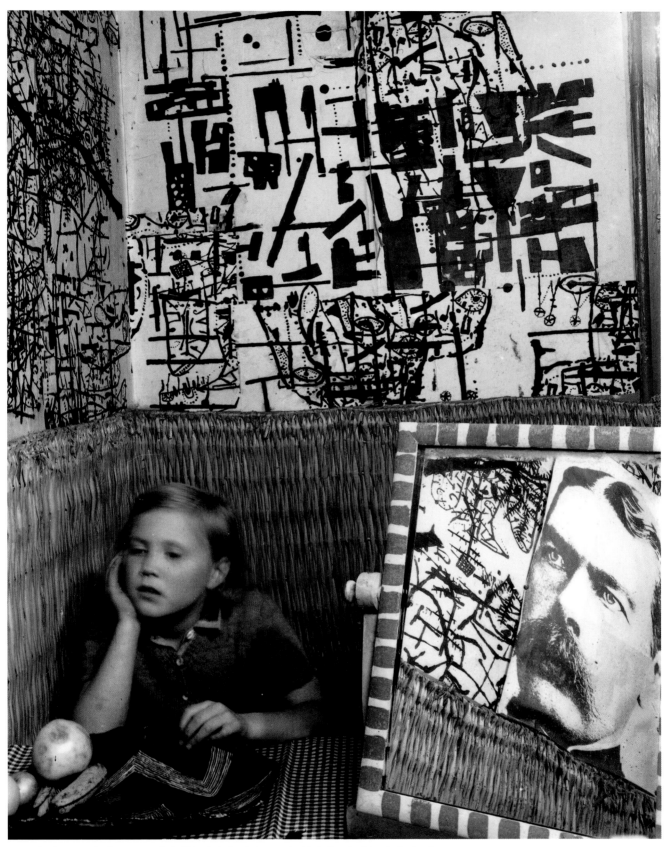

Justin Henderson in the front room of 46, Chisenhale Road, decorated with designs by Eduardo Paolozzi, 1952.

Biography

1917 Nigel Henderson born in St John's Wood, London. After his parents' divorce, grows up with paternal grandparents on Wimbledon Common. Spends holidays with his mother, Wyn Henderson, in Gordon Square, Bloomsbury.

1931–33 Attends Stowe School, Buckinghamshire, but leaves early.

1933 Moves to London to live with his mother.

1935–36 Studies biology at Chelsea Polytechnic. Meets Karin and Adrian Stephen (brother of Vanessa Bell and Virginia Woolf), both practising Freudian psychoanalysts. Meets the scientist J. D. Bernal through Francis Meynell's wife, Vera. Reading Comte de Lautréamont, Louis Aragon, and Paul Éluard in uncut editions which his mother brings back from Paris. Wyn Henderson temporarily moves to Cornwall to run a hotel which is frequented by her friend Dylan Thomas, who becomes fond of Henderson.

1936–39 Working as full-time assistant to Dr Helmut Ruhemann, picture restorer at the National Gallery, London.

1938 Wyn Henderson helps Peggy Guggenheim open and run her gallery, Guggenheim Jeune, in Cork Street, London. Two of Henderson's collages included in an exhibition of collage work by Pablo Picasso, Georges Braque, Juan Gris, Max Ernst and Yves Tanguy. Guggenheim introduces him to Tanguy and Marcel Duchamp in Paris. Henderson helps Duchamp hang a Jean Cocteau exhibition at Guggenheim Jeune. Moves into a studio in Fitzroy Street, where fellow housemates include Adrian Stokes and Lawrence Gowing.

1939–45 Second World War. Serves as pilot in Coastal Command.

1943 Marries Judith Stephen (daughter of Karin and Adrian Stephen), a sociologist with a first-class degree from Cambridge. Suffers from nervous exhaustion and given limited flying duties.

1945 Has a nervous breakdown. Hendersons move to Bethnal Green in the East End of London for Judith to take up work on a neighbourhood study project with the sociologist J. L. Peterson. Tom Harrisson of Mass Observation interested in her research and provides some small financial assistance.

1945–47 Begins studying at the Slade School of Fine Art, London, having received a four-year serviceman's grant. Meets fellow students Eduardo Paolozzi and William Turnbull.

1947 Visits Paolozzi in Paris and meets Constantin Brancusi, Alberto Giacometti, Georges Braque and, through Peggy Guggenheim, Hans Arp. With Paolozzi meets Fernand Léger, who shows them his film *Ballet Mécanique*. Henderson makes friends with Richard Hamilton in London and persuades him to leave the Royal Academy and move to the Slade. Borrows a Leica camera and takes his first photographs.

1949 Paolozzi gives him a photographic enlarger.

1949–51 Begins producing photograms ('Hendograms'). Acquires a Rolleiflex, a plate camera and two enlargers and begins to produce distorted and 'stressed' images. Starts to take photographs of the East End. In December 1950, the ICA (Institute of Contemporary Arts) opens at its new premises in Dover Street, London, and Henderson helps Paolozzi design the bar area.

1951 Henderson and Paolozzi travel to Viticuso in Italy to visit Paolozzi's relatives. Appointed tutor of Creative Photography at London's Central School of Arts and Crafts, where other members of staff include Paolozzi, Hamilton, Peter Smithson, William Turnbull. Paolozzi

introduces Henderson to the Smithsons. Photographic commissions undertaken for *Flair*, *Architectural Review*, *Vogue*. Meets graphic artist Sam Kaner at Central School and through him gains work with *Melody Maker* and Ronnie Scott. Henri Cartier-Bresson commissioned to take photographs of the East End for *Illustrated* and asks Henderson to take him on a guided tour of the area.

1952 Present at the inception of the Independent Group at the ICA. Brooklyn Museum of Art, New York, purchases three stressed photographs.

1953 With Paolozzi, the Smithsons and Ronald Jenkins, Henderson organizes the exhibition 'Parallel of Life and Art' which opens at the ICA in September. In December, it is briefly on show at the Architectural Association in London. Museum of Modern Art, New York, acquires six photographs, including experimental work for its collection, after including the works in the exhibition 'Post War European Photography'.

1954 Sam Kaner introduces Henderson to Roger Mayne, who visits on occasional weekends. 'Photo-Images' – a small exhibition of Henderson's work – opens in the Members' Room of the ICA in April. Jean Dubuffet, a friend and admirer of Henderson, buys six of the works. In June, Henderson stops teaching at the Central School. Contributes a collage *Atlas* (now lost) to Lawrence Alloway's exhibition at the ICA, 'Collages and Objects', held in October. Lends Richard Hamilton his copy of Duchamp's *The Green Box*, which remains on loan for twenty years. Hendersons leave London to live at Landermere Quay in Essex at Judith Henderson's family home. Freda and Eduardo Paolozzi also move down to live in cottages adjacent to the property. They are soon followed by the Samuels family, with which the Hendersons had become friends in the East End and whose lives were briefly documented by Judith Henderson for her neighbourhood study. Sets up textile-

design company Hammer Prints Ltd with Paolozzi. Clients include Jane Drew, Conran Furniture, Bristol Old Vic theatre, the ICA.

1956 Second collaboration with Paolozzi and the Smithsons takes place for the exhibition 'This Is Tomorrow' which opens at the Whitechapel Art Gallery, London, in August. They create an environment, 'Patio & Pavilion', which includes Henderson's *Head of a Man*, one large floor collage representing a pond, and a wall collage of plant life.

1957–60 Begins part-time teaching at Colchester School of Art, Essex. Exhibition of work by Henderson and Paolozzi at the Arts Council Gallery in Cambridge organized by Muriel Wilson.

1960 Invited by Colin St. John Wilson to have a solo exhibition at the School of Architecture, Cambridge University.

1961 Invited by Roland Penrose to have a solo exhibition at the ICA in London. Hammer Prints Ltd ceases business.

1965–68 Becomes Head of Photography at Norwich School of Art, Norfolk.

1972 Judith Henderson dies. Returns to teaching at Norwich School of Art.

1974–75 Two works, *Collage* (1949) and *Plant Tantrums* (1960), purchased by the Tate Gallery, London. Colin St. John Wilson donates to the Tate *Head of a Man*, the collage created for the installation 'Patio & Pavilion' for the exhibition 'This Is Tomorrow' at the Whitechapel in 1956.

1975 Creates a mural for the Department of Environmental Sciences at the University of East Anglia, Norwich.

1976 Begins work on new series of images: *Lovely Linda* and *Southwold*.

1977 Retrospective exhibition at Kettle's Yard, Cambridge. Adds two new collage panels to screen begun in 1949 and now in the possession of Colin St. John Wilson. Exhibition at the Anthony d'Offay Gallery in London.

1978 Exhibition of the East End photographs at the Midland Group in Nottingham.

1982 Exhibition of new work organized by Linda Morris at the Norwich School of Art and accompanied by a catalogue with an essay by Chris Mullen, a fellow lecturer and close friend at Norwich. Mullen bases his essay on information gathered from Henderson in a long exchange of letters which offer invaluable insights to the artist's life and career.

1983 The Norwich exhibition travels to the Serpentine Gallery in London, where it incorporates more new work based on Henderson's collages of his self-portrait.

1985 Nigel Henderson dies unexpectedly at Thorpe-le-Soken, Essex.

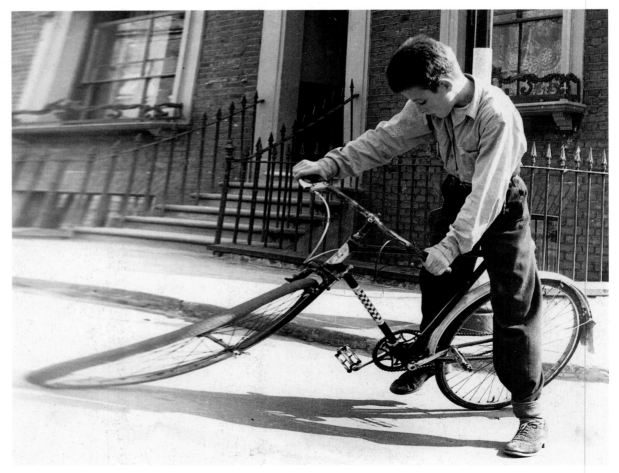

Stressed photograph, c. 1950.

Stressed photograph of locomotive, 1949–51. 19¾ x 15¾ in. (50 x 40 cm).

Exhibitions

Solo Exhibitions

1954 'Photo-Images', Institute of Contemporary
 Arts [ICA], London

1960 'Nigel Henderson', School of Architecture,
 University of Cambridge

1961 'Nigel Henderson: Recent Work',
 ICA, London

1977 'Nigel Henderson: Photographs, Collages,
 Paintings', Kettle's Yard, Cambridge

 'Nigel Henderson: Paintings, Collages and
 Photographs', Anthony d'Offay Gallery,
 London

1978 'Nigel Henderson: Photographs of Bethnal
 Green 1949–52', Midland Group, Nottingham

1982 'Nigel Henderson', Norwich School of Art

1983 'Nigel Henderson', Graves Art Gallery,
 Sheffield

 'Nigel Henderson – Head-Lands: Self-
 Portraits and Imagined Landscapes
 1960–1983', Serpentine Gallery, London

 'Nigel Henderson', John Hansard Gallery,
 Southampton

1989 'Nigel Henderson 1917–1986: Collages',
 Birch & Conran, London

Group Exhibitions

1938 'Collages, Papiers-Collés and Photomontages',
 Guggenheim Jeune, London

1951 'Growth and Form', ICA, London

1953 'Wonder and Horror of the Human Head',
 ICA, London

 'Post War European Photography', Museum
 of Modern Art, New York

 'Parallel of Life and Art', ICA, London

 Group show, 22 Fitzroy Street, London

1954 Milan Triennale

 'Collages and Objects', ICA, London

1956 'This Is Tomorrow', Whitechapel Art Gallery,
 London

1957 'Eduardo Paolozzi and Nigel Henderson',
 Arts Council Gallery, Cambridge

 'Hammer Prints Ltd: An Exhibition and Sale
 of Ceramics and Textiles etc. designed by
 Eduardo Paolozzi and Nigel Henderson',
 Studio Club, London

1976 'Just What is it? Pop art in England 1947–63',
 York Art Gallery

 'The Human Clay', Hayward Gallery, London

 'Pop Art in England: Beginnings of a New
 Figuration 1947–63', Kunstverein in Hamburg

1981 'Constructed Images', Falmouth School of Art

1983 'Portraits and Lives', John Hansard Gallery,
 Southampton

1984 'Headhunters', Arts Council of Great Britain
 touring exhibition

 'The Forgotten Fifties', City of Sheffield
 Art Galleries

1986	'Contrariwise: Surrealism and Britain 1930–1986', Glynn Vivian Art Gallery, Swansea
1987	'Conversations', Darlington Arts Centre
	'British Pop Art', Birch & Conran, London
	'This Is Tomorrow Today', The Clocktower Gallery, ICA, New York
1990	'The Independent Group: Postwar Britain and the Aesthetics of Plenty', ICA, London, touring exhibition
1992	'New Realities: Art in Western Europe 1945–68', Tate Gallery Liverpool
1995	'Photographers' London: 1839–1994', Museum of London
1997	'From Blast to Pop: Aspects of Modern British Art, 1915–1965', David and Alfred Smart Museum of Art, University of Chicago
	'Documenta X', Kassel
1998	'Head First: Portraits from the Arts Council Collection', Arts Council of Great Britain touring exhibition
	'Young Meteors: British Photojournalism 1957–1965', National Museum of Photography, Film & Television, Bradford
2001	'Open City: Street Photographs 1950–2000', Museum of Modern Art, Oxford
	'As Found', Museum für Gestaltung, Zurich
	'Creative Quarters: The Art World in London 1700–2000', Museum of London

Bibliography

All titles are given in chronological order under their respective headings

Solo exhibition catalogues

1961 *Nigel Henderson: Recent Work*, Institute of Contemporary Arts [ICA], London

1977 *Nigel Henderson: Photographs, Collages, Paintings*, Kettle's Yard, Cambridge

 Nigel Henderson: Paintings, Collages and Photographs, Anthony d'Offay Gallery, London

1978 *Nigel Henderson: Photographs of Bethnal Green 1949–52*, Midland Group, Nottingham

1982 *Nigel Henderson*, Norwich School of Art

1983 *Nigel Henderson – Head-Lands: Self-Portraits and Imagined Landscapes 1960–1983*, Arts Council of Great Britain, London

1989 *Nigel Henderson*, Birch & Conran, London

Group exhibition catalogues

1951 *Growth and Form*, ICA, London

1953 *Wonder and Horror of the Human Head*, ICA, London

 Post War European Photography, Museum of Modern Art, New York

 Parallel of Life and Art, ICA, London

 Group catalogue 3rd weekend exhibition paintings, sculptures, mobiles, constructions, furniture, photomurals, 22 Fitzroy Street, London

1954 *Collages and Objects*, ICA, London

1956 *This Is Tomorrow*, Whitechapel Art Gallery, London

1976 *Just What is it? Pop art in England 1947–63*, York Art Gallery

 The Human Clay, Hayward Gallery, London

 Pop Art in England: Beginnings of a New Figuration 1947–63, Kunstverein in Hamburg

1981 *Constructed Images*, Arts Council of Great Britain, London

1983 *Portraits and Lives*, John Hansard Gallery, Southampton

1984 *Headhunters*, Arts Council of Great Britain, London

 The Forgotten Fifties, City of Sheffield Art Galleries

1986 *Contrariwise: Surrealism and Britain 1930–1986*, Glynn Vivian Art Gallery, Swansea

1987 *Conversations*, Arts Council of Great Britain, London

 British Pop Art, Birch & Conran, London

1988 'This Is Tomorrow Today – The Independent Group and British Pop Art' (exhibition texts included in exhibition series publication *Modern Dreams: The Rise and Fall and Rise of Pop*), ICA and MIT, New York

1990 *The Independent Group: Postwar Britain and the Aesthetics of Plenty*, MIT Press, Cambridge, Mass., published to accompany the exhibition 'The Independent Group', ICA, London

1992 *New Realities: Art in Western Europe 1945–68*, Tate Gallery Liverpool

1995 *Photographers' London: 1839–1994*, Museum of London

1997 *From Blast to Pop: Aspects of Modern British Art, 1915–1965*, University of Chicago

1997 *Documenta X*, Kassel

1998 *Head First: Portraits from the Arts Council Collection*, Arts Council of Great Britain, London

 Young Meteors: British Photojournalism 1957–1965, National Museum of Photography, Film & Television, Bradford

2001 *Open City: Street Photographs 1950–2000*, Museum of Modern Art, Oxford

 As Found, Museum für Gestaltung, Zurich

 Creative Quarters: The Art World in London 1700–2000, Museum of London

Photographic work published in periodicals/journals

'The Cover' [photogram], *Architectural Review*, vol. 109, no. 653, May 1951, p. 273

'Italian Scrapbook' [stressed photographs of Paolozzi family at Viticuso], *Architectural Review*, vol. 111, no. 662, February 1952, p. 83

Newton, Douglas, 'Terence Conran at Simpson's', *Architectural Review*, vol. 112, no. 667, July 1952, pp. 55–57

'Children by Nigel Henderson', *Cameo*, no. 2, 1959

'Boat Race Day – 1930', *The Sunday Times Magazine*, 30 January 1977

Articles on Nigel Henderson

Henderson, Nigel, 'Photographs', *Ark*, no. 17, Summer 1956, pp. 48–51

Frampton, Kenneth, 'Nigel Henderson', *Arts Review*, 22 April 1961

'Nigel Henderson', *Camerawork*, no. 11, September 1978

'Four years in the life of Nigel Henderson at the Midland Group Gallery, Nottingham', *British Journal of Photography*, 19 January 1979, pp. 61–63

'Bethnal Green 1949–1952', *British Journal of Photography*, vol. 126, 2 November 1979

Roberts, J., 'Nigel Henderson at the Serpentine', *Studio International*, vol. 196, no. 1000, July 1983, pp. 14–15

Haworth-Booth, Mark, 'Nigel Henderson: a reputation reassessed', *Creative Camera*, no. 3, April–May 1990, pp. 24–26

Articles including Nigel Henderson

Robertson, Bryan, 'Parallel of Life and Art', *Art News and Review*, 5, 19 September 1953

Banham, Reyner, 'Photography: Parallel of Life and Art', *Architectural Review*, vol. 114, no. 682, October 1953, pp. 259–61

Banham, Reyner, 'The New Brutalism', *Architectural Review*, vol. 118, no. 708, December 1955, pp. 355–61

Banham, Reyner, 'This Is Tomorrow', *Architectural Review*, vol. 120, no. 716, September 1956, pp. 186–88

Alloway, Lawrence, 'London: Beyond Painting and Sculpture' [review of 'This Is Tomorrow'], *Art News*, 55, September 1956, pp. 38, 64

'This Is Tomorrow', *Apollo*, no. 64, September 1956, p. 89

Crosby, Theo, 'This Is Tomorrow', *Architectural Design*, vol. 26, September 1956, pp. 302–4

Crosby, Theo, 'This Is Tomorrow', *Architectural Design*, vol. 27, October 1956, pp. 334–36

'Alison & Peter Smithson', *Uppercase*, no. 3, 1961, unpaginated (special issue on the work of the Smithsons, including photographs of Bethnal Green by Nigel Henderson)

Linton, D., exhibition review, *Arts Review*, vol. 29, 30 September 1977, p. 595

Burr, J., 'Everything including the kitchen sink', *Apollo*, vol. 106, no. 188, October 1977, p. 136

Salway, Kate, 'Photography in public places', *British Journal of Photography*, vol. 132, 28 June 1985, pp. 714–15

Massey, Anne, 'Pop at the I.C.A.', *Art and Artists*, no. 236, May 1986, pp. 11–14

Massey, Anne, 'The Myth of the Independent Group', *Block*, 10, 1986, pp. 48–56

Massey, Anne, 'The Independent Group: Towards a Redefinition', *Burlington Magazine*, vol. 129, no. 1009, April 1987, pp. 232–42

Haworth-Booth, Mark, 'Where we've come from: aspects of postwar British Photography', *Aperture*, no. 113, Winter 1988, pp. 2–9

Massey, Anne, 'The Independent Group', *Burlington Magazine*, vol. 132, April 1990, pp. 284–85

Brighton, Andrew, 'Hamilton, Independent Group, mythmaking and photography', *Creative Camera*, no. 3, April–May 1990, pp. 28–30

Grieve, Alastair, 'Towards an art of environment: exhibitions and publications by a group of avant-garde abstract artists in London 1951–55', *Burlington Magazine*, vol. 132, no. 1052, November 1990, pp. 773–81

Whiteley, Nigel, 'Banham and otherness: Reyner Banham 1922–88 and his quest for an architecture autre', *Architectural History*, vol. 33, pp. 188–221

Antonelli, Paola, 'LA: The Independent Group, Postwar Britain and the Aesthetics of Plenty', *Domus*, no. 724, February 1991, pp. 18–20

Newman, Morris, 'The Independent Group – Revels in Pop', *Progressive Architecture*, vol. 72, September 1991, p. 138

Whitford, Frank, 'New Realities: Art in Western Europe 1945–1968', *Sunday Times*, 12 April 1992

Grieve, Alastair, 'This Is Tomorrow: a remarkable exhibition born from contention', *Burlington Magazine*, vol. 136, no. 1093, April 1994, p. 252

Scalbert, Irénée, 'Parallel of Life and Art', *Daidalos*, 75, 2000, pp. 53–65

'Friends of the future: a conversation with Peter Smithson' and 'The architectural cult of synchronization', *October*, Fall 2000, pp. 3–30, 31–62

Books including Nigel Henderson

Banham, Reyner, *The New Brutalism: Ethic or Aesthetic?*, London, 1966

Smithson, Alison and Peter, *Urban Structuring*, London, 1967

Hutton, Helen, *The Technique of Collage*, London, 1968

Finch, Christopher, *Image as Language: Aspects of British Art 1950–1968*, London, 1969

Smithson, Alison and Peter, *Ordinariness and Light: Urban Theories 1952–1960 and Their Application in a Building Project 1963–1970*, London and Cambridge, Mass., 1970

Kirkpatrick, Diane, *Eduardo Paolozzi*, London, 1970

Whitford, Frank, *Eduardo Paolozzi*, London, 1971

Morphet, Richard, *Richard Hamilton*, London, 1972

Smithson, Alison and Peter, *Without Rhetoric: An Architectural Aesthetic 1955–1972*, Cambridge, Mass., 1973

Ades, Dawn, *Photomontage*, London, 1986

Weld, Jacqueline Bograd, *Peggy: The Wayward Guggenheim*, New York, 1986

King, James, *The Last Modern: A Life of Herbert Read*, London, 1990

Tate Gallery, *Paris Post War, Art and Existentialism 1945–55*, London, 1993

Massey, Anne, *The Independent Group – Modernism and Mass Culture in Britain 1945–1959*, Manchester, 1995

Garlake, Margaret, *New Art, New World: British Art in Postwar Society*, London and New Haven, 1998

Harrod, Tanya, *The Crafts in Britain in the Twentieth Century*, London and New Haven, 1999

Canadian Centre for Architecture, *Anxious Modernisms: Experimentation in Postwar Architectural Culture*, Montreal, 2000

General Reading

Moholy-Nagy, László, *The Street Markets of London* (text by Mary Benedetta), London, 1936

Moholy-Nagy, László, *The New Vision*, London, 1939

Kepes, Gyorgy, *Language of Vision*, Chicago, 1944 (New York, 1964)

Moholy-Nagy, László, *Vision in Motion*, Chicago, 1947

Dorner, Alexander, *The Way Beyond Art: The Work of Herbert Bayer*, New York, 1947

Giedion, Sigfried, *Mechanization Takes Command*, New York, 1948

Giedion, Sigfried, *Space, Time and Architecture: The Growth of a New Tradition*, London, 1949

Black, Misha, *Exhibition Design*, London, 1950

Whyte, Lancelot Law (ed.), *Aspects of Form: A Symposium on Form in Nature and Art*, London, 1951

Ozenfant, Amédée, *Foundations of Modern Art*, 1928; translated by John Rodker, New York, 1952

Tapié, Michel, *Un art autre*, Paris, 1952

Gutkind, E. A., *Our World from the Air*, London, 1952

'Exhibitions' [review of 'Opposing Forces' at the ICA], *Architectural Review*, vol. 113, no. 676, April 1953, pp. 272–73

Hodin, J. P., 'Summary of Events at the ICA', *Journal of Aesthetics and Art Criticism*, December 1953, pp. 278–82

Banham, Reyner, 'Collages at the ICA', *Art News and Reviews*, 6, 30 October 1954, p. 30

Banham, Reyner, 'Vision in Motion', *Art*, 5 January 1955

Banham, Reyner, 'Machine Aesthetic', *Architectural Review*, vol. 117, no. 700, April 1955, pp. 225–28

Malraux, André, 'Museum Without Walls', *The Voices of Silence*, London, 1956, pp. 12–127

Hodges, John, 'Collage', *Ark*, no. 17, Summer 1956, pp. 24–29

Alloway, Lawrence, 'Dada 1956', *Architectural Design*, vol. 28, November 1956, p. 374

Myers, Bernard S., 'The Inclined Plane: An essay on form and flight', *Ark*, no. 18, November 1956

Anton Ehrenzweig and the Central School of Arts & Crafts, monograph, private publication, 1959

Cunard, Nancy, *The Book Collector*, London, 1964

Alloway, Lawrence, 'The Development of British Pop', in *Pop Art*, ed. Lucy Lippard, New York, 1966

Guggenheim Museum, *Jean Dubuffet*, exhibition catalogue, New York, 1966

Irwin, D., 'Pop Art and Surrealism', *Studio International*, no. 877, May 1966, pp. 187–91

Ford, Hugh, *Nancy Cunard: Brave Poet, Indomitable Rebel, 1896–1965*, Philadelphia, 1968

Alloway, Lawrence, 'Popular Culture and Pop Art', *Studio International*, July–August 1969, pp. 17–21

Ray, Paul C., *The Surrealist Movement in England*, Ithaca, N.Y., 1971

Ades, Dawn, *Dada and Surrealism Reviewed*, London, 1978

Guggenheim, Peggy, *Out of this Century: Confessions of an Art Addict*, New York, 1980

Johnstone, William, *Points in Time*, London, 1980

Penrose, Roland, *Scrapbook 1900–1981*, London, 1981

Thistlewood, David, 'Organic Art and the Popularisation of Scientific Philosophy', *British Journal of Aesthetics*, 22, Autumn 1982, pp. 311–21

Hebdige, Dick, 'In Poor Taste', *Block*, no. 8, 1983, p. 67

Konnertz, Winifred, *Eduardo Paolozzi*, Cologne, 1984

Cohen, Arthur C., *Herbert Bayer: The Complete Work*, Cambridge, Mass., 1984

Krauss, Rosalind, Dawn Ades et al., *L'Amour Fou: Photography and Surrealism*, Washington, D.C., and London, 1985

Museum of Mankind, *Eduardo Paolozzi: Lost Magic Kingdoms*, London, 1985

Robertson, Andrew, *Angels of Anarchy and Machines for Making Clouds: Surrealism in Britain in the 1930s*, Leeds, 1986

Chanzit, Gwen Finkel, *Herbert Bayer and Modernist Design in America*, Ann Arbor, 1987

Lawson, Thomas, 'Bunk: Eduardo Paolozzi and the Legacy of the IG', in *This Is Tomorrow Today*, New York, 1977, reproduced in *Modern Dreams: The Rise and Fall and Rise of Pop*, Cambridge, Mass., 1988

Kostelanetz, Richard, *Moholy-Nagy: An Anthology*, New York, 1991

Grieve, Alastair, *New Beginnings: Postwar British Art from the Collection of Ken Powell*, Edinburgh, 1992

Thévoz, Michel, *Art Brut*, Geneva, 1995

Banham, Mary, et al. (ed.), *A Critic Writes: Essays by Reyner Banham*, Berkeley, 1996

Krauss, Rosalind, and Yve-Alain Bois, *Formless – A User's Guide*, New York, 1997

J. Fineberg, *Discovering Child Art: Essays on Childhood, Primitivism and Modernism*, Princeton, 1998

Institute of Contemporary Arts, *Fifty Years of the Future: A Chronicle of the Institute of Contemporary Arts 1947–1997*, London, 1998

Dunn, Jane, *Antonia White*, London, 2000

Unpublished dissertations

Kirkpatrick, D., 'Eduardo Paolozzi: A study of his art 1948–68', Ph.D., University of Michigan, 1969

Jackson, C., 'Nigel Henderson', Hornsey College of Art, 1973

Senter, T. A., 'Moholy-Nagy in England', M.Phil., University of Nottingham, 1976/77

Furse, J., 'This was Tomorrow: the Smithsons 1956–66', M.A., University of Sussex, 1977

Karpinski, P., 'The Independent Group, 1952–1955 and the relationship of the IG's discussions to the work of Hamilton, Paolozzi and Turnbull', B.A., Leeds University, 1977

Massey, K. A., 'The Independent Group: towards a redefinition', Ph.D., University of Newcastle upon Tyne, 1985

Whitham, G., 'The Independent Group at the ICA: Its origins, development and influence', Ph.D., University of Kent, 1986

Pringle, J. L., 'Eduardo Paolozzi: a critical reappraisal', M.Phil., University of Lancaster, 1987

Hamilton, P. T., 'The role of Futurism, Dada and Surrealism in the construction of British Modernism 1910–1940', D.Phil., University of Oxford, 1987

Garlake, M., 'The relationship between institutional patronage and abstract art in Britain 1945–56', Ph.D., Courtauld Institute of Art, 1988

Walker, I., 'Paris as the site of surrealist photography 1924–39', D.Phil., University of Sussex, 1995

Wang, H. P., 'The British response to abstract expressionism of the USA c. 1950–53', Ph.D., University of Newcastle upon Tyne, 1996

Opposite: Paris wall (detail), 1949.

Index

Illustration Credits

Most of the images in this volume are reproduced from vintage prints made by Nigel Henderson. Unless otherwise stated, his original prints were made on 10 x 8 in. (25.4 x 20.3 cm) paper.